EXPERT TECHNIQUES FOR

CREATIVE PHOTOGRAPHY

EXPERT TECHNIQUES FOR
CREATIVE PHOTOGRAPHY

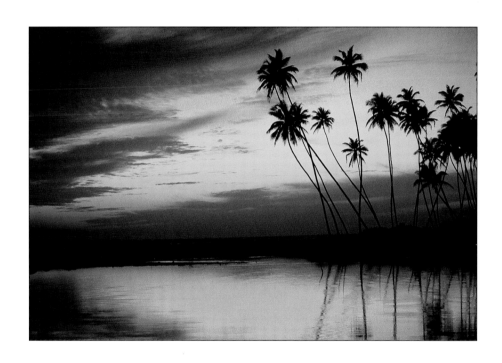

MICHAEL BUSSELLE

CINCINNATI, OHIO

Also by Michael Busselle

Master Photography
Take Better Photographs
Photographing People
The Encyclopedia of Photography
The Photographer's Question & Answer Book
The Wine Lover's Guide to France
Landscape in Spain
Castles in Spain
Three Rivers of France

First published in the U.S.A.
by Writer's Digest Books, an imprint of
F & W Publications, Inc.
1507 Dana Avenue, Cincinnati, Ohio 45207.

ISBN 0-89879-526-5

Designed by COOPER · WILSON, London
Typeset by ICON, Exeter
and printed in Singapore by Saik Wah Press Pte Ltd
for David & Charles plc
Brunel House Newton Abbot Devon

INTRODUCTION

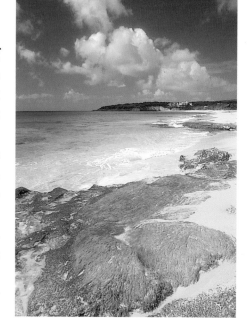

I still remember as a child discussing with groups of friends, 'what shall we do today?'. Quite often no useful suggestions came forward and the day was spent in aimless idling. It's a feeling which continues to haunt most adults from time to time.

For people with a creative bent it can be particularly frustrating: writers have blocks, painters gaze at blank canvases and photographers become overfamiliar with and bored by their surroundings.

The secret, if that's what it is, of producing good work is simply to be strongly motivated. Being creative is largely a state of mind. It's surprising how the urge to do something increases the ability to achieve it.

The purpose of this book is to provide a series of ideas and suggestions which will trigger those creative urges. Each section provides a different approach ranging from the visual and the thematic to applied photography and techniques which exploit the special qualities of the photographic process and equipment.

The book has been planned so you can dip into it and select assignments to suit your mood or circumstances, with ideas for both indoor and outdoor photography, portrait and landscape, still life and darkroom.

There are suggestions for expanding and developing the individual assignments, and it is intended that you might see ways in which the essence of several different projects can be combined to create many further permutations.

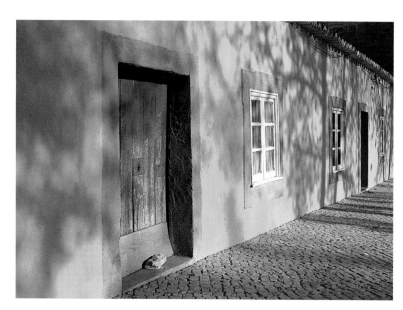

CONTENTS

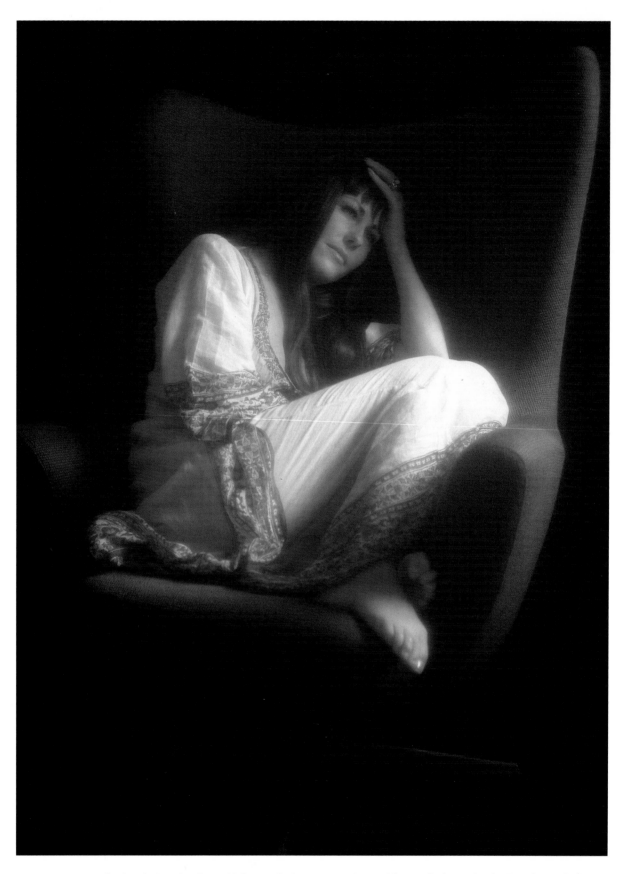

Portraits can quite often benefit from the effects of diffusion, if only to create a degree of flattery. In this studio shot I made use of soft focus to add an element of mood and to enhance the effect of the lighting. I used strips of Sellotape stretched over the front of my lens hood leaving a central hole about a centimetre square and set a widish aperture of f5.6

PART ONE

DIFFUSION

Modern camera lenses, even quite inexpensive ones, are capable of producing very crisp images. With most photographs the aim is to establish the sharpest image a lens can achieve but there are occasions when fine detail and revealing clarity can be a disadvantage.

A slightly diffused image has a number of very appealing qualities: colours can be softer and less saturated, the contrast range of the image can be reduced and the lack of fine detail can make a picture more atmospheric.

There's a considerable difference, however, between a diffused image and one that is simply out of focus or blurred through camera shake; this is seldom an attractive quality.

There are a variety of ways in which a soft-focus image can be produced. Attachments may be bought to fit most cameras, although the effect can only be judged accurately when using one with through-the-lens viewing systems like an SLR or view camera. Most filter manufacturers have their own method of achieving diffusion; the Zeiss Softar is considered one of the best.

It can, however, be more interesting, and the results less predictable, to improvise with diffusing devices. One of the easiest methods is to simply stretch a piece of fine-gauge nylon mesh over the lens with a small hole cut in the centre. This allows the image to retain a residual core of sharpness.

The method works well with portraits especially if light flesh-tinted nylon is used, like ladies' tights for example, giving a little added warmth to skin tones. You will find that a small lens aperture will minimise the effect and a wide aperture will enhance it.

When using this technique with a portrait it is best to ensure a good tonal contrast between the model's face and background. Most methods of diffusion result in the lighter tones of the picture spreading slightly into the darker areas. Against a dark background the model's outline will have a slight halo effect which will be accentuated with backlighting.

A light background — an indoor portrait shot against a window for example — will tend to bleed slightly into the darker tones of the model. Both effects can be pleasing providing you control them and do not allow them to occur indiscriminately.

For a more extreme spreading of highlights and greater loss of detail, sellotape, petroleum jelly and clear crinkled acetate over the lens can be effective — again with a clear hole in the centre.

Petroleum jelly, smeared onto a skylight filter — not the lens — has the advantage that it can be teased around with a finger tip to create a variety of effects. This can be particularly striking if the subject is backlit, or if there are strong highlights in the image, when it can be used to produce semi-abstract effects.

Unless you want to produce very soft images with muted colours it is best to use this technique with subjects which have a good brightness range and well-saturated colours. Diffusion is most suited to subjects with a potentially romantic quality: a portrait of a child or girl would be more appropriate than a character shot, for example, or a woodland scene rather than an industrial landscape.

Backlighting and high subject contrast have enabled a considerable degree of diffusion to be used in this landscape shot without making the resulting image too degraded. I used a piece of clear, slightly crinkled acetate over the lens with a small aperture cut in the centre

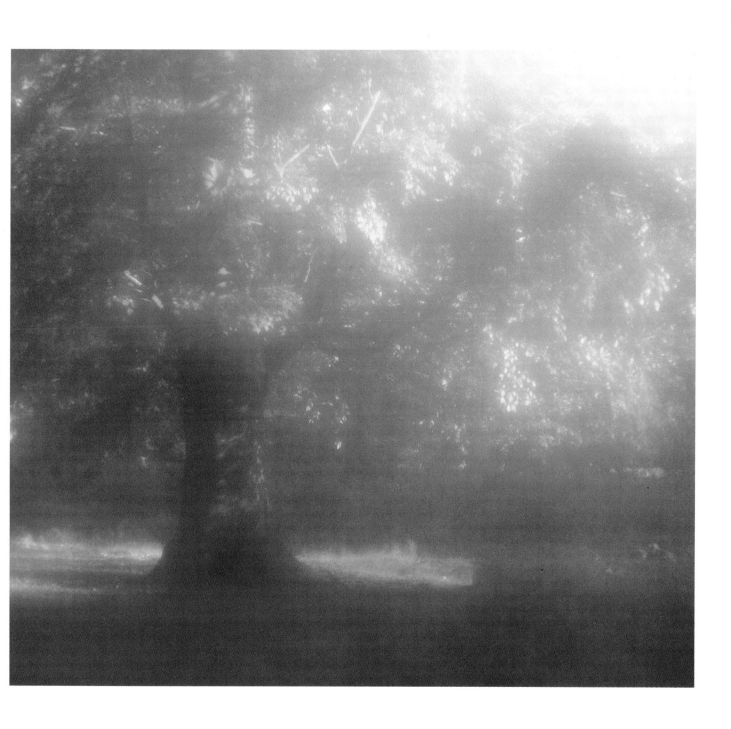

CREATIVE FOCUSING

Some people probably consider that having to focus a camera is a rather tiresome procedure from which autofocus cameras have freed them. In fact the ability of a camera to select and control the areas of an image which are recorded sharply and those which are blurred is a valuable creative tool.

When you use small apertures the depth of field, or band of sharp focus, is relatively broad, particularly with short-focal-length lenses. With lenses of longer focal length and with wide apertures, however, the depth of field becomes quite narrow and it is possible to create bold distinctions between the parts of the image which are sharp and those which are not.

This technique can be used to make certain parts of a subject stand out clearly from the rest of the image. A common and sometimes striking application of this is in outdoor portraiture, when the camera is focused on someone quite close to it and the background details beyond are recorded as a soft homogeneous blur. It makes the subject stand out in bold relief and prevents the background becoming intrusive and distracting. An equally important facet of the effect is that it can make the background tone an interesting and effective element of the composition.

Sunlit foliage with dappled highlights and shadows, for example, if recorded sharply would create a very unattractive background for a portrait, but when thrown well out of focus the highlights become hazy discs blending into the darker tones producing an atmospheric and attractive effect.

It is important to ensure that such details are very positively out of focus and not just slightly unsharp. For this reason you should use the widest-possible aperture and, ideally, a long-focus lens as well as positioning your subject as far as you can in front of the background. Fashion photographers working on location favour lenses like a 300mm f2.8, for example, simply to achieve such effects, but it is quite possible to produce

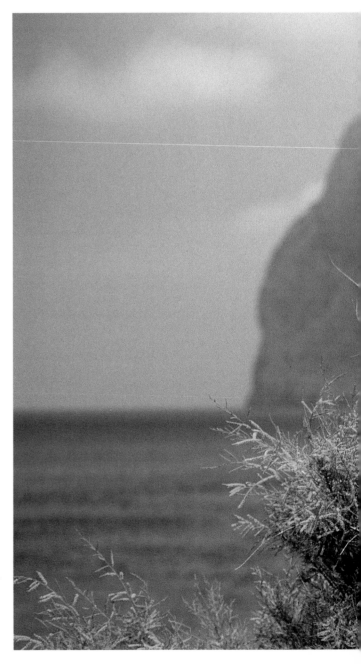

In this Majorcan seascape, I used a long-focus lens combined with an aperture of f4 to create a bold contrast betwen a sharply focused foreground and the soft, slightly hazy background of cliffs and sea. The colour contrast was enhanced by using a polarising filter to make the blue background richer and stronger

striking results with more modest objectives. This technique need not be limited to portraits; subjects like still lifes, landscapes and wild life can all benefit from this technique.

Out-of-focus foregrounds can be used just as imaginatively as blurred backgrounds, as when shooting through a soft screen of foliage to a distant landscape or building.

When both distant objects and close foreground details are included in the frame, instead of allowing parts of the image to be unsharp it can be effective to reverse the technique. Selecting a very small aperture will greatly extend the depth of field especially when a wide-angle lens is used.

Pictures taken in this way, with bitingly sharp detail throughout the image, can have a powerful impact.

Depth of field extends half as much again beyond the point of focus as it does in front. This means to achieve maximum depth of field you need to focus at a distance about one-third of the way between the nearest foreground details and the furthest point of the image.

Seeing an image in terms of how it can be focused most effectively is simply a question of being aware of the various possibilities and recognising the best ways in which it can enhance a picture.

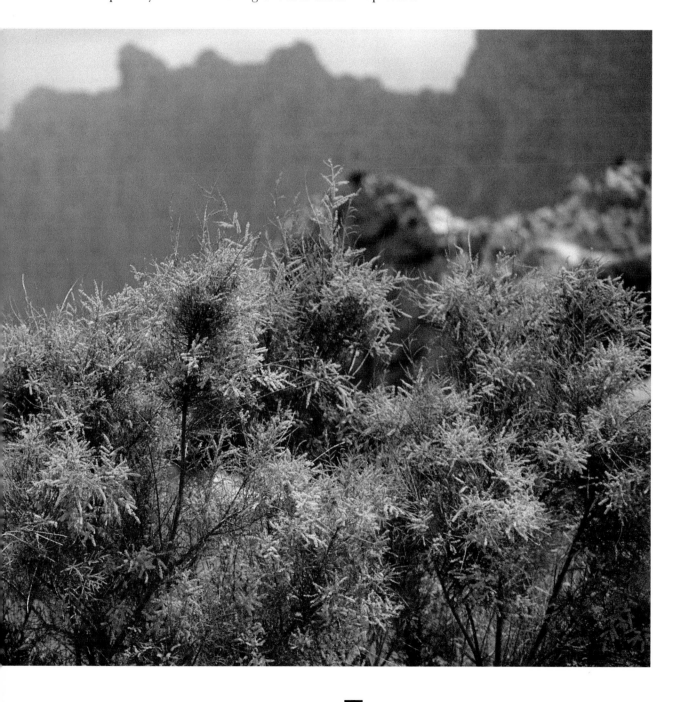

INFRA-RED EFFECTS

The emulsion characteristics of different film types can sometimes be used creatively to enhance an image and to alter its quality. Infra-red film is a good example of this. It is film made primarily for aerial survey work and produces a variety of tonal and colour distortions which can add considerable impact to a photograph.

The black-and-white version is available in 35mm format, 120 and 5 x 4 sheet films. It is a fast film which can be used with a visually opaque UV filter to record only infra-red radiations. In this way a flash gun can be fitted with a filter enabling pictures to be taken with the subject unaware of the flash.

In normal circumstances, however, it is used with a red filter, a Wratten 25, which also allows some visible light to record on the film. When used with landscape subjects the effect is to record blue skies as near-black, similar in fact to the effect of a normal panchromatic film with a deep-red filter. The most noticeable difference, however, is that green foliage is rendered as an

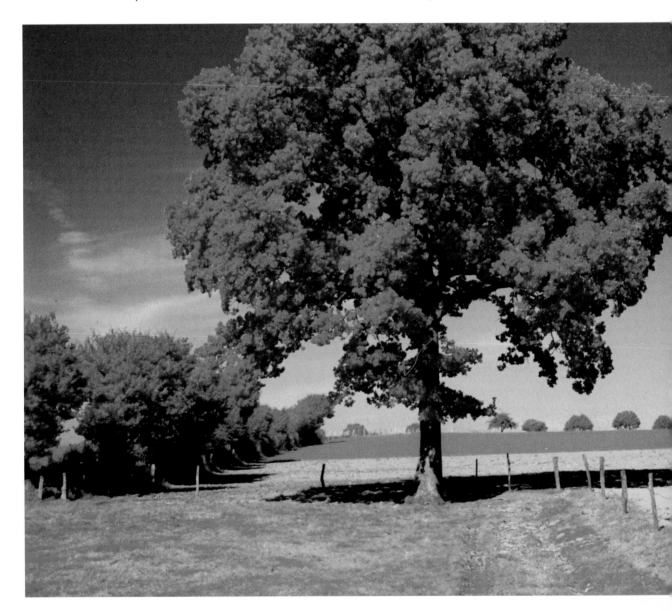

almost-white tone, often creating a quite bizarre and dramatic quality. This is frequently accompanied by a slight halo effect and the film is also quite grainy. Skin tones in portraits can have an interesting chalky quality with infra-red film.

Results are not entirely predictable, since the emulsion is recording something which you cannot see. Normal film-speed ratings do not apply but a starting point would be to set the film-speed dial to ISO 100. It's best to bracket exposures quite widely, at least a stop each side of that indicated. Often a quite dense negative produces a more interesting effect. The film is very easily fogged and it is best to load and unload the camera in complete darkness.

The colour-transparency version is available only in the 35mm format and has to be processed in the old E4 chemistry.

The recommended filter for this film is the Wratten 12, Yellow. Orange and red filters can also be used for more extreme effects and I have found the Cokin sepia filter to give interesting results. Exposure settings and results are similar to the black-and-white film — rather unpredictable — and a degree of trial and error based on bracketing and a rating of ISO 100 is necessary.

The most predictable quality is that green foliage is recorded, with the Wratten 12, as red and blue skies tend to be grey. An interesting variation is to process the film in C41 chemistry to produce a negative image with foliage recorded as green but with the tones reversed.

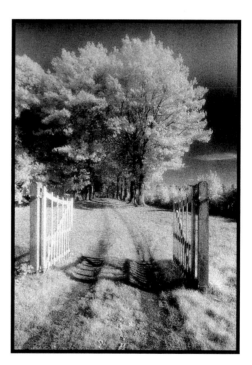

Above *The white, snow-like foliage in this landscape was produced by shooting on Kodak's black-and-white Infrared film with a deep-red filter*

Left *The green foliage of the tree in this landscape, shot on Kodak's Infrared Ektachrome with the help of a Cokin tobacco-coloured filter, has registered in a strikingly saturated hue. The effect has been enhanced by the grey tone of the sky which was, in fact, piercingly blue. I've found this filter very effective on a number of occasions for landscapes shot on sunny days with blue skies — but the results are never truly predictable*

GRAIN IMAGES

The film on which you make your exposures can have a dramatic impact on the quality and effect of a photograph. Each film has different characteristics and these can often be used to enhance a photograph.

Perhaps the most basic of these differences is that of the grain structure of the emulsion. Slow film has a very fine grain, ideal for recording fine detail, and faster films, useful in poor light, have a coarser, more visible, grain.

Making the grain a positive element of the image can add a very pleasing and interesting feel to a photograph. Grain has always appealed to creative photographers and through the years there have been certain films which have been valued for their graininess. A couple of decades ago it was GAF and a number of well-known photographers built their reputations on its rather special properties.

A good successor available today is 3M ISO 1000 transparency film although any very fast transparency film is suitable. The grain can be exaggerated by rating the film at two to three stops faster and asking the lab to push process by the corresponding amount.

Negative colour films do not tend to have quite the same tight crystalline quality. For those who prefer to use colour negatives it is possible to process 3M 640T film in C41, negative chemistry. It has an excellent grain structure and also produces some interesting colour effects.

With black-and-white photography, Kodak 2475 Recording film has a very attractive gritty character and, when up-rated and push-processed, Kodak Tri X also produces a good grainy image.

The key to good grain pictures lies first in the choice of subject. Whatever you decide — portrait, still life or landscape for example — it's best to steer clear of those images with masses of fine detail and look for subjects with areas of relatively plain tones or colours. Excessive contrast should be avoided as contrast is increased when push processing is used. I often employ a pastel, or fog, filter to reduce contrast, and diffusion (see page 10) can also be used to enhance the grain effect.

The degree to which the image is enlarged is also a significant factor. In general the more it is enlarged the better, so it is best to use only a small portion of the transparency or negative. A simple method of doing this is to frame the picture in the normal way to create the most pleasing composition, and then simply switch to a shorter-focal-length lens to take the shot. When using 35mm, if you frame the image with say a standard lens, for instance, and then use a 24mm lens to take the photograph it will have to be enlarged about 16 times to produce a 10 x 8 print which will give a very grainy image.

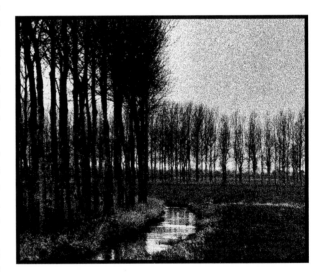

Above *I saw this landscape in the Contentin region of France on a dull cloudy day. I used Kodak's 2475 recording film and framed the image so that a tiny central portion of the negative could be greatly enlarged. The print was made on grade 5 paper which has made the grain appear almost as a pure black dot, like a printer's screen*

Right *The very plain tones and simple colours in this cloudscape have helped to emphasise the coarse grain structure of the GAF film used for the shot. I framed the image so that only a small central portion was needed, allowing it to be enlarged as much as possible to further enhance the effect of the grain*

COLOUR SEPARATIONS

In the early days of colour photography it was common practice to take photographs by exposing three black-and-white images through filters of each of the primary colours and then adding the colour to each image afterwards and superimposing them. Indeed, a special camera was made called a 'One Shot' which enabled the exposures to be made simultaneously on three glass plates.

This separation of colours can still be achieved, much more easily, to produce some interesting effects. You need a camera with the facility of making multiple exposures since three exposures must be made on the same piece of film. You can buy a set of primary, or tricolour, filters (red, green and blue) from a professional dealer. The procedure is quite simple but you require a firm tripod.

Initially you might try a subject which is essentially static but with a moving element: a waterfall surrounded by rocks and foliage is an obvious choice, or even white clouds moving across the sky in a landscape picture. As long as some part of the subject moves between each of the exposures, the effect will be revealed.

First you must frame the shot and focus, lock the tripod firmly and calculate the basic exposure in the normal way. Each filter, however, requires a different exposure because of their varying densities. Having established the shutter speed and aperture required without a filter, give this exposure through the red filter. For the green filter you must increase the exposure by a factor of three, or open the aperture by one-and-a-half stops. For the blue filter you must increase the exposure by a further half a stop giving two stops more than the red filter. You must not, of course, wind on or move the camera between the exposures.

This will produce an image in which the moving elements of the subject are fringed with colour. The static elements of the scene should have a normal colour balance, but if you use a colour-negative film any slight colour bias which

Left *I used a zoom lens to alter the image size slightly between each of the exposures in this shot of a silhouetted tree. Again, the same proportion of one, three and four was used for the red, green and blue filters*

Right *The fact that it was a dull grey day for this seascape of Bedruthan Steps in Cornwall has helped to make the colour fringing of the moving waves even more striking. I took a reading without a filter and gave the exposure indicated with the red filter in position. I then gave one-and-a-half stops extra for the green filter and two stops extra for the blue, resulting in a neutral overall colour balance*

might occur through an imbalance in the exposures can be corrected when the print is made.

There are numerous ways in which the colour fringing can be produced. You can, for instance, change the point of focus very slightly between each shot, or you could use a zoom lens to make the image slightly smaller for each exposure. With a still-life shot you could remove one item for one or more of the exposures, or when using petroleum-jelly diffusion (page 10) you could tease the jelly into a different configuration between each exposure.

Under studio lighting you could move the position of one or more of the lights between exposures. In this way the colour fringing will occur where the highlights and shadows have changed position. The challenge of this technique is largely in visualising ways in which the image can be made to change slightly to create interesting colour effects.

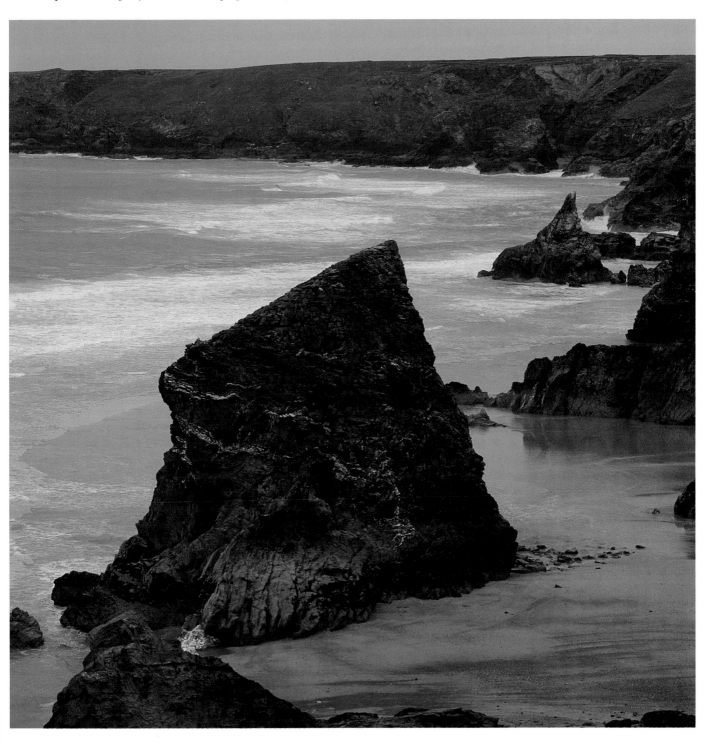

CREATIVE BLUR

Blur through movement is one of the unique features of the photographic process and something which cannot be seen without the aid of a camera. It can produce images of surprising beauty and considerable impact.

The most obvious example of blur contributing to a photograph is in sports photography, when the camera is panned with a subject moving across the field of view and a relatively slow shutter speed is used. This results in the subject remaining quite sharp but the background and static elements of the scene are recorded as a blur. Not only can this produce a pleasing quality, but it will make the subject stand out more clearly and also enhance the impression of speed and action. With practice, quite slow shutter speeds of 1/30 second or less may be used and still produce a sharp image of a rapidly moving subject.

Of course, you don't have to photograph a world-class athlete or a Formula One motor race for this technique to work well. Indeed, there's a distinct advantage in having a more controllable subject like a child on a swing or riding a bicycle. The technique works best when the background contains quite defined colours, highlights and a mixture of tones; with a co-operative subject you can choose your background and have practice runs adjusting the speed and direction of the action if necessary.

It is also interesting to reverse the effect and have the moving element of the subject blurred and the static part sharp. A popular subject for this treatment, but none-the-less satisfying when it's done well, is moving water. A waterfall or river with overhanging foliage, for example, or waves breaking over rocks can produce quite compelling images. A long exposure of several seconds or more can create a quite ethereal atmosphere, with fast-moving water taking on the appearance of smoke or mist.

Long exposures in bright light may need a smaller aperture than those with which the lens is provided. The use of a neutral density or a polarising filter can overcome this problem.

Of course, water is not the only suitable moving subject for this treatment. Traffic can be effective in street scenes, for example, and at dusk the light trails add a further dimension.

Although the results are rather unpredictable and control is limited, it can also be interesting to experiment with the entire image being blurred. Ernst Haas took some very fine photographs of a Spanish bullfighter in this way. The method can be employed even with a totally static subject by using slow shutter speeds during controlled camera movements. Swinging or panning the camera, so that the movement enhances the shapes within the subject, can produce intriguing semi-abstract effects. Subjects containing bold forms, colours and highlights are likely to produce the most interesting results.

An exposure of several seconds was used to create a marked degree of blur in this shot of water running down a rockface in the Auvergne. I used a neutral-density filter to allow a long exposure to be used as the light was quite bright. The dark background of rocks has helped to enhance the ethereal, smoky quality of the moving water

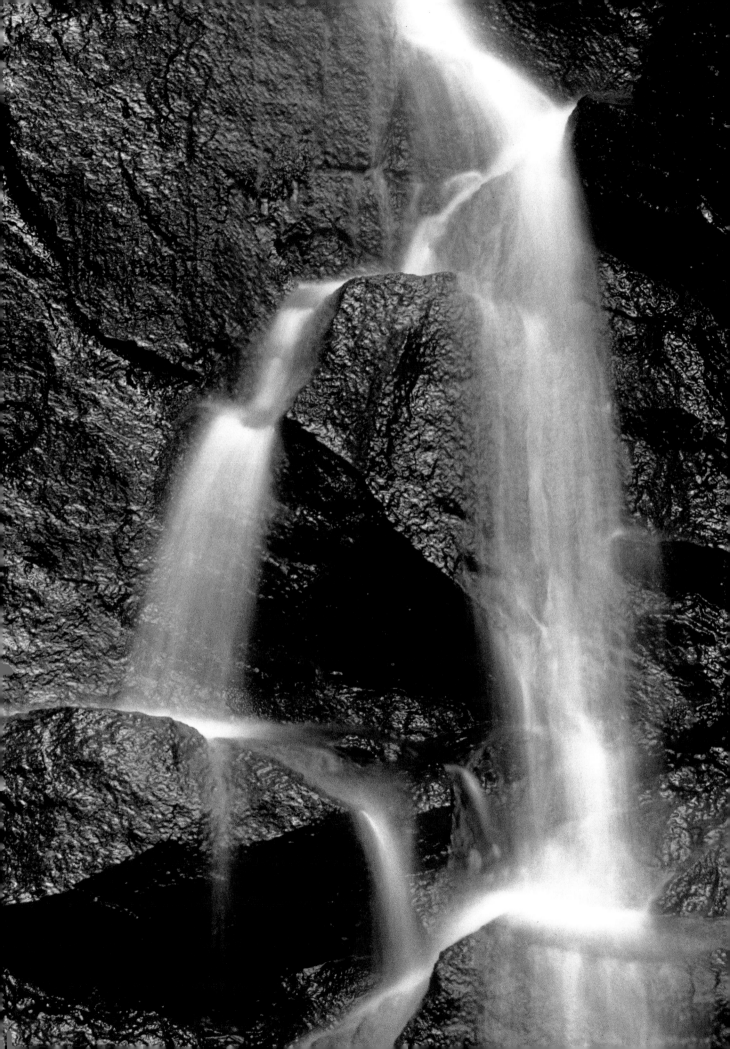

SIMPLE OPTICS

Soft-focus effects can create very attractive images, possessing a more romantic and less 'photographic' quality than the bitingly sharp images produced by modern camera lenses. The usual method of creating soft-focus effects is to use attachments that degrade the image created by a high-definition lens. It can be rewarding, and the effects more interesting however, to use a more simple, even crude, lens on your camera.

You need a view camera or an SLR with interchangeable lenses and, for the latter, it will make it easier to fit your simple optic if you have a bellows attachment or extension tubes.

There are several choices for an alternative lens. One is to search the junk shops for a discarded box camera which you can dismantle, or you might discover an old brass-mounted lens. However, even these types of lens can create surprisingly clear images, and if you are seeking a really soft effect then a magnifying-glass lens, or something similar, may be a better choice. I took some very pleasing shots with the lens from an old-fashioned torch.

You will need to consider the focal length of the lens you select. This can be measured by focusing an image of the sun onto a piece of paper, and measuring the distance between the lens and the paper. As a general rule, when using an SLR camera, it is easier to use a lens of longer-than-standard focal length, for example a 10cm lens on a 35mm camera.

With a bellows unit or a view camera, you can mount the lens directly onto the panel which holds the normal lens and focus in exactly the same way. In other cases you will need to make a simple focusing device which can be fixed to the camera body. Two cardboard tubes, one of which fits tightly inside the other, are a simple but effective way of doing this. Lining them with black felt paper will prevent light leak and they can be fixed to the camera body with black tape.

Exposure assessment is easier if you know the effective aperture of the lens, although with many TTL meters you will be able to read the exposure in the normal way. The aperture can be determined by dividing the diameter of the lens into its focal length. If the lens is, say, 3cm in diameter and its focal length is 12cm, its effective aperture will be f4. You may reduce the aperture by mounting a piece of card with a circular hole behind the lens; this will also slightly improve the quality of the image if desired and increase the depth of field.

As well as being much less sharp, the contrast of a crude lens will also be far lower than that of a high-quality objective. For this reason, it is best to choose subjects with good contrast. Backlit scenes can look particularly pleasing with a simple lens.

The lens used for this shot of a poppy was from an old magnifying glass. I found two cardboard tubes which fitted inside each other. With the lens fixed to the end of one tube with gaffer tape, the camera body was similarly taped to the other end of the inner tube. Focusing was achieved by telescoping the tubes and the TTL meter on my Mamiya 645 camera gave me a surprisingly accurate reading

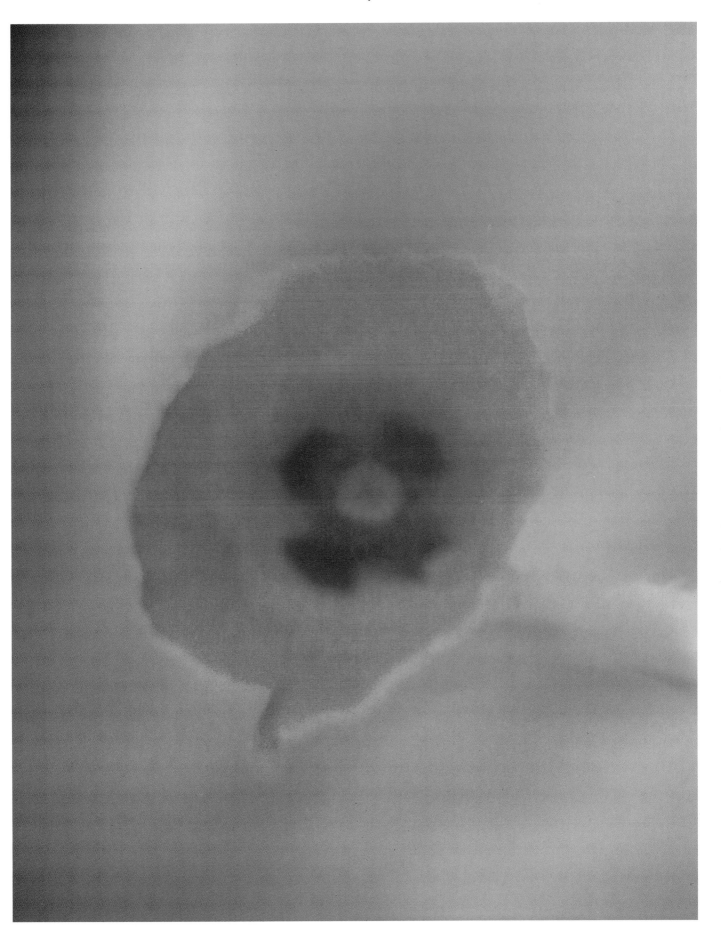

MULTIPLE EXPOSURES

The great strength of photography is generally considered to lie in its accurate and realistic means of recording a subject. However, it is also a medium which lends itself to more abstract and expressive images.

Combining two or more images is one way in which a photographer can create pictures of a more personal nature, free of the visual limitations of a single subject.

The most basic method of creating multiple images is by making more than one exposure on the same piece of film. Random multiple exposures are unlikely to be successful and it is vital to plan your pictures carefully. When using a camera with a viewing screen you can make a trace of each image to help visualise and compose the finished result.

The approach most likely to be successful is to consider the final image as being composed of background and foreground components. In other words, one image should dominate and the other play a supplementary role. As a general rule it is best not to attempt more than a double exposure in the camera unless a completely black background is used. It is important to appreciate that second and subsequent exposures will only record with any degree of clarity where the film has previously recorded a dark tone.

In the simplest terms, the technique works best when the light tones of one image are juxtaposed against the dark areas of another. In this way a face could be superimposed against, say, a gnarled tree trunk. Both images should be given about one stop less than the exposure indicated. The background image can be given even less exposure if necessary, to ensure that the second image is more clearly defined. Other ways of making the images more distinct from each other include throwing one slightly out of focus and using a filter to create a colour cast on one or both images.

If you use this technique against a black background it is possible to build up a quite complex image with a greater number of exposures. Pseudo-strobe effects can be achieved in this way by making a sequence of exposures and slightly changing the position of the object or person between each. Indeed, with a motor drive and a rapid-recharge flash it is possible to obtain a strobe effect in a single continuous movement.

With this technique, rim lighting is best since it will illuminate the subject's profile, showing the movement, but leave large areas of shadow so that the image does not become too confused. This type of lighting is arranged by placing the lamps behind and to one or both sides of the

subject, and aimed towards it, him or her. Be careful to shield the light so that it does not shine directly into the camera lens or spill onto the background.

While it is perfectly feasible to make double exposures in the camera, it is easier to control if you make individual exposures on film and then combine them by making duplicate transparencies or colour prints in the enlarger. In this way the images can be pre-selected and combined with greater accuracy using tracings for position.

Left *The Christmas decorations in London's Regent Street provided the subject for this very straightforward hand-held double exposure. I gave half the indicated reading to each exposure and simply held the camera the other way up for the second shot*
.

Below *Rather more precision was needed for this studio shot. The apple was set up on a dark background, its position marked on the view-camera's screen and a sheet of film exposed. The apple was then replaced by a candle and the camera adjusted carefully so that the size and position of the flame was aligned with the apple stalk. The sheet of film was then re-exposed*

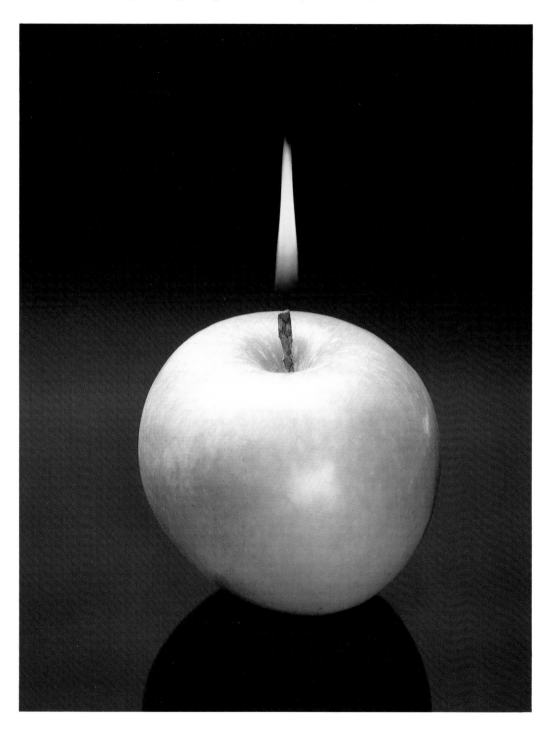

BLACK-AND-WHITE TECHNIQUES

Shooting in black and white is not simply a question of loading the camera with monochrome film. It requires a quite different approach to shooting in colour and a new way of looking at a subject. Many professional photographers, myself included, dislike having to shoot black and white and colour on the same assignment because it involves having to switch constantly to another mode of seeing.

It is important to ignore the colour content of a scene when shooting in black and white. A subject may look as if it will result in a strong image with good contrast and well-defined details when shot in black and white, but this may not be so if you allow yourself to be misled by its colour content.

Imagine a situation where, say, a red tractor is ploughing a green field above which is a deep-blue, cloudless sky. A bright, punchy image you might think. Yes, true — in colour. In black and white, however, the same scene would reproduce with each of these elements recorded as a similar tone of mid-grey; very flat and dull. This is because although the colours create bold contrasts the tones are very similar.

It is possible to buy a green-tinted viewing filter which helps you to see the tonal range of subject more easily, but viewing through half-closed eyes, or with the lens stopped down manually, will achieve much the same result. Once you become aware of the tonal content of a scene as a element separate from the colour you will soon learn to see it unaided.

Filters can help to create contrast between similar tones of different colours. The key to understanding how filters work in black and white is to remember that each of the primary colours — red, green and blue — makes its own colour lighter in a black-and-white print and the other two colours darker.

Thus in the above example a red filter would make the tractor lighter but the sky and grass darker. With the blue filter, the sky would be lighter and the other tones darker, and a green filter would reproduce the grass lighter and the tractor and sky darker. In practice, however, these effects are not so defined since natural colours are seldom pure and fully saturated.

As a general rule, the best black-and-white photographs result when the tones in the image consist of those created by lighting or those inherent in the subject. A subject which has a full range of tones, like a man with a weathered face in a dark patterned shirt standing by a light textured wall, would need only a soft, shadowless lighting, since a rich range of tones already exists. However, a subject without inherent tonal contrasts, like the scene described earlier, would need the right type of lighting to reveal a good range of tones, like low side lighting on a summer evening for instance.

The elements which help to ensure a rich and satisfying black-and-white print are a full range of tones, from white through to black, and bold textures, shapes and lines which are defined by the variations in tone.

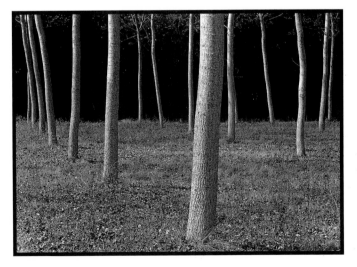

Simplicity is the keynote of this picture in a French tree plantation. The soft light of an overcast day has helped to produce an image with a full range of tones and to emphasise the pattern created by the trees. Finding the most effective viewpoint and focal length of lens on my Nikon took a little while and I tried a few versions. This, with an 85mm lens stopped right down for maximum depth of field, was the one I liked best

I photographed this scene at the entrance of a Las Vegas hotel. Its wide range of tones help to make a striking black-and-white image. The reflective elements in the subject and the exaggerated perspective caused by using a very-wide-angle lens have also contributed to a quite bold and dynamic picture

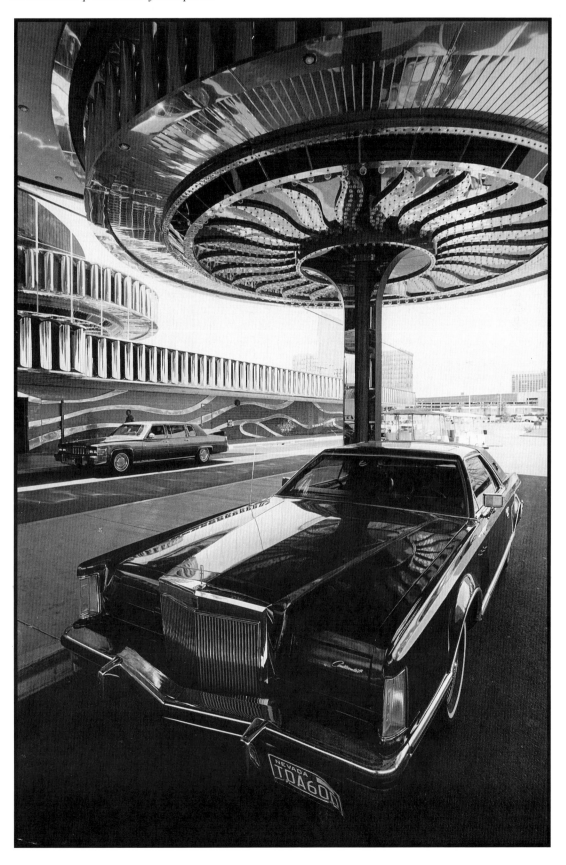

CREATIVE
EXPOSURE

Sensitive exposure meters are built into all but the simplest cameras and ensure that, in most normal circumstances, automatic exposure will produce an acceptable result. However, this is often quite different from an ideal result and it should also be recognised that many of the lighting conditions which create outstanding pictures are also those where an averaging exposure reading will lead to an incorrect exposure.

Like auto-focus, auto-exposure also encourages photographers to stop thinking about the creative possibilities which these basic camera controls can provide. To some extent, variations in image density and quality can be made at the printing stage when using colour-negative and black-and-white materials, but with colour-transparency film the quality and effect of the image can only be created at the moment you make the exposure.

Exposure meters are calibrated on the premise that if all the tones in a scene are mixed together it will produce a medium tone, and the exposure indicated is intended to reproduce this on the print or transparency. If a subject is inherently much darker or lighter than average, like a snow scene for instance, or if the lighting creates exceptionally bright highlights or dense shadows, the exposure indicated will need to be modified.

The most common circumstances in which it is necessary to modify the reading given by an exposure meter are: when the subject contains large areas of very light or very dark tones; when the brightness range, or contrast, of the subject is very high; when shooting into the light and when light sources, such as street lights at night, are included in the picture. A scene which is inherently darker than average will need less exposure than indicated and one that is light will need more.

As well as avoiding incorrect exposure in unusual circumstances, an understanding of the effects of exposure will also help to produce more interesting and striking photographs of normal subjects.

Underexposure will create richer, more saturated colours, enhance highlight detail, reduce shadow detail and will tend to increase contrast. Overexposure will make colours paler and less saturated, increase shadow detail, decrease highlight detail and will tend to decrease contrast.

It will help a great deal to understand how variations in exposure can affect image quality by bracketing your exposures. This means simply taking several frames of the same subject, one at the exposure indicated, four more decreasing the exposure in half-stop increments and a further two increasing the exposure by half a stop each time.

A degree of underexposure will often help to create more dramatic images, enhance the effect of texture and produce bolder colours and richer tones. A degree of overexposure will help to create softer, more romantic images, especially in soft or misty lighting conditions, and create more flattering skin tones in portraits.

These two photographs show how much the colour, contrast, quality and mood of an image can be controlled by the exposure. The lighter picture has had half a stop more exposure than indicated and the darker picture three-quarters of a stop less

MIRROR IMAGES

There are many ways of manipulating and distorting an image created by a camera lens to produce photographs with a more abstract and less realistic quality. A mirrored surface is one means of doing this in a way which may be seen and controlled in the camera's viewfinder.

A simple handmirror can be placed close to the camera lens near its centre, and almost parallel to the optional axis. By making slight adjustments to the mirror's angle you can create a reverse image of the subject at which the camera is aimed, and also reflect an image of objects and details to one side of the subject, thus creating a montage effect. The adjustments needed are very slight, and it helps a great deal to have the camera mounted on a tripod and to hold the mirror in place with a small craft or laboratory clamp.

An ordinary mirror will create a slight ghost image, which may not be detrimental, but if you want a completely sharp reflected image you must use a front-silvered mirror or mirror foil mounted on a perfectly flat surface. With close-up objects you can create a kaleidoscope effect by using two mirrors placed either side of the subject at an angle of 60°.

Mirror foil can be used to create distorted images by photographing a subject reflected in its surface. By laying a sheet of mirror foil over a firm support, like a piece of card, and allowing slight ripples to occur in its surface, the reflections can be manipulated into quite bizarre and convoluted shapes. Used in a similar way the material can also be effective as a surface for still-life arrangements.

A semi-silvered mirror, or even a piece of plain, good-quality glass, provides an interesting way of creating in-camera montages. If you set up a camera on a tripod and, using a clamp or support, place a piece of semi-silvered glass close to the lens at 45° to the optical axis, it will allow the camera to 'see' straight through it to the object at which it is aimed. At the same time it will also reflect objects or details placed at right angles to the camera. Although this technique can be used in outdoor photography the effects are easier to control when studio lighting is used.

If both images are to be sharp, the main subject and the reflected montage image need to be at about the same distance from the camera. The principle is similar to that of a double exposure, in that the light details of one image will read more clearly when juxtaposed against the darker areas of the other. By varying the brightness level of the lighting on each subject, you can make one image more dominant than the other. You can also use coloured gels over one or both of the light sources for added effect.

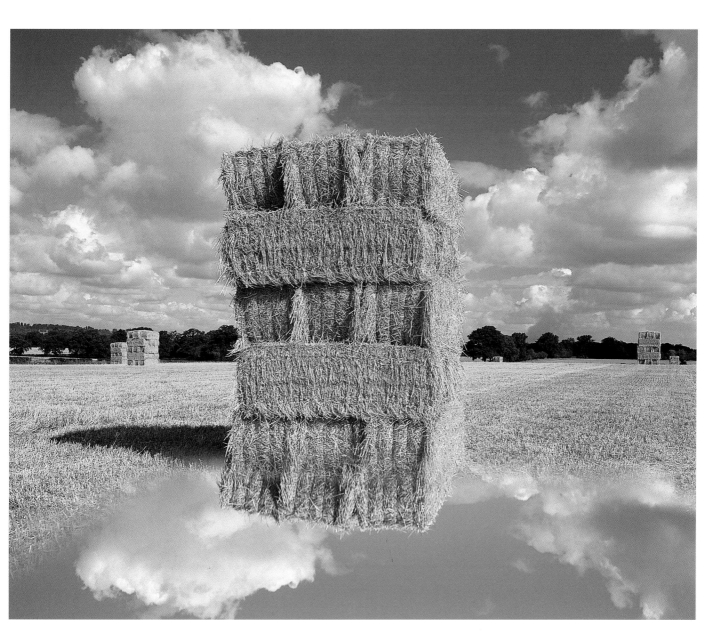

Left *This curious image was achieved by using the glass-montage technique. The model's face was directly in front of the camera and another model's hand placed at right angles to the camera at a similar distance. A piece of semi-silvered glass fixed at an angle of 45° in front of the camera lens has superimposed the two images. I lit the face and hand independently so that I could juxtapose the highlights of one image against the darker areas of the other*

Above *I've used a mirror in a rather obvious way in this landscape shot. I tried initially to use it with a longer-focal-length lens so that the reflected sky covered the whole of the base of the image. I found the result more interesting, however, when I used a wide-angle lens and the mirror simply created a pool of sky in the cornfield. I also decided to use a polarising filter to make the sky a richer blue and to emphasise the clouds*

PROJECTED IMAGES

There are various ways in which photography can be used to create images which are not restricted to the visual qualities of a single subject, like the multiple-exposure and slide-sandwich techniques described on pages 24-5 and 182. These methods, however, have the disadvantage that the final effect of the image is difficult to judge in the camera's viewfinder.

A slide projector can be used quite simply, however, to produce interesting effects and to combine different images in a way which can be seen quite accurately in the viewfinder.

The technique needs to be carried out in a room which can be darkened, since the quality of the projected image will be degraded by unwanted ambient light. The most basic way of using this technique is to project a slide of one subject onto another subject. An example would be to project a fairly abstract image, a cloudscape for example, or perhaps a physiogram (page 184), onto a person's face or body.

The projected image can be used as the sole source of illumination. If the projector is positioned fairly frontally and close to the camera, the subject it illuminates will have little modelling and will act rather like a flat screen. If, however, the projector is moved to one side and the subject has pronounced contours, like a face for example, shadows and form will be created within the subject and the projected image will be less clearly defined.

If the subject is placed in front of a dark background the projected image will illuminate its shape quite clearly. However, if the subject is placed close to a white background the effect will be more subtle, with the projected image continuing onto the background and the subject's outline partially hidden within it. If you have access to two projectors you can create even more complex images.

It is possible to use additional lighting to illuminate areas of the subject selectively, but care must be taken to limit the light spill. A snoot or cone of black card taped to the reflector will ensure that the light reaches only the areas of the subject you wish it to. In this way you can define the shape and form of the subject more clearly, leaving the areas of shadow created by the light to be illuminated by the projected image.

The technique can also work well in reverse. You could, for example, project an image of a clearly defined subject, such as a landscape, onto a textured or detailed surface like a piece of hessian, a grained wood surface or a sheet of crumpled white paper.

You will need to use artificial-light film if the colours of the projected image are to be accurately recorded, and this means that any additional lighting used will also need to be fitted with tungsten or halogen lamps; electronic flash is in any case likely to be too powerful for the projected image.

Another interesting technique for which a projector can be used to create a multiple image in camera is back projection. It is particularly effective when used to combine a background image on a slide with a foreground subject set up in front of the camera. It can only be used with static subjects like a still life, because two separate exposures must be made on the same frame of film.

You will need a tracing-paper screen, similar to the one described on page 134. It must be large enough to cover the background area behind the still-life arrangement. You will also require a piece of black velvet large enough to cover the screen.

First set up your still-life arrangement on a bench and light it to obtain the effect you want. If

The projected image was the sole source of illumination for this studio nude who was positioned close to a white background. I placed the projector slightly to one side of the camera so that a degree of modelling was created within the outline of the body and shadows were cast onto the background. The transparency used in the projector was made by photographing a black-and-white moire pattern using a coloured filter

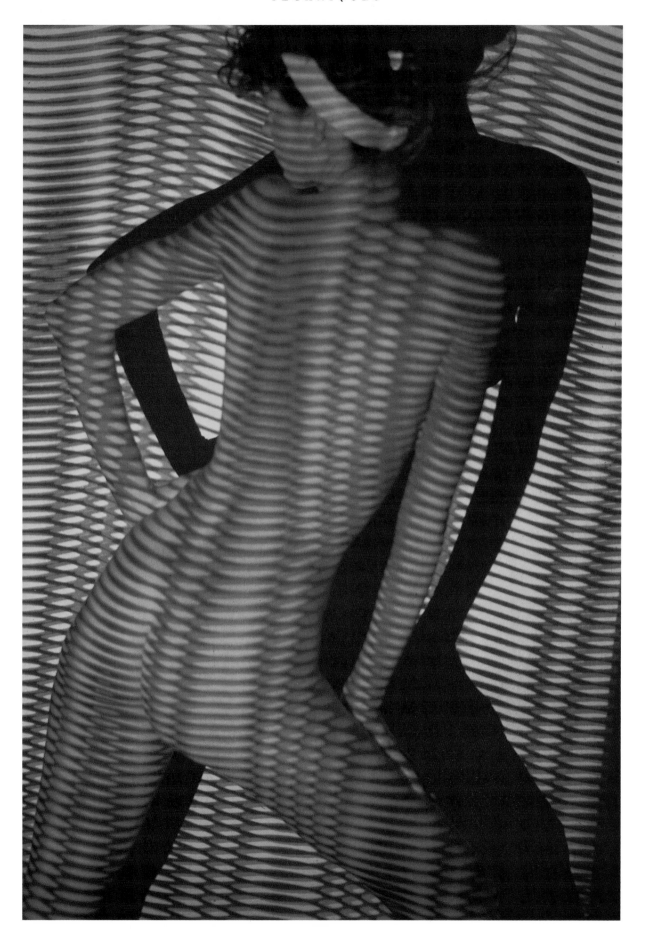

your intention is to achieve a realistic effect, like a basket of fruit with a landscape in the background perhaps, the still life should be lit in a similar way to the background image, with shadows falling in the same direction and of a proportionate size and similar quality.

Next, with the screen placed immediately behind the still life, set up the projector behind the screen and adjust the size of the background image to fill the screen. If space is limited, you could use an angled mirror behind the screen to allow the projector to be positioned at right angles to the still life.

Calculate the exposure for the background image and the still life independently of each other. With your camera set up on a firm tripod, place the black velvet over the screen, switch off the room lights and the projector, and make an exposure. Next, without moving the camera or winding on the film, remove the black velvet from the screen, switch off the lighting for the still life and switch on the projector. You can now make an exposure to record the background image.

You can produce very convincing pseudo-location pictures in this way; it also lends itself well to creating abstract and fantasy images.

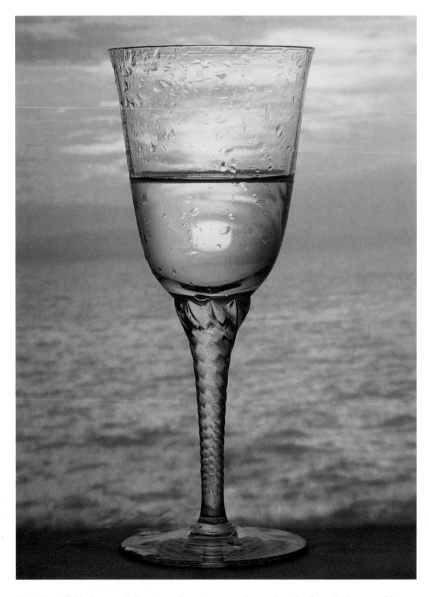

For this still life I suspended a piece of tracing paper from a length of wood above a table top so that it formed a curve onto its surface. I then placed the wine glass at the point of the curve and projected the background image from behind it. Shot in a partly darkened room, a little daylight has added details to the glass without unduly degrading the projected image

PART TWO

SUBJECTS

TREES

Over the years I've recognised that there are a number of subjects which I respond to with an almost reflex action. Many other photographers who shoot pictures regularly also have an identifiable 'repertoire' of themes which recur throughout their work.

This is by no means a negative thing, as it helps to define a personal style and also provides an on-going focus of interest. Having a series of pet subjects does not mean your pictures will necessarily be 'samey' since, once you acknowledge the appeal of certain visual situations, you become more concerned about different ways of approaching them.

One of my favourite themes is trees, especially single trees which are isolated in some way. I've now started to compile a collection of lonely trees — there may even be a book in it sometime. Trees have enormous visual appeal and are one of the most attractive natural forms.

In photographic terms they have a vast pictorial potential once you become tuned in to their possibilities. The shape of a tree gives it a quite tangible character and yet it is created by an apparently arbitrary set of circumstances. An entire art form, bonsai, has evolved around the control of tree shapes.

A single tree undergoes such a wide range of changes, from the bare-branched tracery of the winter months through the yellow-green budding of spring and the full, dense foliage of summer to the extraordinary colour changes that take place in autumn. Each of these stages has enormous possibilities, and the lifecycle of a single tree would make a wonderful subject for a time sequence (page 144).

Tree shapes tend to make more satisfying pictures when they are clearly defined against an area of sky or are isolated in some way from the surrounding landscape. A sky background needs to be interesting: a white or flat grey sky is seldom appealing but a dark stormy sky or one that is dense blue with white clouds can be very effective.

There are no hard-and-fast rules concerning the best viewpoints or lenses. In some cases a distant viewpoint with a long lens will create a telling shot, while at other times you will find that shooting upwards from almost underneath a tree with a wide-angle lens will produce a strong picture.

Trees *en masse*, like a forest or plantation for example, can create marvellous situations for photographs. Shooting under trees in this way can produce interesting and atmospheric lighting. There is opportunity here also for pictures with a sense of pattern and order: finding a position where the trunks and branches on different planes combine to make a satisfying arrangement can help you to a proper understanding of the vital link between viewpoint and composition.

A closer look at trees is equally rewarding. There are the textures and forms of gnarled trunks, for example, and the colours and patterns created by leaves and branches. It's easy to take trees for granted, but in Britain at least the hurricane of 1987 which swept across the south of the country has made many people much more aware of their presence, and the enormous contribution they make to the landscape.

Above *I found this autumnal plantation of poplars in Spain just after sunset. The very soft light has helped to retain the intensity of colour and the simplicity of the image. It needed an exposure of several seconds with the lens stopped down to f22. I used a 35mm shift lens on my Nikon so that more of the foreground could be included without having to tilt the camera downwards. This would have caused the tree trunks to converge and so spoil the symmetry of the picture*

Below *This nicely isolated tree was seen in Brittany. I chose a viewpoint and framed the image so that all other details were excluded. A white cloud hovered distractingly close to the edge of my picture area and I had to wait for a while before shooting to let it move away. I used a polarising filter to make the sky a deeper shade of blue and an 81C filter to add warmth to the yellow of the rape field*

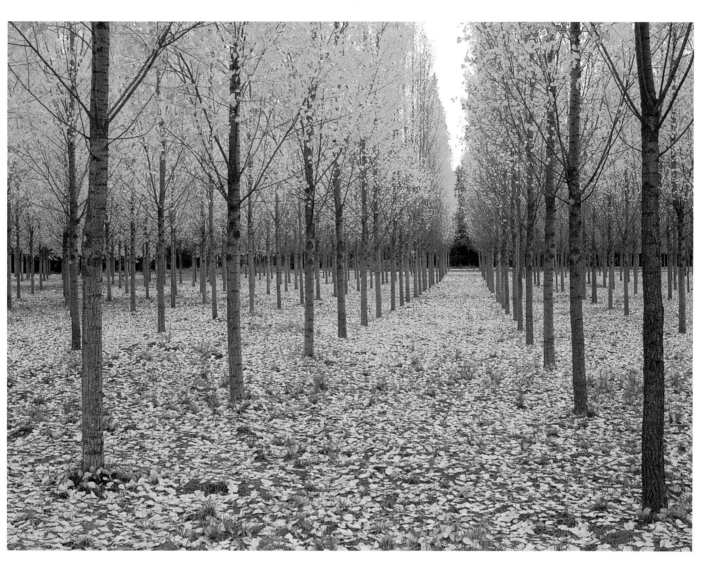

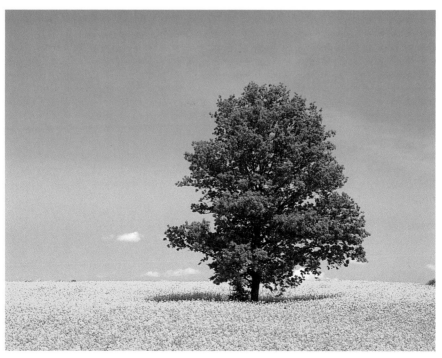

MARKETS

When I am planning a photographic trip I like to do as much research as possible. I buy a map, a good guide book or two, and collect as much information as possible from the appropriate tourist office. No matter where I'm going, I usually like to seek out a local market. I find markets fascinating places to explore and wonderful venues for photography.

I've been very lucky in that my job has allowed me to visit some of the most exciting and colourful markets in the world, like the flea market in Paris for instance, and the fish market in Tokyo. However, any market can be a rewarding and stimulating place to look for pictures. Ironically, for many years before it was redeveloped, I had a studio in the heart of London's Covent Garden and I don't recall ever taking a single picture of it – now it's a part of history.

One reason why I find a market such a satisfying place to photograph is because of the atmosphere. Everybody has a job to do and there is, as a rule, a lively, good-humoured bustle of activity. It's a good location for taking candid unseen pictures since everyone is so preoccupied. Market people tend to be quite colourful and extrovert, and will usually respond well to requests for more organised portraits.

A market place is inevitably a rather untidy and cluttered environment and you need to take more than the average care to ensure that your pictures don't finish up the same way. Choose viewpoints and frame your pictures so that only the essentials are included in the frame. Take special care over the background areas as it is easy for an otherwise good shot to be spoiled by a distracting detail or patch of colour. With pictures of people in particular, a long-focus lens used at a fairly wide aperture will help to isolate your subject from the surroundings by throwing background details out of focus.

Cattle and fish markets, where auctions are usually held, can provide some wonderfully animated pictures and flea markets often have a bizarre assortment of both goods and people. The current popularity of yard sales could provide a great theme for a photo essay or an illustrated feature.

I especially like fruit and vegetable markets because they often provide what I call 'found still lifes', ready-made arrangements of produce which simply need careful framing to make a striking photograph. In French food markets the produce is often displayed as if it had been prepared especially for a photographic session, and I have vivid memories of a market in Sri Lanka where the most colourful and exotic fruits and vegetables were laid out like a Tessa Traeger still life.

I felt slightly guilty at sneaking a shot of such a sitting duck in the Paris fleamarket but he looked so good I felt justified. I had my exposure pre-set so it was only necessary to move to the best viewpoint, focus quickly and press the button; it only took about a second

BUILDING
AND SETTINGS

Much of my work is travel photography and a large part of this involves photographing architecture. Although there are various approaches to photographing a building, famous or otherwise, one type of picture which is always in demand by magazine and book editors is that showing the building in the context of its surroundings. Such photographs also have more appeal and interest as a holiday record than tightly framed, close-up pictures.

The key to pictures of this type is the choice of viewpoint. In an urban environment this is often quite restricted and the main difficulty is usually in finding a distant position from which you see the building well.

If it is a well-known building the local postcards are always worth studying. The photographers who take these shots have usually spent some time exploring all the possibilities and most of the potential viewpoints will probably be evident from a look at the postcard racks. Not that you should follow them slavishly. Postcard publishers generally prefer to show the building in its entirety, and if you are unconcerned by this restriction there are often alternative viewpoints nearby for a more interesting picture.

From postcards you can often judge the best time to take a shot in terms of the lighting. In the confined space of a town or city, the middle of the day tends to be the safest bet in strong sunlight since the shadows will be at their smallest. Early morning, evening and dusk are also good times to shoot for atmosphere and colour quality.

In a less confined space the choice of viewpoint may be much wider and I enjoy exploring as many angles and locations as possible when time allows. A good way of short-cutting this search is to stand in front of the side of the building you wish to photograph and look at the surroundings to see if you can identify a possible location from which to take your shot. Often you will spot a house, a hillside or a distant road which you can then head for. If the building is in a quite prominent setting, and you have a long-focus lens, it is feasible to travel a considerable distance away to get your shot.

Buildings like castles or manor houses with large parks or gardens, often have built-in viewpoints from which the structure looks its best and these too are worth looking for. From whichever viewpoint you choose, try to find an angle, foreground interest or aspect of lighting which gives your picture an individual quality. It often requires little effort to do this and the result will be far more satisfying than a straightforward view.

The Château of Chambord is a supreme example of a building designed to look impressive from almost every aspect. I took this shot from a viewpoint chosen to take advantage of the fine avenue of trees and the direction of the light at the time of my visit. I used a wide-angle lens on my Mamiya 645 and a neutral graduated filter to make the sky darker near the top of the frame. I had to wait while a group of about thirty Japanese tourists finished photographing each other in the foreground

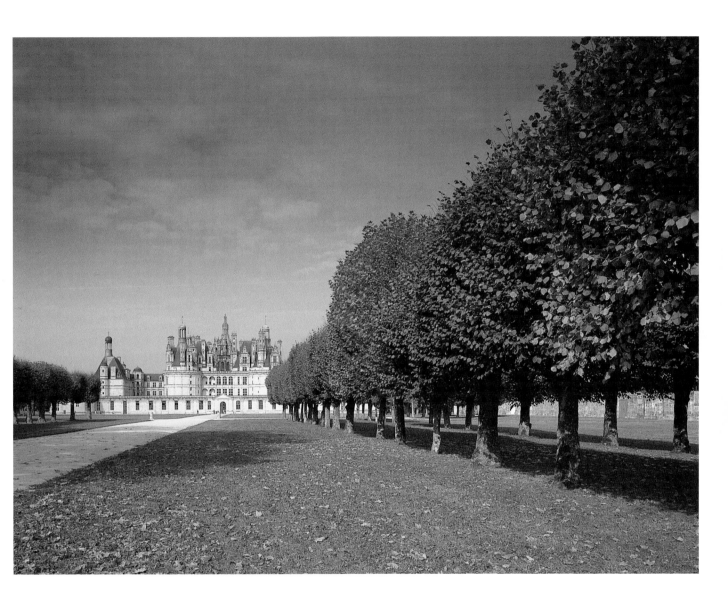

PARKS
AND GARDENS

Looking for photographs can, on occasions, be a frustrating affair. Sometimes on a day when the light is perfect and everything seems right it's possible to spend hours without seeing a good picture. I have a number of recurring themes which I often return to on days like these, and which always seem to provide me with good subjects. A park is one such place. It's partly because a park has been planned and landscaped to create pleasing aspects, and furthermore there is an in-built sense of order and organisation which undoubtedly helps you to create well-composed and balanced images.

City parks can be especially fruitful. Areas like the Tuillerie Gardens in Paris, New York's Central Park and St James's or Hyde Park in London have so much variety of interest that it's hard *not* to see a good picture. The contrast between the rural tranquillity of such spaces and the high-rise buildings which surround them is also fascinating to explore. Large parks usually have a wealth of statues, fountains, decorative benches and pretty buildings which can often be used to create a point of focus and interest. Such objects frequently make worthwhile detail shots and can also be an ideal setting for exploring the effect of different viewpoints (page 78).

City parks in particular are good hunting grounds for human-interest pictures. They tend to attract regular visitors, and there's often a space where people can play football, fly kites or go boating on a lake. The daily life of a park would make an ideal subject for a photo-essay or perhaps a time sequence photographed at a particular spot.

Left *City parks, like this one in Paris, are usually full of interesting objects and decorations as well as people and provide plenty of opportunities for satisfying pictures. I chose a viewpoint which allowed me to create a pleasing balance between the various elements of the scene, and used a long-focus lens to frame the image quite tightly*

Right *I have to confess to a liking for park benches and they often feature in my shots. The stark simplicity and symmetry of this one appealed to me as a black-and-white image although it seemed less interesting in colour*

Even small towns and villages usually have a park or open space where similar pictorial qualities may be found. A children's area like an adventure playground can be a good location for lively action pictures and candid shots.

A park or public garden is also a good place in which to shoot flower pictures, since they are usually particularly well stocked and tended. Local newspapers often publish lists of country-house parks and gardens which are open to the public on certain days, and a visit to one of these may provide a rewarding day's photography.

Good photographs of classic gardens are much in demand by publishers and photo libraries, and a productive period in an interesting garden could well result in some very saleable pictures. Make sure that foreground blooms are in good condition, and choose angles and viewpoints that show different features and aspects of the garden design.

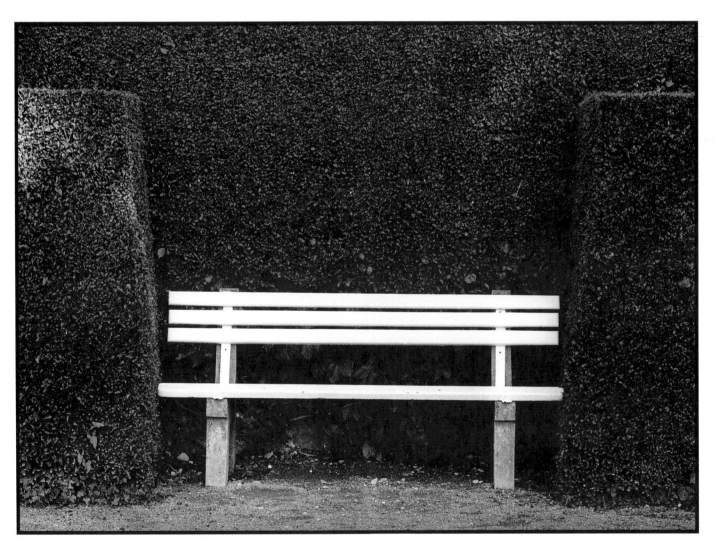

FLOWER IMAGES

Like trees, flowers are natural forms which can be used to create very appealing and striking photographs. Visual qualities, like shape, colour, texture and pattern, exist in lavish variety and any difficulties experienced in photographing them successfully are caused largely by having too much interest in the image. For this reason you need to be very selective.

This is particularly true of flowers *en masse*: wild flowers in a meadow, for instance, or a

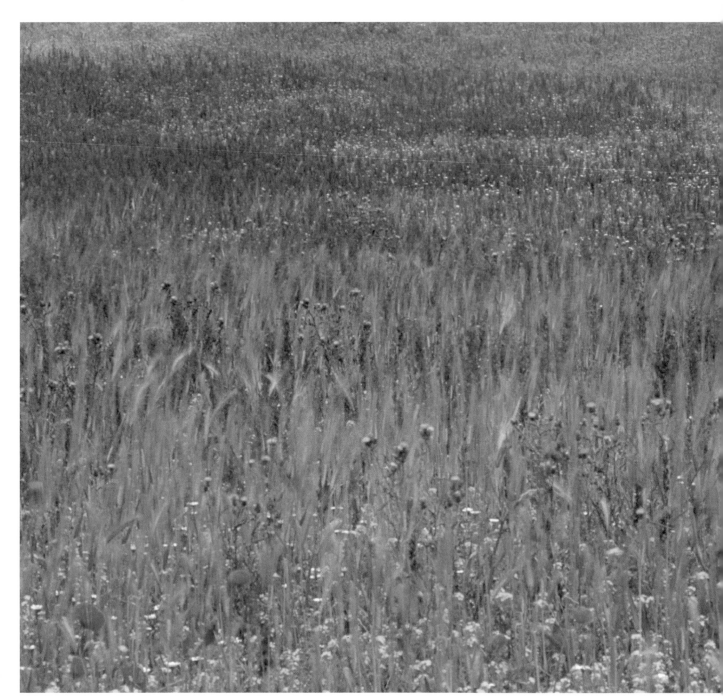

planted border in a garden. I recently visited Claude Monet's garden in Giverny on the river Seine, a breathtaking display of colour in which you can see the qualities which he created in his paintings. To photograph it successfully, however, is a different matter. A broad view of such a display is least likely to be successful, and it is necessary to focus attention upon quite small areas in order to avoid a confusing and discordant image.

A long-focus lens is ideal for situations like this, as it will allow you to isolate a small section of the scene and also to use differential focusing to keep background details from becoming too obtrusive. When bright mixed colours are thrown well out of focus in this way by using long-focus lenses and wide apertures the result can be very attractive.

Extreme close-up images of individual flowers *in situ* can also produce striking images. A tripod is invaluable for such pictures, since it enables the image to be framed accurately and to ensure there is no camera shake. Wind movement is sometimes a problem with outdoor photography, and you may find it necessary to erect a small cardboard screen around a bloom, or even to reinforce the stem of a plant with wire or a thin wooden splint. Choose a viewpoint which allows a contrasting tone or colour to be used as a background area. With close-up images, if the natural background is unsatisfactory, you can use pieces of coloured card or cartridge paper to create a plain, even tone.

As a general rule, direct sunlight is not ideal for flower pictures simply because it can create too much contrast and the hard, dense shadows it produces will cause subtle colour and detail to be lost. In such conditions shooting against the light can create pleasing effects, but you will need to give extra exposure when using an averaging reading.

Don't despise flowers in pots or arrangements of cut flowers in a vase. These will allow much more control over the composition of the image as well as the background and lighting. Interior daylight can be an ideal means of lighting an arrangement of this type, using white-card reflectors and small mirrors to control the contrast and to add highlights.

A blaze of wild flowers seen in a meadow while driving through Spain's La Mancha was a subject hard to miss. The best way to shoot it, however, was less immediately obvious. I finally opted for a 300mm lens on my Nikon to compress the colours and isolate a small area of the meadow. The shallow depth of field has also contributed to the effect, making some of the colours appear to blend

URBAN LANDSCAPES

The term 'landscape photography' invariably suggests the open countryside and images of wild and remote places. However, the possibilities which exist in towns and cities can be equally challenging and satisfying if rather different in terms of mood.

There is no doubt that the rather idealised approach to a subject which the rural landscape encourages, and which I frankly enjoy, is becoming increasingly out of touch with the way we actually live in Western society. It's also probably true that photographs of the urban landscape will have more importance and significance in an historical context than images of unspoiled countryside.

Because the urban landscape is man-made it has an inherent sense of order, a sort of built-in composition which in some ways makes it easier to create balanced and harmonious images. Whereas in a rural landscape the visual elements tend to be quite abstract, with soft hues and gentle contours, the urban scene is hard and angular with boldly defined shapes and colours.

The temptation with a rural landscape tends to be to create romantic and wistful images; with the urban landscape you can indulge in a harsher, more realistic approach. Bold shapes and colours which you simply will not find in the countryside can make a refreshing change and encourage a quite different approach to both the composition

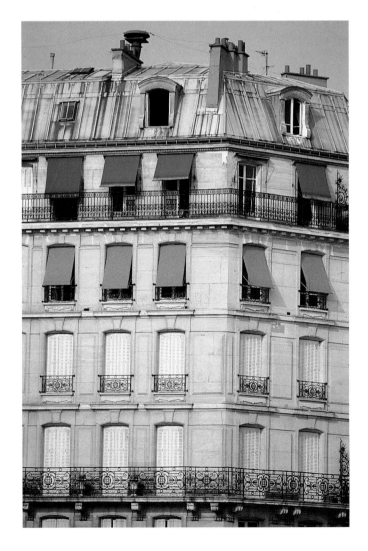

and mood of your pictures. Shop windows, streets of terraced houses, railways, buses, garishly painted doors, advertising hoardings, graffiti, monumental office blocks, concrete and glass — these can be challenging and stimulating elements when you take a fresh look at them.

The urban scene is not of course all brash and modern. Fine old buildings can be found in most towns and in every city there is a wealth of historical heritage to explore. In London, for example, you can move from buildings like the Houses of Parliament to the futuristic developments along the Thames wharves in just half an hour or so. Indeed, the contrast between ancient and modern is worth exploring for its own sake.

City skylines are often striking subjects for photographs and it can be rewarding to explore the possibilities of viewpoints afforded by high-rise buildings. Rivers, lakes and large open spaces like parks also offer good opportunities for such images; the Thames Embankment and New York's Central Park are good examples.

Lighting is just as important with urban landscapes as it is in the countryside. Early morning and evening light can create very atmospheric pictures, and at dusk in the city you have the additional element of artificial lighting to create colours and effects which simply do not exist in a rural landscape.

Below *Buildings of this type — mirrored glass, angular lines and chrome — were once restricted to brash modern cities but now even older towns have at least one such building. This structure, seen in Cardiff, was photographed on a 35mm wide-angle lens; a polarising filter was used to control the density of the sky and its reflection in the windows*

Left *I used a long-focus lens to isolate a small area of this Parisian apartment block making the rows of red and blue blinds the focus of attention. The compressed perspective and lack of depth which occurs with such lenses has contributed to the simple graphic quality of the picture*

SEASCAPES

A good photograph depends upon a variety of factors for its success: strong composition, good lighting, pleasing shapes and lines and interesting textures and colours. All of these visual qualities are created by the subtle tones from white to black which make up an image. These tones are formed by the reflective qualities of the subject and the highlights and shadows created by the lighting. The sea is one subject where this combination of transient, and often elusive, qualities can create a particularly wide range of effects, from the soft and subtle to the dark and wildly dramatic.

There are few other subjects where the changing light can have such a dramatic effect on tones and colours. The sea is a wonderful place to be on those days when the sky is heavy with broken cloud and shafts of sunlight filter through. At these times there can be an enormously rich range of tones which shift and change by the second as the light from the sky is reflected in the moving water. Sunsets and sunrises can have an especially dramatic effect on a seascape. When seen over the sea the colours and tones in the sky are reflected in the water and continued into the lower half of the picture.

On becalmed and misty days the sea can create soft, subtle high-key tones, and when there is a deep-blue sky still water will show rich translucent colours. Shooting into the light, towards the sun or a bright patch of sky can produce brilliant highlights and sparkle on the water.

Filters will often enhance the quality of water. A polarising filter can reduce reflections, producing richer colours and tones in calm water. It can also be used effectively to reduce the brilliance of highlights created by backlit water. A neutral graduated filter is invaluable for retaining tones and colours in bright skies. There is a tendency for pictures taken near the sea to have a strong blue cast because of high levels of ultra-violet light. This effect can be successfully countered by using warm filters in the 81A to 81EF range.

A successful seascape will, however, need another element, since sea and sky alone are unlikely to create a completely satisfying picture. Foreground details of rocks, boats, rippled sand and breakwaters, for instance, can be included in the image to heighten the sense of depth and distance. It's worth featuring the coastline, too, since that can add contrasting shapes, lines and colours to the picture.

Above *This picture of the Spanish coastline near Santander was taken near the end of a dull overcast day when I had all but given up the prospect of a picture. However, a sudden break in the clouds created this striking lighting effect. I used a wide-angle lens with a neutral graduated filter to help retain detail and colour in the brightest part of the clouds*

Below *I used a 20mm lens to shoot this picture of the Cabo de Creus on Spain's Catalan coast. The closest part of the rock was only a foot or so from the camera and I stopped the lens right down to obtain maximum depth of field. Shot as the sun was going down I used a neutral graduated filter to retain some colour in the sky and to prevent it being overexposed*

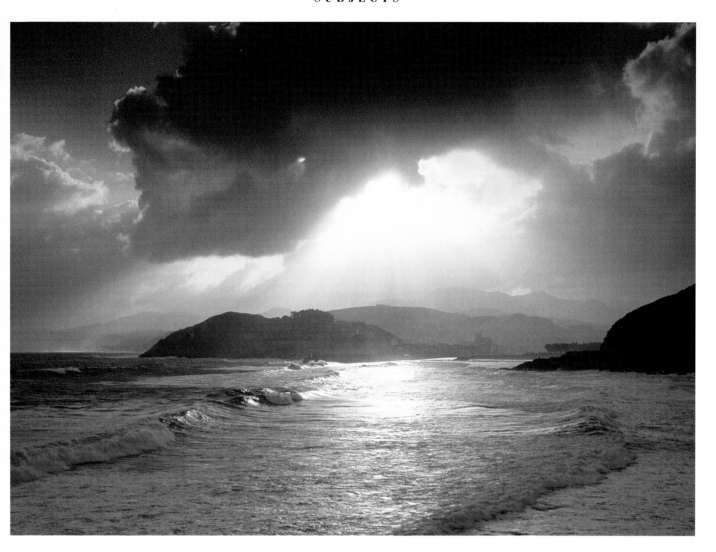

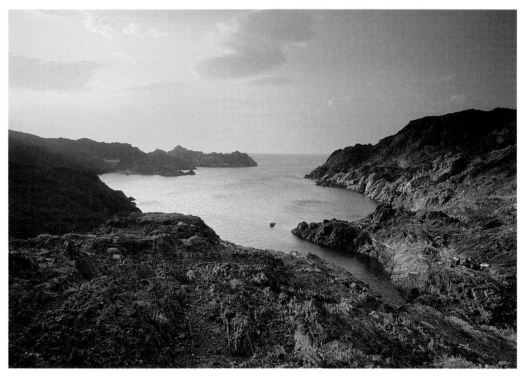

INDUSTRY

Photography can sometimes be a frustrating medium because there are occasions when the camera fails to capture the appeal of a subject or scene, no matter how hard you try to succeed. This is often true of particularly attractive situations, like a rural landscape or a picturesque village.

On the other hand, inherently unattractive scenes can frequently be used to create powerful and atmospheric images. Industry is a good example of a subject which can be unappealing in an aesthetic sense, but which can be used to provide strong visual elements in a photograph.

Large industrial complexes like steelworks, chemical plants, coalmines and potteries frequently have qualities which lend themselves well to a landscape approach. A forest of towers, pylons and chimneys can look dramatic and atmospheric when there is a moody sky and interesting lighting.

If you can obtain permission to shoot pictures within a factory or works, there good opportunities for dramatic wide-angle shots in which the perspective is deliberately distorted by the use of close viewpoints and tilted camera angles. Close-ups and details of oily cogs, polished ducts and coloured tubing can create images with a strong sense of design, accentuating forms, colours and textures.

Good industrial shots are not necessarily dependent upon vast enterprises. Interesting pictures can be found in small-scale industries, like a brick works for instance, and access may well be made easier. Craft industries such as hand-made pottery, wine-making and small boatyards also have considerable potential.

There are many worthwhile possibilities for photography which illustrates aspects of industrial archaeology, like abandoned tin mines or ancient water mills for example. Loal tourist information can be a good way of discovering such places.

Pictures taken with long-focus lenses from distant viewpoints can create interesting juxtapositions of shapes, and the compressed planes and sense of scale, which a long-focus lens accentuates, can produce images with a strong graphic quality.

The presence of billowing smoke does much to create a feeling of mood, and it can look especially dramatic when shooting into the light. Industrial complexes are often well lit at night, and pictures taken at dusk (when there is still some light left in the sky) can create bold colour effects combining the influence of both daylight and artificial light.

Above *A wide-angle lens was used to create a heightened sense of perspective and depth in this industrial shot. I gave one stop less exposure than indicated to produce rich tones and a sombre mood. These were further accentuated by the use of a neutral graduated filter to make the sky much darker*

Below *Low-angled glancing sunlight has created a bold shape and emphasised the texture of these oily cogs, part of the winching gear in a fishing port. I used a long-focus lens to isolate a small part of the subject and a small aperture to obtain maximum depth of field*

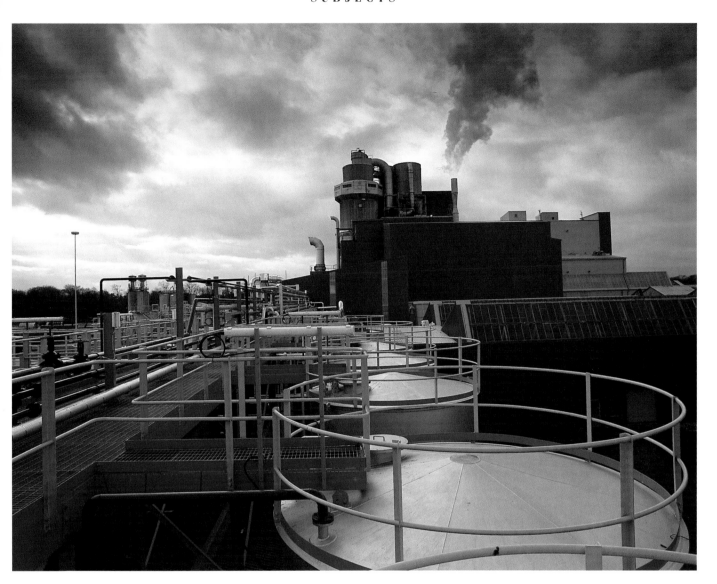

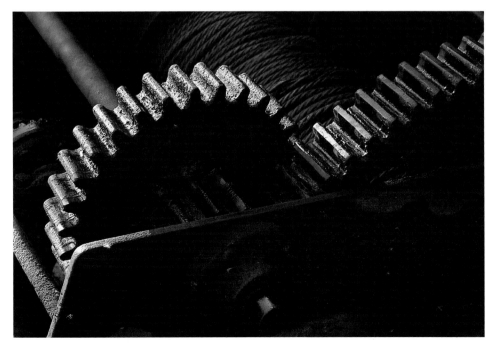

RIVERS

I spent several months a year or so ago taking photographs to illustrate a book on three French rivers, the Dordogne, Lot and Tarn. By some extraordinary coincidence, during the same year I was also commissioned by magazines to photograph the rivers Gambia, Rhine and Mississippi. I have consequently become very enthusiastic about the pictorial potential of rivers.

One reason for my enthusiasm is that rivers have an existence quite independent of their surroundings. The landscape through which they run, the activities which they generate, the buildings on their banks, the wildlife they support, the waterfalls, weirs and bridges which mark their course and, not least, the fascination of water itself — all of these things make a river a stimulating place to look for photographs.

Recording the course of a river has been the subject of many books and magazine features, and it doesn't have to be a famous or romantic river like the Mississippi. Most people have a river somewhere near their home and whether it is a quiet mountain stream or an industrialised urban waterway there are almost certain to be possibilities for challenging photography.

Access to a river is not always entirely straightforward, since some run through private land and others stray far from roads and footpaths. But this is part of their fascination and unpredictability. A large-scale map, like one in the Ordnance Survey series, is a good starting point for a project like this, since you will be able to chart its course and identify the places where you will be able to reach it most easily. I use fluorescent highlighting pens to mark interesting spots on the map, which makes it much easier to read, especially if you are travelling by car.

Some rivers have towpaths which make it possible to follow its course for considerable distances, and of course a boat provides opportunities for a completely different view. Shooting pictures from a moving boat does mean, however, that you will need to use quite fast shutter speeds, and a tripod will be of little or no help. For this reason, a slow film can be rather limiting, especially when the river is shaded by overhanging foliage, and a film of ISO 200 or more will be a better choice.

It's a positive advantage to be able to shoot some pictures from the waterway itself. When investigating small, shallow rivers putting on a pair of waders, or just taking off your shoes and rolling up your trousers, can enable you to find some more interesting viewpoints. You can also use your map to locate bridges and weirs.

A river would make an ideal subject for a photo-essay or an illustrated feature (pages 140–3), and if you live near an interesting river it can provide an on-going theme you can return to time and again.

One of my favourite places in England, the Duddon valley in Cumbria. This shot was taken from the riverbank near the bridge at Ulpha in the early spring. I used a long-focus lens to isolate a small part of the scene and a polarising filter to increase the colour saturaton in the grass and water. A small aperture was necessary to obtain sufficient depth of field

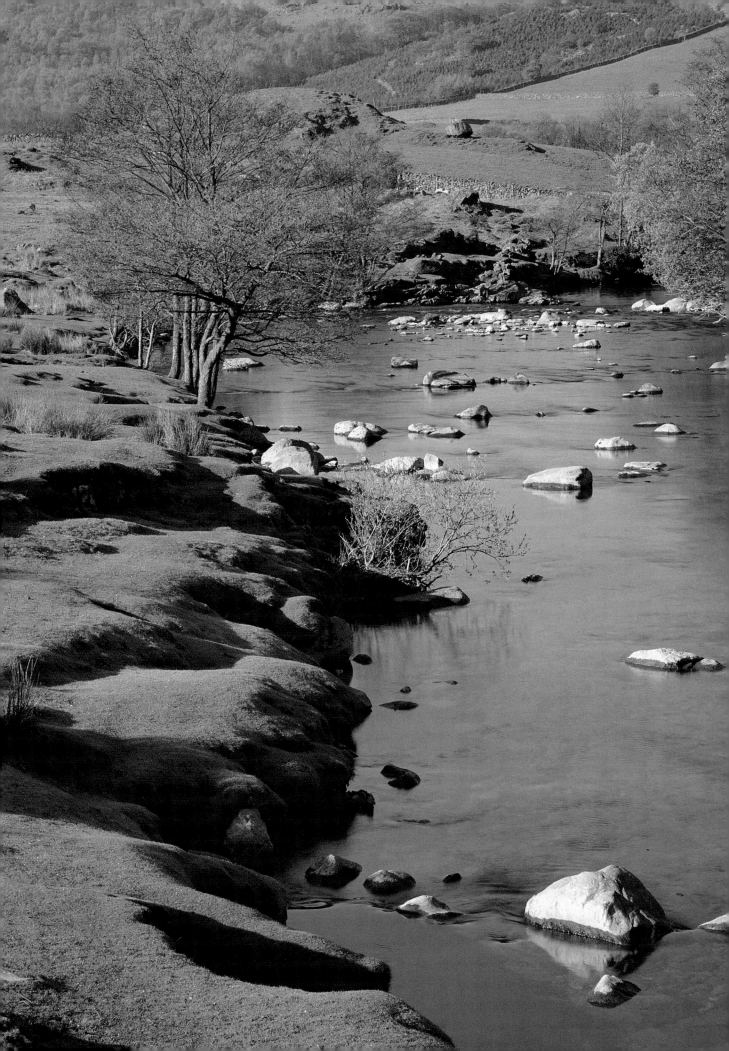

HARBOURS
AND BOATS

Among the subjects I find myself drawn back to time after time when the opportunity arises are harbours and fishing boats. Whenever I'm travelling near the sea or by river and lakeside, and see a sign to the port, I simply can't resist going to have a look even if it has little to do with the project I'm working on.

I find that these places make wonderful hunting grounds for photographs because there are so many interesting shapes, textures and colours and often a great deal of activity. A while ago I spent a fascinating hour or two in a busy fishing port on the north coast of Spain watching

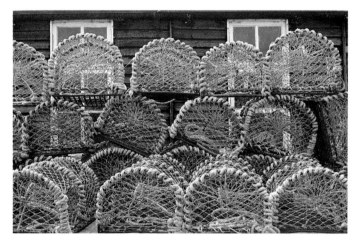

Above *I find many things connected with harbours and fishing very photogenic. These lobster pots were piled up around one of the fishermen's huts on Holy Island in Northumbria. I used a long-focus lens to frame the image quite tightly and a small aperture to ensure the image was sharp from front to back*

Right *This shot was taken in Galicia on Spain's northern coastline. It rains a great deal in the region but this was a sparklingly clear day. I used a wide-angle lens stopped well down to obtain sufficient depth of field and a polarising filter to make the sky bluer and to throw the clouds into more dramatic relief*

the catches being brought in, and the fishing boats jostling each other like dodgem cars for a place to tie up by the quayside.

There is tremendous scope for detail and abstract shots with the rich textures of peeling paint, fishing nets, lobster pots, coils of rope and wet cobblestones. There is also considerable potential for pattern pictures and bold colour images. Fishing boats often have painted designs which have strong regional characteristics; this could make an excellent theme for a photo essay.

Choose your viewpoints carefully, so that the lighting enhances textures and creates interesting juxtapositions of colours and shapes. For pictures of this type a long-focus lens will allow you to isolate small details and frame the image tightly to emphasise the dominant visual elements.

Colourful fishing boats are ideal subjects for dull days when a soft light will enhance bold rich colours.

Bright sunshine will create strong highlights and dense shadows which can diminish the effect of the colour. The presence of water and the possibility of reflectons can make low light and sunset pictures more interesting. A stormy day with dark clouds can produce some atmospheric and dramatic shots.

A harbour can be a good location for pictures of people. It is always easier to take natural and spontaneous shots of people when there is lots of activity and your potential subjects are preoccupied. Try to discover at what time the catch is brought in and, if there is a fish market nearby, when that starts. Close-ups of fish and crustacea like lobsters, for instance, can make striking images. It's best to use a tripod and to choose a small aperture so that the image is really sharp. At close-focusing distances depth of field is very shallow unless the lens is stopped well down to f16 or smaller.

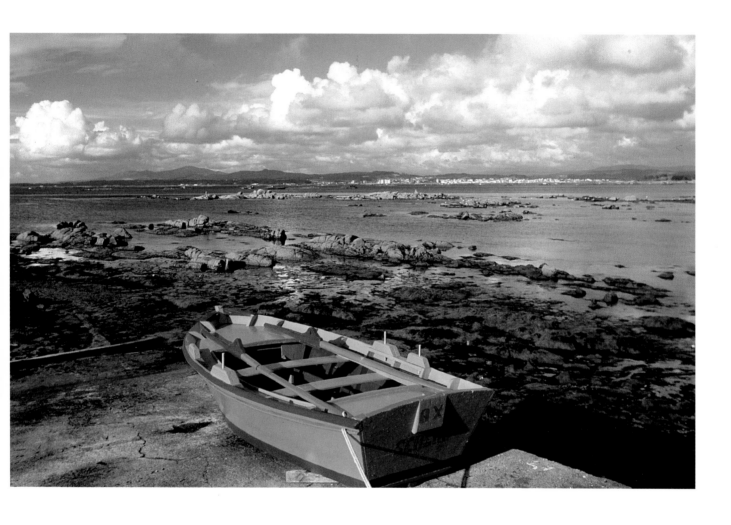

GLASSWARE

Glass is a very satisfying and intriguing substance to photograph and one where a special approach to lighting is needed. Because glass both reflects and refracts light, an enormously wide range of effects can be created with simple glass objects and a basic lighting arrangement. The glossy magazines often contain striking examples of glass photography in advertisements for products like perfumes, glassware and even beer. It is worth studying these to see what can be achieved.

If the objects, or group of objects, you intend to photograph have pleasing lines and shapes, you can create delicate high-key images by using primarily transmitted light to illuminate the arrangement. With studio lighting equipment, the easiest way to do this is to set up a largish area of white background some distance behind the still life and light it as evenly as possible, making sure that no light spills onto the glassware. You can achieve a similar effect by setting up your still life indoors in front of a window, the light from which has been diffused through tracing paper or translucent acetate.

This will create a high-key image in which the form and shape of the glass is defined by darker tones where it is cut or moulded. The effect can be varied by moving the subject closer to, and further from, the white background. Darker tones in the image can be intensified, and added, by placing pieces of black card close to the glass on either side and slightly behind.

The same type of lighting can be used to create a bolder image by using a darker toned background and illuminating the glassware by placing one or more large diffused light sources behind the set up and close to the edge of the picture. In this way the glass is still illuminated by transmitted light but with more direction and with a darker background. This technique is often used for photographing liquids like beer.

Backlighting in this way emphasises the refractive qualities of the glass. Cut glass, or objects with different planes and facets, can also be lit effectively with a frontal light emphasising the reflective qualities of the surfaces. Large diffused light sources will result in the best reflections; harder undiffused lights tend to create smaller reflections which are too defined and bright. The angle and position of the light sources will depend upon the shape and contour of the glass surfaces.

By combining both back and frontal lighting you can create further variations in the tones and forms of glassware by revealing both its reflective and refractive qualities. Even by using daylight you can establish varied effects by using diffusing screens and a combination of black and white cards to shade and reflect the light.

A simple still-life set up on an indoor window ledge. The window provided the backlighting to give the glass a nice translucent quality and I employed two small white reflectors to add a degree of frontal lighting, spraying the window with water to add interest. I used a 150mm lens on my Mamiya 645 stopped right down to obtain maximum depth of field

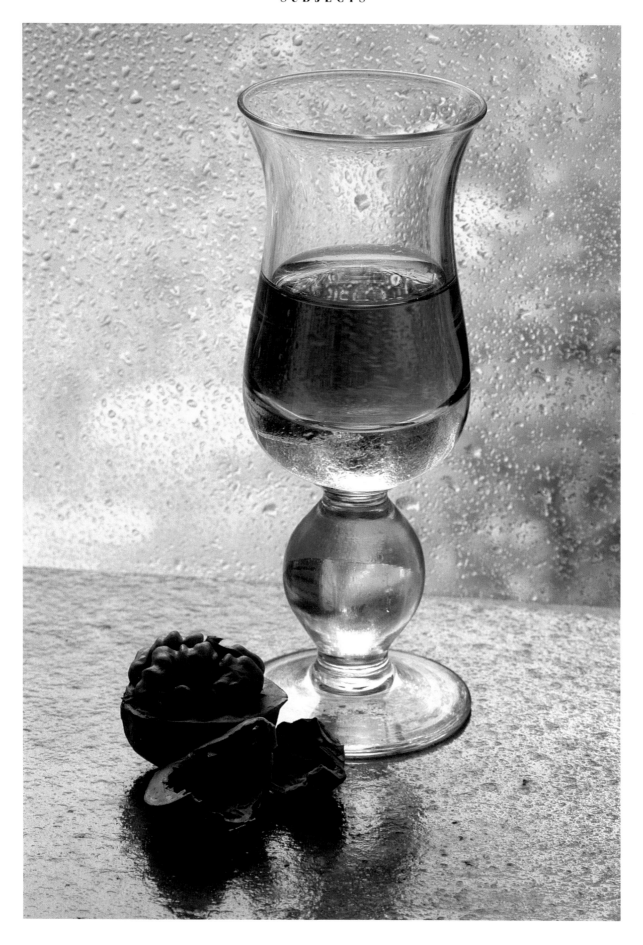

ANIMAL PORTRAITS

Among actors there's an adage that says 'never work with children and animals'. This is, I imagine, because both rather tend to be scene stealers and there is no doubt that good photographs of both children and animals have a quite compelling quality. Animals make wonderful subjects for photography and in some ways can be less difficult subjects than children.

A family pet is an obvious choice for a picture and yet many people don't think of photographing it. I had a Siamese cat for many years, a great character, which I always meant to photograph and somehow never did; now it's too late.

As a general rule, animals like cats and dogs are best photographed quite close to. The texture of fur and the subject's expression will be emphasised and the photograph is likely to have more impact than a longer shot. Backgrounds are best kept relatively plain and simple, and should be chosen to provide a good colour or tonal contrast to your subject.

I don't very much like the more contrived style of studio shot where the animal is posed and lit in front of an obviously artificial background, but such pictures do show the subject clearly and it is purely a question of personal taste. If the background tone and colour is well chosen, and the lighting kept simple (flash with an umbrella reflector from fairly close up gives a soft daylight effect), then the results can be pleasing.

My preference is for a more natural setting using say window-light indoors (see page 130), or outdoors in the garden or a park perhaps.

Under these conditions, background details may need to be subdued by ensuring that they are thrown well out of focus. Make sure your pet is some distance in front of the background and use a fairly wide aperture to limit the depth of field. The use of a long-focus lens will help in this respect, and will also enable you to shoot from a more comfortable distance and still obtain a close-up image. A tripod will help you to frame your picture more accurately and eliminate the possibility of camera shake.

A soft, diffused light is preferable to direct sunlight, which is likely to obscure the subtleties of fur texture and the animal's features because of the dense shadows it creates. A bright but hazy or cloudy day is ideal; if it is sunny take the picture in open shade — under a tree for instance.

An assistant will make the job much easier, preferably someone the animal knows. He or she can keep the animal in the chosen position and amuse it while you take the pictures.

For more variety, or if you don't have a pet, farm animals can make ideal subjects and are readily accessible, as are zoos and safari parks.

I fell in love with this gorgeous creature at the Pushkar camel fair in Rajasthan. She posed shamelessly and it would have been difficult to have taken a poor picture of her. The sky has provided an ideal background and I used a long-focus lens to provide a large image of her head from a safely distant viewpoint. In spite of her obvious charm I don't entirely trust camels

CASUAL PORTRAITS

Many photographers prefer to shoot portraits under controlled conditions in a studio. While this allows the widest choice of lighting effects and backgrounds it does impart a degree of formality to the proceedings, and sometimes it is preferable to undertake portraits in a more casual and less inhibiting way.

This approach is also necessary when photographing people you encounter while travelling. Although an unseen camera can produce spontaneous and unposed pictures of people, it is often more interesting to have their co-operation in taking a shot. Some photographers tend to be apprehensive about approaching a complete stranger for this purpose, but in practice most people are either flattered or amused by such a request and the results can frequently be more revealing and pleasing than a candid picture.

The first step is to have a clear idea of how you want to photograph the person before you make your request. It helps to create a relaxed atmosphere if, once you have gained permission, you are in full control of the situation and are not hesitant or indecisive in the way you work.

There are two important factors to consider, the background and the lighting. Look carefully at the surroundings to see if there is a relatively plain uncluttered area in front of which you can position your model. It should provide a tonal or colour contrast with your subject, so that he or she stands out clearly. If all of the options are cluttered or distracting, then you may consider using a long-focus lens and a wide aperture to ensure that background details are kept well out of focus.

While choosing the best background area, and your model's position, you also need to consider the lighting. In general, a fairly soft light is best for portraits, and open shade is ideal. Direct sunlight can create pleasing effects, especially with dark-skinned subjects, but it does mean that you have to be more careful about the model's head position because deep shadows will be created which can easily look unattractive. They tend to be much darker and more dominant on film than in life.

Once you have made your choice and asked permission, the next step is to ensure that your subject is comfortable and relaxed. It is best to have your model seated or supported in some way; even leaning against a wall is preferable to a free-standing position. People never quite know what to do with their arms and hands when standing and it is more difficult for them to feel at ease.

It is also important to keep up a flow of conversation while taking your shots. It doesn't even matter if there is a language barrier as long as you display an enthusiastic and encouraging manner. To allow a stilted silence to develop will virtually guarantee awkward and self-conscious pictures.

A long-focus lens is a good choice for pictures of this type, since it allows you to obtain tightly framed images of your subject without having to place the camera too close. A zoom lens will enable you to adjust the framing from say, three-quarter length to full-frame head, without changing the camera position.

This young man in Sri Lanka was pleased to be photographed. His dark skin made the direct sunlight a more acceptable form of illumination. I used a 35mm wide-angle lens to allow me to show the basket of fish more readily

I saw this French farmer working in his garden as I drove past. He was only too willing to be photographed although his rather domineering wife wanted to be in the shot as well and made him take his hat off and comb his hair. After I'd photographed them together, which wasn't very satisfactory, I persuaded him to put his hat back on for a solo picture which I shot in the shade of his cottage doorway

PART THREE

THE CREATIVE APPROACH

MOOD AND ATMOSPHERE

When you consider that a photograph is simply a piece of paper on which an image is formed by chemicals and dyes, it is remarkable how many subtle qualities it can possess. A feeling of depth, distance, form and texture can all be conveyed most tellingly by a good photograph. Perhaps the most elusive quality which a photographic image can convey is that of mood.

It's elusive because it depends upon so many different things. The subject itself may impart a strong sense of mood, like the harrowing images of war and famine shot by news photographers like Don McCullin, for example. However, an atmospheric subject does not guarantee that a photograph will necessarily convey the same mood. Factors like lighting and image quality can enhance or destroy this, often, indefinable quality.

Lighting is crucial since it helps to establish the tonal range of the image. It would be hard to convey a sombre mood when a scene was lit by bright sunlight with sparkly highlights, just as a lively happy mood would not be created by subdued shadowy lighting. A high-key image which consists of primarily light tones and pastel colours tends to create a soft and romantic mood, like a misty landscape for example. A low-key image in which dark rich tones and subdued colours predominate will impart a more sombre and serious atmosphere.

In studio portraits and still lifes the tonal range created by the lighting can be controlled quite readily, but in outdoor photography there is a more limited degree of control and factors like the time of day and the weather will largely determine both the lighting quality and the mood of a picture.

Low evening sunlight and dark stormy skies make for low-key images with rich tones and colours, which may be enhanced by choosing a viewpoint and framing the picture to emphasise the darker areas of the scene. Shooting into the light also creates this effect, particularly when the image is slightly underexposed.

The romantic and light-hearted quality of a light-toned picture is more likely to be found on days when the sky is overcast or hazy with a soft indirect light and no deep shadows. Misty mornings over a stretch of water afford ideal opportunities for high-key images, and so too do wintery days when the landscape is veiled by frost or snow.

The colour quality of a photograph will also have a significant effect on its mood. A scene where bright saturated colours like red and yellow predominate will help to impart a lively happy atmosphere; more subdued colours like green, blue and purple tend to produce a more restful and introspective mood and pale pastel colours give an image a more whimsical quality.

A wintery morning on the river Lot in France has created this monochromatic image. An unwanted blue cast is usually unattractive in a photograph but a picture which is assertively blue like this invariably has an atmospheric quality. In some cases I will use a filter of the same hue to strengthen the effect of a colour bias but in this case it was not necessary

THE UNSEEN CAMERA

In many ways I prefer to photograph people with their knowledge and co-operation, but there are occasions when it is better if they remain unaware of the camera. More spontaneous expressions and gestures may be recorded in this way, and the results can look more natural and relaxed than a set-up picture. In travel photography candid pictures of this type provide a more documentary feel to the images than when the subject is looking at, or is conscious of, the camera.

Taking such shots can seem rather daunting to the inexperienced photographer. He is usually an alien element of the environment he is photographing, and tends to feel self-conscious and very noticeable. However, it can be easier than imagined to become almost invisible; like sleight of hand it's really a question of mind over matter.

The first, and most important, factor is to take your time. Don't simply start aiming your camera at all and sundry the moment you arrive at a location. Wander around for a while, get accustomed to the place and the people and let them get accustomed to you. When you produce your camera, just take a few general shots to begin with and make no attempt to be secretive or furtive in the way you behave. Most people have a very short attention span and although your presence may be a great source of interest initially, they will very soon become uninterested and cease to really notice you.

This does not mean that you should be indiscreet. Don't walk around bristling cameras draped on straps like a video bandit, and it's also unhelpful to have an ostentatious camera bag. You need to be well prepared before you attempt to take a shot. Once you have selected the best viewpoint, assess the exposure and set the camera, make sure you have the right lens in place and even pre-focus if possible before raising it to your eye. I prefer to retreat to a quiet corner, out of people's gaze, to change lenses and film.

The temptation with candid, unseen pictures is to use a long-focus lens and a more distant viewpoint, and this can indeed be effective in some circumstances. Keeping at a distance from your subject makes you less noticeable, but it can be more restricting in terms of camera angles and there is always the risk of other people moving between you and your subject. When you use a long-focus lens it is very apparent at whom it is being aimed. With a wide-angle lens and a much closer viewpoint, however, it is possible to include a subject within the frame while giving the impression that the camera is not directed at them.

The ease with which you can take pictures in this way will depend partly upon the locations in which you choose to shoot. Busy places are best: markets, city streets, fairs and festivals, for example, because your potential subjects will be preoccupied and less likely to be interested in what you are doing.

This attractive balloon-seller was seen at Disneyland in California. A crowded place like this makes the unseen approach a relatively simple matter. I shot this from a fairly distant viewpoint using a long-focus lens and it was quite easy to take a series of shots without her knowledge. Afterwards, I took some shots with her aware of, and looking at, the camera but this spontaneous and unselfconscious picture was easily the best

This picture, taken in Jerusalem's Orthodox quarter, was rather more of a challenge since outsiders stand out like sore thumbs. After a while, however, I ceased to be the focus of attention and was able to shoot quite freely. The photograph represents one stage in the complex process of buying a chicken. First you purchase a live bird, next you take it to a registered kosher slaughterer to have it ritually dispatched and finally to this gentleman to have it plucked

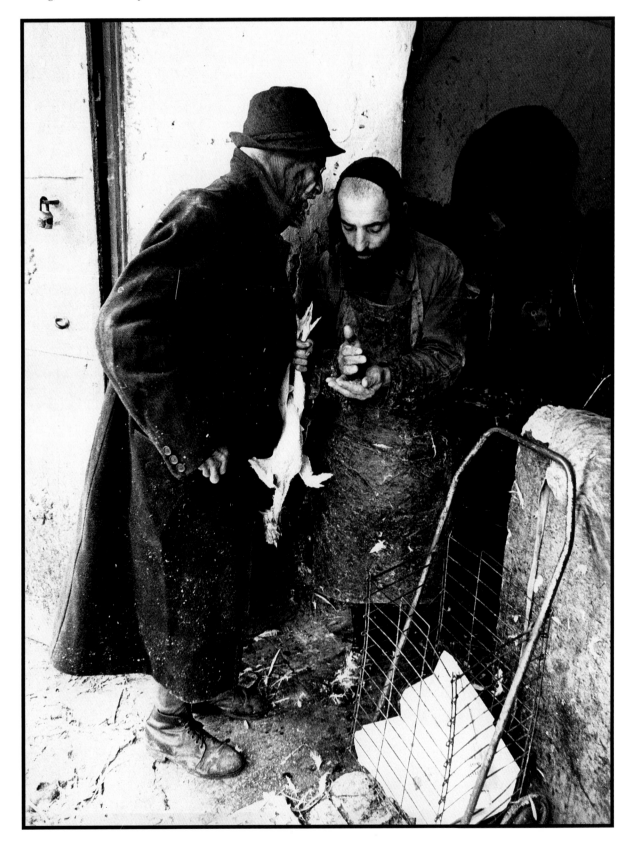

STYLE
PORTRAITS

There are many different approaches to portrait photography, but one basic distinction is between portraits which are intended primarily to please the sitter and those which are produced to fulfil some other requirement. This might be for the photographer's personal satisfaction or for professional purposes, like an advertisement for instance or a magazine feature. The approaches required to satisfy these various needs can often be very different and sometimes at odds with each other.

The style of high-street portrait photographers is, of necessity, geared to creating pictures which flatter the model and are most likely to mirror his or her own self-image. This frequently means that the results are rather bland, using soft-focus, canvas-bonded prints and gilt frames to simulate the traditional style of a portrait in oils.

A much more direct, innovative and visually exciting style of photography is feasible when it is not so important for the model to like the results. A glance through the fashion and image magazines will reveal just how different such pictures can be from high-street portraits. Some indeed are positively unflattering to the subject, although this does not necessarily have to be the case.

One enduring style of editorial portrait photography is the stark, harshly lit black-and-white images which Richard Avedon made his hallmark in the 1950s, and which David Bailey and others have carried through until the present day. The essence of this approach is a strongly directional, slightly diffused key light which is intended to create high contrast. Often shadows are left black with no reflector or fill-in light, and the highlights devoid of detail with only the mid-tones showing skin texture.

Backgrounds for this type of portrait are usually very plain. Richard Avedon favoured white, but grey or black can be used equally well as long as there is separation between the model's face and the background. There are no hard-and-fast rules about the angle of the light source, since the effect it creates will depend a great deal upon the position of the model's head. As a general rule it should result in about half the face being lit, with the shadows and mid-tones creating pleasing shapes and textures.

This rather aggressive style of portrait best suits fairly extrovert male sitters, where lively expressions and gestures will heighten the immediacy of the lighting. Quite often, the exaggeration of perspective which is obtained by using standard and wide-angle lenses from quite close viewpoints can contribute to the effect.

To ensure adequate contrast, use a 'black reflector' opposite the key light to prevent light being spilled back onto the shadow side of the

This young man's own rather extraordinary fashion design seemed striking enough and I used just a plain paper background and a large diffused light source from the right of the camera with a reflector on the opposite side to reduce the shadow density

model's face. When shooting in black and white it can be easier to control the final result by adjusting the lighting so that a more normal brightness range is created, and by using hard grades of paper when making the print to achieve the exact degree of contrast required.

A very different style of lighting is generally used for photographing women, particularly for beauty shots in cosmetic ads and magazine covers. In these cases the aim is to use lighting in such a way that shadows on the model's face are either very soft and subtle or non-existent. The easiest way to achieve this effect is with a very large soft-light source close to the model's face and more-or-less in line with her nose. Professional photographers use soft boxes or window lights supported on a boom arm just above the camera, but a tracing-paper screen may be used in a similar way.

Another method of attaining this shadowless quality is to place two large white polystyrene reflectors on each side of the model in a V-shape, with the camera peeking between them at the apex. A light source is then aimed at each of the reflectors, and in this way the light reaching the

For this double portrait I used a painted canvas backdrop and soft even lighting from a large diffuser to create a natural, daylight look. I also used a large white reflector to reduce the shadow density and to give the image a light, open quality

model is very diffused and equally balanced. Whichever means you use, there will inevitably be a small amount of shadow created under the chin and in the eye sockets; this can be reduced or eliminated by using a small white reflector positioned directly under the model's face.

Another widely used style of portrait — especially suitable for three-quarter and full-length shots as well as groups — is what I call the artist's-studio portrait. It requires a very soft open light which can also be quite directional. It is, in fact, the quality associated with a large north-facing window, and some photographers have studios specially designed to enable them to use daylight.

The effect can be created artificially by using a very large diffusing screen placed quite close to the model; ideally the screen should be approximately the same size as the subject it is illuminating. A wooden frame covered with tracing paper would be quite inexpensive to make, and one or two light sources, such as flash heads, can be placed several feet behind to light it as evenly as possible. A similar effect can be created by bouncing one or more light sources from a large white reflector.

The basic effect of the light will depend upon its angle with the subject. A frontal position close to the camera will create a soft image with little modelling and minimal shadow. Used from right angles to the model it will achieve strong modelling and bolder shadows, which can be left dark for a more dramatic quality or a reflector can be used to create a softer, more open light.

The background tends to be a more important and dominant feature in this type of portrait. The present trend, and one that enhances the artist's-studio atmosphere, is to use textured or subtly painted canvas backdrops. They are quite expensive to buy readymade, but you can purchase cheaper calico up to 11ft wide from theatrical supply stores and paint it yourself with the water-based acrylic paints used by set builders.

A large soft box from close to the camera position was the sole source of illumination for this flawlessly oriental face. I placed two large white reflectors each side of the model and one below her face to further reduce the shadows and create a very soft, smooth effect. The background was a piece of mottled fabric stretched over a wooden frame to make it creaseless

FOOD ART

In recent years especially, food photography has become a very innovative aspect of the medium. The advent of *nouvelle cuisine* in particular has led to a much greater sense of style and design in the way food is illustrated in magazines and advertisements. How food looks on the plate is now so important that some food writers claim that recipes are being made with their photogenic qualities uppermost in mind. The stark simplicity of many dishes lends itself perfectly to the bold graphic treatment favoured by today's photographers. A look through a well-photographed cookery book can be an inspiration indeed!

The potential of food as a subject for a more adventurous approach to photography is by no means a new discovery. Edward Weston produced a series of stunning black-and-white images based on the humble pepper. It is an ideal subject because food is very accessible and has such a rich variety of forms, textures and colours; it is also an excellent means of learning both the basics and subtleties of lighting and composition. Although prepared food is perhaps rather more difficult to photograph, cold dishes and arrangements of ingredients can be equally effective.

A small table is ideal for setting up your shots, and daylight controlled by reflectors is quite adequate in terms of lighting. Studio lighting will allow a wider range of effects and more control but it is by no means essential. You will need a camera capable of focusing down to half a metre or less, a macro-focusing lens or extension tubes for an SLR are ideal. You will also need a tripod since small apertures will be required to ensure adequate depth of field and it will also allow you to frame and focus the image more accurately.

It's best, before you start, to sketch out some basic ideas, possibly adapting from a photograph you like in a magazine. It helps to narrow things down a little as the choices are so wide. You might even consider basing your still life on a specific recipe or a theme like tropical fruits, for example.

You will need to think about backgrounds and surfaces on which to set up your arrangements. You can look through the pages of good food books and magazines for ideas: a plank of old knotty wood, coarse fabrics like hessian, a slab of marble, stone or ceramic tiles and glossy laminates — all of these can be effective.

Props too are useful. Many will probably come from your own kitchen but junk shops and flea markets can often yield an inexpensive selection of photogenic items like terracotta pots, baskets, wickerwork and kitchen implements – a chef's knife, and so on.

The main subjects are easy to find during a wander round a good foodstore or market. It's a good idea to buy a wide selection from which to choose your arrangements, since it's unlikely that anything need be wasted. Look for things with appealing shapes and contrasting colours and textures: glossy vegetables, shiny silver fish, brown speckled eggs, nuts, pasta shapes and crusty loaves — the possibilities are endless.

A very simple arrangement of melon slice and grapes lit by daylight and a small white-card reflector. I used a tile from a builder's merchants, wetted to give it a sheen, as an interesting but uncluttered background for the fruit. It was, in fact, shot in my garden on a sunny day in the shade of my shed

LANDSCAPE PATTERNS

Pattern can be a powerful element in an image. It has a compelling and reassuring quality which can make a photograph almost irresistible to look at. In a photographic sense, pattern need not necessarily be a completely accurate repetition of shapes like those created by artificial objects (brick walls or office-block windows, for example); there can also be implied patterns resulting from an arrangement of similar shapes, lines, colours or tones. Patterns of this type may be found readily in the landscape and when used as an element of a composition they can lead to strong and satisfying images.

The pattern made by furrows in a newly ploughed field, or stoops of wheat at harvest time, are instances of this type of picture. It is possible, however, to build up strong pattern effects with even more arbitrary arrangements — think of the tracery of a bare-branched tree in winter or autumn leaves on a forest floor.

Lighting can also help in achieving a pattern effect, emphasising, or indeed creating, an impression of repetitive shapes. Something as abstract as the highlights on rippled water or wet sand can lend a pleasing and almost hypnotic quality to an image. Shadows too, cast by direct sunlight, become a pattern in themselves; the dappled effect created by light filtering through foliage on a sunny day is an example of this.

These types of patterns, found in essentially quite random arrangements, depend a great deal upon the choice of viewpoint and the way in

A vineyard in the Champagne region with a light dusting of snow was the subject of this picture. Vineyards are one of my favourite topics and can create striking patterns. The presence of snow helps to simplify the image and give an even more graphic quality

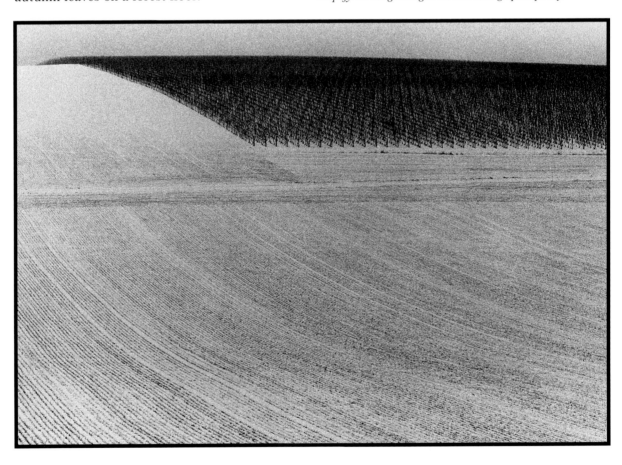

which the image is framed. The effect often comes about by isolating a small area of a scene, and here the choice of lens is an important factor.

A long-focus lens allows a more distant viewpoint, which in turn helps to compress the perspective and make quite separate objects appear to be closely juxtaposed. In other situations, a wide-angle lens permits the camera to exaggerate the perspective effect and create the impression of pattern through lines and shapes.

Close-up images of natural forms like tree bark, leaves or pebbles on a beach are readily found, and with extension tubes or a macro-focusing lens an entirely new range of possibilities emerges.

It is important to appreciate, however, that pattern alone in an image is unlikely to have more than a superficial impact. There also needs to be a centre of interest which focuses the viewer's attention by causing a break in the pattern. In the early example of the furrow pattern in a ploughed field, the well-placed presence of the plough, perhaps surrounded by a flock of gulls, would change it from an interesting image into a satisfying and well-balanced photograph.

This extraordinary pattern of fields was photographed in Spain's La Mancha region. The viewpoint was from the top of a steep ridge dotted with windmills above the village of Consuegra. I used a polarising filter to add clarity and colour saturation to the image and a long-focus lens to enable the strongest portion of the scene to be tightly framed

CLASSIC LANDSCAPES

Landscape is one of the most popular subjects with photographers. It is also one of the most accessible, since the countryside is available to most people and fine landscape photographs can be taken with the most basic equipment. It is true to say, however, that good landscape pictures are not as commonplace as one might expect.

One reason for this is simply that it appears almost too easy. A beautiful view seems to require little more than aiming the camera and pressing the shutter release. In practice, a stunning view is probably less likely to produce a memorable picture and is certainly a more difficult subject to photograph well than you might imagine.

The reason why a lovely view is often disappointing when photographed is because there is usually too much going on in it. Our eyes scan a wide area, zooming in on aspects which appeal and ignoring less interesting segments and things which are unattractive. A camera sees everything within its field of view with equal emphasis, and often the most pictorial elements of a scene are lost in a jumble of irrelevant detail. The choice of viewpoint and lenses will allow you to be selective, focusing interest on the strongest elements of the scene and excluding unwanted areas.

A good landscape shot needs shapes and lines to form the basic structure of its composition. These elements are found in the contours of the land, the tone and colour of fields and foliage and the outlines created by trees and clouds. Very often such elements combine to perfection in

Right *I saw this compelling scene while driving through the Maestrazgo, one of Spain's more remote and undiscovered regions. I chose a viewpoint which allowed me to include just a part of the stone wall and which placed the further field of poppies in the most pleasing relationship to those in the foreground. I used a polarising filter to increase the colour saturation of the flowers, grass and sky and to give the clouds stronger relief*

Below *Photographed near the village of Goudhurst in Kent, this landscape relies largely upon the lighting for its effect. The cloudy sky combined with a low-angled sunlight has created a rich tonal range which works particularly well in black and white. I used a long-focus lens to frame a small section of the scene*

situations in which a conventional 'good view' does not exist.

Lighting too is a vital element, whether it is created by low evening sunlight, skimming across the countryside revealing colours and textures, or whether it is a soft atmospheric light filtered through dark stormy skies. There are no set rules; what may appear as a dull and uninteresting scene on one occasion may be transformed into a compelling picture when the light is different. You learn to spot when a scene's potential will only be realised under different lighting conditions.

The time of year is also a factor to consider. In northern Europe, I find the green summer months of July and August — when the sun rises high in the sky, and it is often hazy — the least productive. Early spring, when the foliage has a much wider range of colour, is more interesting; so too are the months of October and even November when the leaves change colour, when crops are harvested and the fields are ploughed creating stronger textures on the land.

Wide-angle and long-focus lenses are equally useful for landscape photography. In some circumstances a wide-angle lens helps to establish a greater sense of depth and distance, and emphasises the foreground elements of a subject. In other situations, the ability to isolate a small area of a scene, reveal distant details and create tighter compositions makes a long-focus lens equally useful.

EXPLORING VIEWPOINTS

Many inexperienced photographers take a picture without giving much, if any, consideration to the best camera viewpoint. This is one of the most fundamental errors and the cause of a high percentage of disappointing results. The choice of viewpoint is one of the most important ways of controlling the content and composition of an image.

If an artist is making a drawing or painting, it is a relatively simple matter to alter the positions of the objects within the scene he or she is painting in order to improve the composition. To a lesser extent this can also be done in photography by changing the camera's viewpoint.

An illustration of this can be made by considering a situation in which there are two objects at different distances from the camera; say a person with a distant tree immediately behind them. By moving the camera to the right the tree will move also to the right in relation to the person, and when the camera is moved to the left the tree will move in the same direction.

By moving the camera closer the person will become larger in the frame and the tree will appear smaller in relation to them. By moving further back the person will become smaller in the image and the tree will become larger in proportion to them.

If the camera is moved to ground level, the top of the tree will move down towards the person's head and by raising the camera higher the tree will also move higher above the person's head. When you begin to notice what happens as the viewpoint is changed in this way, it becomes apparent that you can have a great deal of control over the arrangement of seemingly fixed elements within the frame.

I will very rarely take photographs of a subject from a single position, even though I may have viewed it first from several angles. You can learn a great deal about composition by choosing an interesting subject, one with foreground, middle-ground and distant details, and taking a series of photographs from a variety of viewpoints, discovering just how much you can alter the arrangement of the image in each one.

Of course, it is not strictly necessary to make exposures, since just looking at the subject from different positions will reveal a great deal. However, placing a series of photographs side by side will be even more informative. I sometimes discover that I prefer an alternative to the viewpoint I liked best when taking the shots.

When the choice of viewpoint is combined with the use of lenses of different focal lengths it can be surprising just how much control can be exercised over immovable objects.

It is important to appreciate that the choice of viewpoint also affects the lighting as well as the composition, especially on a sunny day when the light is both hard and directional. Changing the viewpoint alters the direction of shadows and the position of highlights. Indeed, the quality and mood created by lighting can be completely changed in this way.

This photograph of the river Lot in France is a good example of how even just a slight change in the viewpoint could completely alter the composition. The image depends largely for its balance and effect upon the juxtaposition of the tree trunks and the critical position for my tripod was a matter of just an inch or so. The shot was taken on a wide-angle lens

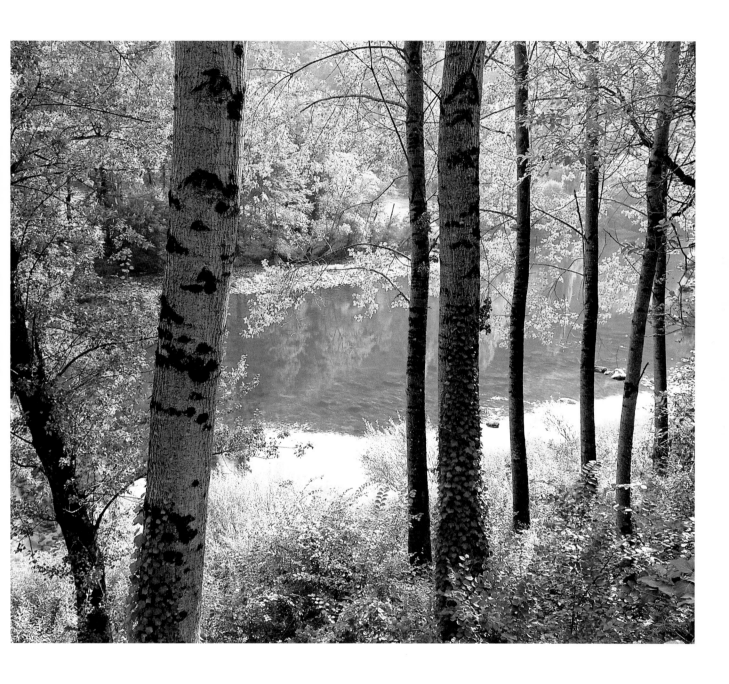

REFLECTIONS

The ability to see and photograph things is only possible because of reflections. Light reflected from the surface of objects is diffused and scattered in ways which define their shape, form and colour. With certain surfaces, however, the light source is not diffused and scattered but reflected so that, to a degree, the light rays remain parallel and an image of the light source is visible in the surface which reflects it. With a smooth, flat, highly polished surface — like a mirror or metal plate — the reflected image is almost perfect. In others like rippled water the reflection can be distorted in such a way so that an abstract or repeated version of the light source is seen.

I find reflections quite fascinating because they offer opportunities to produce images of an unusual and unrepeatable quality. Even if the light source is simply a bright unobscured sun, it may still create some striking effects on certain surfaces. Think of evening sunlight skittering across a wet sandy beach after the tide has gone out, for example, and those sparkly sunspecks on a fast-flowing river. Quite often, reflections of this type are too bright and cause the highlight details to be burned out. In many cases, though, you can use a polarising filter to reduce their intensity and considerably improve the image quality.

The most interesting effects, however, are created when the reflection is not directly from the sun but off something which is being illuminated by it — a bright cloudy sky reflected in a lake or the windows of an office block, for example. This is where it becomes particularly fascinating because the relationship between the relative brightness of the reflective surface and the surface reflected in it can create an enormous variety of exciting effects.

Modern city buildings with mirrored glass can create a kaleidoscopic range of images, and the choice of viewpoint has a dramatic effect on the nature and intensity of the reflections. When the image is tightly framed with a long-focus lens the result can be almost completely abstract. A polarising filter is also a useful means of control in these circumstances.

When both reflection and source are quite distant the effect of focusing will be insignificant. However, if the reflective surface is quite close to the camera you must allow for depth of field. With the reflective surface a few feet from the camera, for instance, and the source of reflection at infinity, you will need to use a very small aperture to record both sharply. Interesting effects can also be produced by focusing on one plane and allowing the other to remain out of focus.

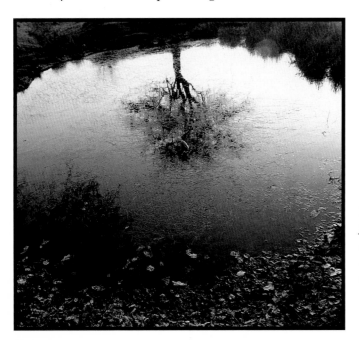

Right *Photographed in Los Angeles, this effect was created by one apartment block being reflected in the mirrored glass windows of another. I used a long-focus lens to frame a small area of the building which has helped to create a rather ambiguous and abstract image*

Left *It's not often you see a picture by looking down at your feet but this wintery dewpond made a far more interesting picture than the scene it was reflecting. I used a wide-angle lens with a small aperture to ensure the image was sharp from foreground to distant tree*

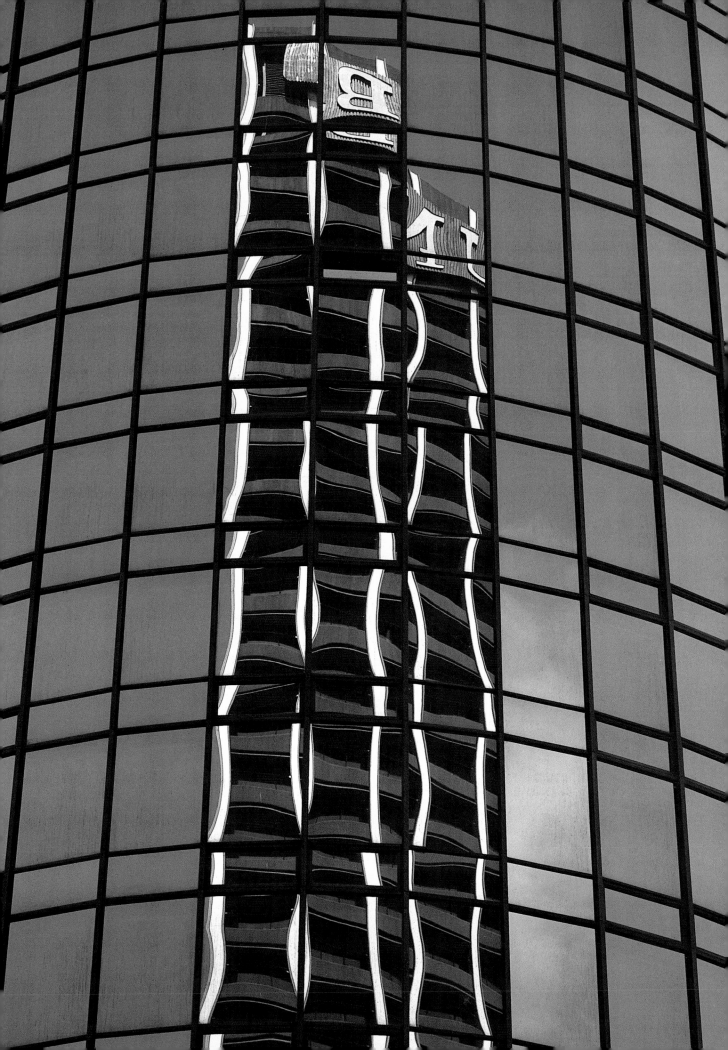

STRIKING SUNSETS

One subject which has a perennial popularity with photographers is a sunset. Like many situations which have an instant and irresistible appeal, it is one which can be disappointing unless given some careful thought.

When you photograph a sunset you are in effect photographing a light source. This means that an exposure which records adequate detail and colour in the sky will result in other elements of the scene being underexposed and too dark. For this reason the way in which you photograph a sunset, the method you use to calculate the exposure and other elements included in the picture are all very important. The difficulty is compounded because a sunset will seldom make an interesting picture on its own; it needs additional elements to create a satisfying image.

One solution to the problem is to find foreground details and objects which look effective in silhouette: an interestingly shaped tree, for example, or a distinctive building or structure like a pylon or tower. In this way you can calculate the best exposure for the sunset and simply allow other details to record as dark tones.

Another possibility is to look for a foreground which has reflective qualities; water is an obvious choice. A sunset over the sea or a lake will mirror the colours in the sky and extend the tonal range of the sunset into the foreground. Wet sand, a rain-washed street or even the windows of an office building can be used in a similar way. If I feel that a good sunset is likely I usually spend an hour or so beforehand looking around for the most effective foreground.

It is possible to obtain more detail in the foreground by using a neutral graduated filter. This allows you to give more exposure overall, revealing more foreground detail, without overexposing the sky and making it too light.

Calculating the best exposure is not entirely straightforward. Underexposure is the most likely result of taking a normal reading direct from the sunset, especially if the sky is very bright and the sun itself is included in the image. A useful technique is to take a reading from the sky above your head or well to one side of the area where the colours are strongest.

It is invariably best to bracket the exposures quite widely, as much as two stops or more each side of the calculated exposure. Quite often acceptable, and quite different, pictures can be created over a quite wide range of exposures.

On many occasions sunset pictures will be more effective after the sun has gone down. Some of the most subtle colours and effects occur as much as an hour or so after sunset. Long exposures are often necessary in these circumstances so a tripod is essential.

When shooting at sunset don't forget to look behind you. Often the orange glow of the sun just before it sets leads to some stunning lighting effects on landscape and buildings, which can be more interesting than the sunset itself.

This picture of the Provençal hilltop village of Gordes was taken just before the sun dipped below the horizon. Many subjects of this type can appear far more interesting and atmospheric when lit by the red tinted rays of evening sunlight. If a good sunset is probable when I'm on an assignment I always try to be in a place where it will be useful to me

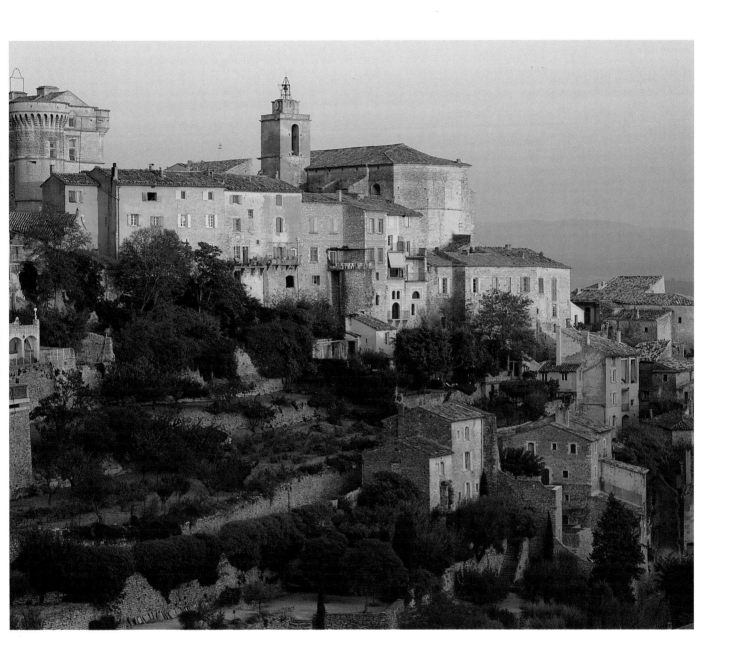

PERIOD
PORTRAITS

Looking at old photographs makes you aware of the ways in which photography has changed during the century and a half of its existence. Some of the appealing qualities of these old images are due to changes in the process itself as well as to the cameras, lenses and film used.

With studio photography, changes in lighting styles account for many of the differences between contemporary and period photographs. Even in the space of a decade or less distinctive shifts occur in the ways in which lighting effects are used. Only a few years ago food photographs were lit almost exclusively by large soft 'window lights' giving the impression that the arrangement was illuminated by natural daylight. In the past few years, however, the style has changed: spotlights now tend to be more favoured,

skimming across the surface of the food creating an almost theatrical quality.

These changing fashions are particularly noticeable in portrait photography and it is relatively simple to recreate the effects of earlier classic styles. All that is needed is a room of reasonable size and two or three light sources — which can be either flash heads or simple photofloods on stands.

Although not essential, the full period effect does require the photographs to be shot in black and white. For those who do not process their own films it would be worth experimenting with Ilford XP2. When processed and printed by colour laboratories in the same way as ordinary colour-negative films it can produce monochrome prints with an attractive sepia-type image.

I've always thought that the very distinctive lighting style used by the great Canadian portrait photographer Karsh was particularly effective for male portraits. The basis of his approach was to use rim lighting to achieve a very three-dimensional quality and at the same time to produce an image with rich tones and pronounced skin texture.

A plain dark-toned background is needed and it should, ideally, be positioned at least ten feet or so behind your model. It will be easier to control

Left *The lighting for this male portrait was achieved by bouncing the light from two flash heads off white reflector boards placed each side of, and slightly behind, the model. I placed a third reflector board in front of him to throw some light back into the shadow areas to reduce the contrast and then calculated the exposure to give good tone and detail in the highlight areas*

Right *I used a slide projector to create a tightly focused beam of light for this portrait of a girl. The positions of the light source and the model's head were quite critical in order to produce good modelling and to avoid unattractive shadows on the face. I used a second light to illuminate the background and soft-focus attachment has made the harsh lighting rather more flattering*

the lighting effect if the room is fairly dark. Two diffused lights should be placed close to the background and aimed towards your model. They are intended to be at an acute, glancing angle almost backlighting your subject's head so they need to be moved in to the very edge of the picture area. It is necessary to eliminate as much light spill as possible. Sheets of black card can be taped to the sides of the reflector creating a narrow channel of light which just illuminates the model's head.

This very directional type of lighting means that the angle of the lights, the camera viewpoint and the position of the model's head are all very critical. You will need to set your camera on a tripod and to adjust the lights and model's pose until the highlights created are in the most effective place.

There are two main pitfalls to avoid: one is overlighting, meaning that the highlights are too strong and the skin texture and detail will be 'burned out'. The other is that the backlighting might spill onto parts of the face in such a way that they create unattractive highlights and shadows. Glancing highlights on the side of the model's nose, for example, can be quite ugly and shadows beside the nose and in the eye sockets can also look unpleasing. It is largely a question of careful observation and making fine adjustments to avoid these effects.

Backlighting alone will usually result in too much contrast, unless there is a great deal of light

For this male portrait I used a soft box from well to the left of the model's head, and a light fitted with a snoot from behind his head to the right, to create highlights and emphasise the skin texture on the side of his face. A white reflector placed in front of him has bounced some light back into the shadows and reduced the brightness range

that it is the lighter tones which are the most important and the best method is to take a close-up reading from the rim-lit areas.

Remember too that what the model wears will have a considerable influence on the effect of the photograph. Something quite plain in tone and fairly dark is best, and you should avoid anything with white or very light details since it is important that the hightlights on the model's face are the lightest tones in the image.

For female portraits in particular the 1930s-Hollywood style of lighting has a particular charm. This technique depends upon a very hard and directional key light used to create modelling on the subject's face. Large spotlights were used for this, but a very similar quality may be achieved with bare bulbs, flash heads, domestic spotlight bulbs or even a slide projector.

This type of light is quite hard and unforgiving so it needs to be directed with care. As a general rule, it should be positioned a foot or so above the model's eye level and slightly to one side of her nose. The shadow from the nose is a good indication of the best position for the light. Normally, it should not be long enough to reach her top lip and it should not rise above the crease from the nose to the corner of the mouth. The model's head position is important too and once the lighting is set your model will need to remain in the same pose.

This single light will probably create too much contrast on its own and you will need to use reflectors to throw some light back into the shadow areas. Further refinements of this technique could be to use additional light sources to cast shadows and highlights onto the background, and to provide a hairlight. This is a light suspended on a boom arm directly above the model's head in order to create highlights and bring out the texture and detail in her hair.

The Hollywood photographers used mainly 10 x 8 plate cameras for this type of work, but slow fine-grained film with smaller cameras can produce a very satisfactory result. The potential harshness and unflattering quality of this type of lighting was eliminated by the use of make-up and retouching, or by using soft focus and diffusion devices (see page 10). These are the easiest and most convenient way of creating a smoother and more pleasing skin quality.

spill and the room is small and light toned. To add light to the shadow areas and reduce contrast you simply need to place one or two large white reflectors close to the model on each, or just one, side of the camera. If you have a third light source it could be used to create a variation in the background tone, a soft-edged pool of light behind the model's head for instance.

When calculating the exposure remember

PART FOUR

COMPOSITION AND STYLE

FRAMES WITHIN FRAMES

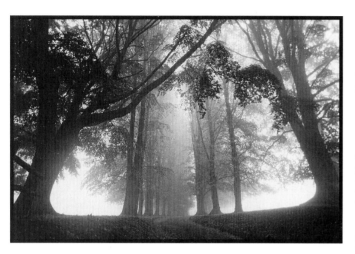

The art of composition is simply the ability to organise the important elements of a scene into a pleasing and balanced arrangement within the frame. The so-called rules of composition, like placing the main point of interest on the intersection of thirds, for instance, and using lines to lead the eye into the image, are a useful guide to creating pleasing, and inoffensive, pictures. However, there are occasions when something more is needed to add interest and impact to an image, and to give photographs a more individual and personal quality.

A device that can often be used effectively is to look for ways in which elements of a scene can be used to form an additional frame with the borders of the photograph. It's not necessary for a frame to literally surround the image; it can be just as useful when only one or two sides of the image are contained in this way. It is a potent method of focusing attention on a subject and a means of containing and tidying an image. It also masks unwanted or distracting details in a scene.

On days when a sky is dull and flat, for instance, the inclusion of interest at the top of the image (overhanging foliage is a classic example) can add impact and eliminate much of the offending area. With a bright sky it also helps to improve image quality in the darker details of the picture by eliminating flare and increasing contrast.

A frame often increases the feeling of depth and scale in a picture. With a distant landscape, for instance, when the image is largely on the same plane, shooting through a gateway or over a stone wall can make the image seem much more three-dimensional. On days when the light is soft, and the scene has a limited range of tones, the inclusion of a dark or even silhouetted frame can have a striking effect. This is especially telling with misty or high-key images.

Shooting through an archway or window is often an effective device when photographing buildings, as it can enhance the effect of perspective; and when wide-angle lenses are used it creates quite dynamic compositions.

A compositional frame does not have to be formed by an object; it can be established just as effectively by tones or colours within an image or by lighting. A good example of this is in studio portrait photography, where a pool of light is thrown onto a dark-toned background to create a frame around the model's head.

As well as being a way of adding foreground interest, frames within the scene can be just as potent when they are used as elements of the composition. I have a fondness for photographing doors and windows and I find the neatly ordered effect of differing rectangular shapes with the borders of the image very pleasing.

Above *I used a 20mm lens on my Nikon and deliberately tilted the camera upwards to produce the distorted perspective in this shot of an avenue of trees. The mist has helped to simplify the image and to emphasise the shapes created by their trunks and branches*

Right *The old town of Arbois in the Jura was the location of this picture. It would have made a nice shot anyway, but the presence of the lady in the window was, I felt, a gift from the gods. I used a long-focus lens to frame the four windows quite tightly*

A LONGER VIEW

Interchangeable lenses give a photographer a wide range of options for the way in which images are composed. The most basic control which can be exercised when choosing a focal length of lens is its field of view.

A lens with a focal length longer than a standard lens (50mm with a 35mm camera and 80mm with a 6 × 6cm camera), produces a narrower field of view. This reduces the area of a scene included in the frame and enlarges the details within it. The degree of enlargement is equal to the increase in focal length; thus a lens of 150mm will enlarge the subject by a factor of three compared to a 50mm lens.

If you have a lens with significantly longer-than-standard focal length, a 200mm with a 35mm camera for instance, it opens up entirely new picture possibilities. It allows you to look for compositions created by details which are simply far too small or insignificant when seen with a standard-focal-length lens. This is particularly useful in landscape photography, when often it is simply not possible to obtain a larger image by moving closer with the camera.

In many ways acquiring a long-focus lens provides you with a new way of seeing pictures. Elements like patterns, textures, shapes and colours are revealed and emphasised by a long-focus lens. It helps to become aware of these possibilities by going out a few times on photographic trips taking only a long-focus lens with you.

A lens of this type opens up other possibilities too. With wildlife, for example, moving too close with a camera will simply frighten a subject away, and with sports photography you are limited by barriers and boundaries from getting closer.

There is another aspect of long-focus lenses which makes them a valuable creative tool: their effect upon the perspective of an image. Because long-focus lenses allow the use of more-distant viewpoints, objects at different distances within the frame are shown closer to their true proportions than when viewed close to.

In this way, quite striking juxtapositions can be created, especially with very-long-focus lenses like, say, 400mm with a 35mm camera. A distant building in a landscape shot, for example, will appear dwarfed by a mountain range behind it, or

Seen at a wine fair in the Dordogne this candid portrait was photographed with a 200mm lens on my Nikon. It allowed me to obtain a close-up image from a more distant viewpoint, which avoided distracting him, and also helped to throw the background details well out of focus

a setting sun can be shown as an apparently enormous disc behind a closer object like a tree.

In addition, by focusing attention upon distant objects, eliminating the closer elements of a scene and reducing the effects of depth and perspective, you can make images of a more graphic, and sometimes more abstract, quality.

A long-focus lens does need some special care in use, however. They have a shallow depth of field in comparison with a standard lens, and small apertures must be used if you want both near and distant details to be acceptably sharp. Indeed, with very-long-focus lenses, even at small apertures, details only a small distance in front and behind the point of focus will be recorded sharply.

Camera shake is also a major problem. A solid tripod should be considered obligatory and a cable release or delayed action used to eliminate the possibility of jarring the camera when the shutter is released. Likewise a mirror lock is invaluable with a SLR camera as it avoids the vibration caused by it flipping up.

I used a 300mm lens on my Mamiya 645 to isolate a small area of this autumnal scene in the Dordogne. Photographed in evening sunlight, the compression of perspective has helped to concentrate the colour and give the image more impact. I used a mirror lock and remote release to ensure there was no vibration and a polarising filter has helped to maximise the colour saturation

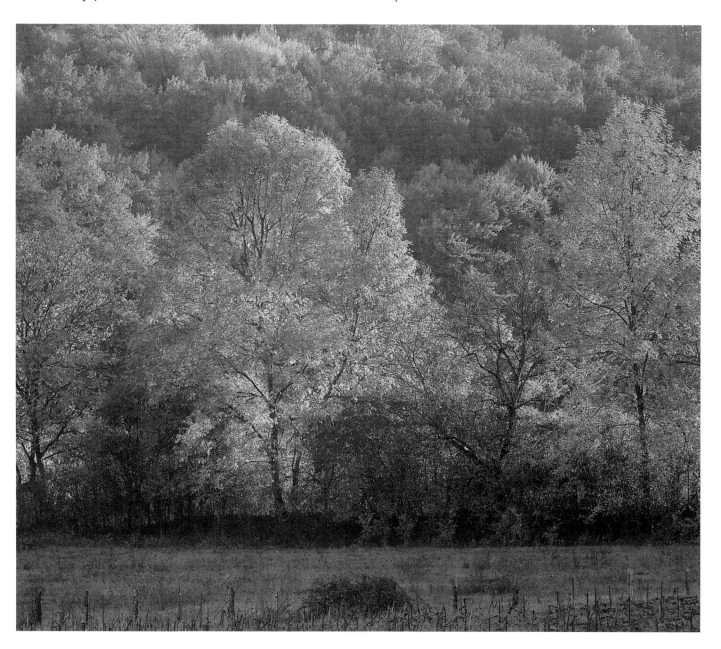

A WIDER VIEW

Just as a long-focus lens encourages new ways of seeing pictures, so too can a wide angle. A shorter focal length than a standard lens produces a wider field of view, includes more of a scene in the frame and reduces the size of objects within it. It is worth remembering when deciding what lens to buy that while the effect of a longer-focal-length lens may be obtained by enlarging the image and cropping, it is not possible to produce the effect of a short-focal-length lens any other way.

Although the more obvious uses of a wide-angle lens — for instance, photographing in a limited space — depend upon being able to get more into the frame they also have other useful qualities.

For example, changing the focal length of a lens allows you to control the perspective of an image. The impression of perspective depends upon the fact that objects of a similar size appear to become smaller the further they are away. Because a wide-angle lens permits you to include both very close and distant objects in the frame, it can have a quite marked effect on the perspective of an image. This in turn helps to establish a much stronger impression of depth and distance in a photograph, which can be especially useful in landscape photography.

The perspective effect can also form strong receding lines in the image — an avenue of trees for instance, or a street of houses — leading the eye to the main focus of interest. This can be used to create dynamic compositions and a sense of movement in a picture. The effect will become greater when the camera is moved closer still to foreground objects and when lenses of very short focal length are used.

Wide-angle lenses have effectively greater depth of field than a standard lens, but when both very close foreground objects and distant details are required to be sharp it is necessary to use the smallest possible apertures. The available depth

The exaggerated perspective and heightened sense of depth in this shot of the steps to the Château of St Aignan in the Loire have been created by the use of a 24mm lens

of field is most fully exploited by focusing at a point about one-third of the distance between the closest and furthest objects.

Wide-angle lenses also tend to enhance the effect of both high and low viewpoints and the converging verticals caused by tilting the camera upwards — when photographing tall buildings for instance. Perspective effects can be striking when created deliberately, but accidental distortions may look unattractive. A slight converging of verticals in a photograph of a building makes it look as if it is about to topple over, and when people are photographed with a wide-angle lens from too close a viewpoint their features and limbs can appear distorted.

It is also necessary to pay careful attention to composition when using a wide-angle lens, as the inclusion of wide areas of a subject and a wealth of detail can bring about confusing and muddled images. The choice of viewpoint is absolutely vital as is the way the image is framed since these decisions can help to eliminate unwanted detail and to pick out a boldly defined centre of interest.

For this shot of fishing boats on a beach in Sri Lanka I used a 24mm lens on my Nikon to exaggerate the effect of perspective and to enhance the impression of depth and distance. I used a small aperture to obtain sharp focus from the close foreground to infinity. A polarising filter has made the sea a stronger colour, and I used a neutral graduated filter to make the sky much darker and to increase the dramatic quality of the rather soft lighting

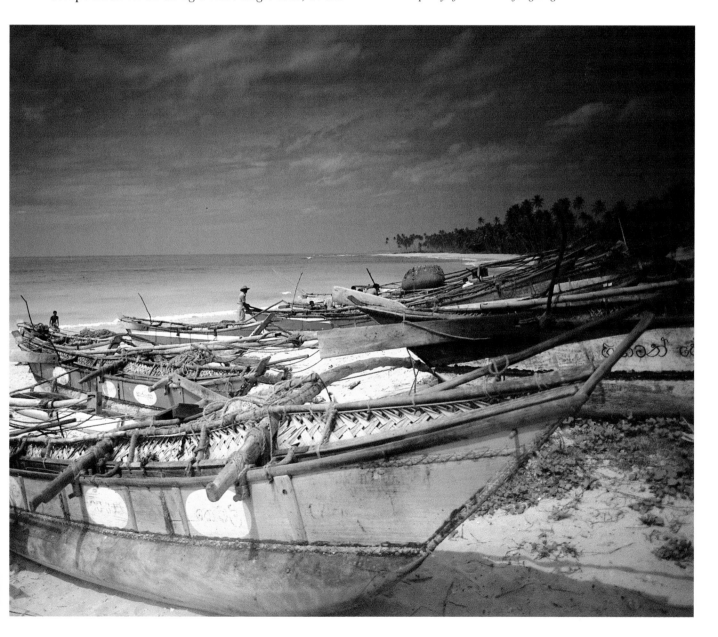

CREATIVE
COMPOSITION

Much is made of the art of composition in photography and there are well-defined rules for the way in which the perfect picture should be arranged. These rules, such as the main point of interest being placed at the meeting point of lines dividing the image into thirds, are based on sound principles and if followed will at least ensure that a photograph has a basic well-balanced appeal.

In practice, however, composition is no more and no less than arranging the elements of an image in a way which pleases you and creates the emphasis and effect you want. A personal style is, to a large extent, dependent upon you following your own instincts and not mindlessly adhering to a prescribed set of rules.

Above *Like the panoramic landscape, the use of a square format camera has dictated the choice of viewpoint and framing of this shot of a nude. Although it could be cropped to a different shape I feel that it would not be so pleasing and had I been using, say, a 35mm camera I would have chosen a quite different angle to fill the narrower frame*

Right *This photograph of the French hilltop village of Vezeley was taken while I was experimenting with the panoramic format of a 6 × 12cm camera. Although it would have been possible to have included both the rising sun and the village in a square or normal rectangular format it would have also meant including more foreground or sky than I would have wished. Of course, such a picture could just as easily been achieved by cropping but the use of a less-familiar format can help you to see some subjects in a different way*

Film format is a good example of the way in which the approach to composition must be tailored to personal preferences. For many years the 35mm format reigned supreme, and many find the two-to-three proportions of the 35mm frame the most pleasing. Some famous photographers, like Henri Cartier-Bresson for example, would not allow their images to be cropped — the full frame must be used. This is because the composition which creates the most pleasing balance within those proportions would not necessarily be right for a picture of a different shape.

There has been a recent vogue for the square format. In its early days it was considered to be a useful film size because it could be cropped in a variety of ways but was seldom used square. Lately, however, a number of landscape photographers, like Fay Godwin for instance, have composed within the square shape, using it in its entirety. An even more recent trend, indeed almost a craze, is to use the panoramic format of 6 × 17cm for creative landscape photography;

again, this requires an entirely different approach to image composition.

If you are taking photographs for a particular purpose, a magazine cover perhaps or a poster, the way the picture is composed may well be dependent upon making an allowance for a title or headline to be incorporated within the image. When shooting pictures for a book it is often necessary to think of ways in which a subject can be composed to fill a full page or a double-page spread, and sometimes shooting alternatives so that the designer has a choice.

When you are taking photographs purely for your own satisfaction you can choose the proportions of your picture and arrange the various elements of a scene within it in a way which creates the most telling effect. But you should remember that there is seldom only one way of doing this and the options are often far greater than you might think. You will take a big step towards developing a personal style in your photography if you constantly question the way in which you have framed your pictures.

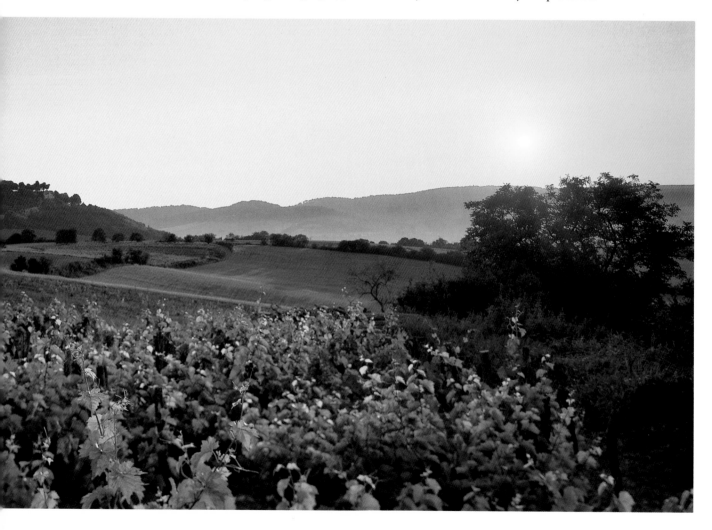

SIMPLICITY

If there is a single dominant feature to be found in photographs which catch the eye, win prizes and grace the covers of books and magazines it is that they are invariably quite simple. In the same way a common factor among unsuccessful photographs is that they often have too much going on, appear fussy and confusing and are seldom satisfying to look at.

'Keep it simple' is one of the most useful rules of thumb for a photographer to work by, but it is not always something which comes naturally. Often a simple picture needs to be carefully contrived.

One of the most basic ways in which a minimalist approach can be made to photography is to simply move closer with the camera. Standing too far back to take a photograph is perhaps the overwhelming fault which befalls most beginners, and there are numerous examples of pictures which could have been vastly improved by just taking a step or two closer to the subject.

A good example is the casual portrait in which the subject is shown full or three-quarter length. In most cases a close-up, head-and-shoulder shot will be far more telling. Unless it is well posed and relaxed and the background is interesting, a long shot of a person is seldom pleasing.

Even pictures which exclude part of the subject's head can sometimes be effective. You need to be careful, however, to avoid the exaggeration of perspective and the apparent distortion of features which can result from moving too close. In these cases it is better to use a long-focus lens instead of a very close viewpoint.

A long-focus lens also enables you to keep your pictures simple, since it allows you to isolate small areas of a scene and to exclude superfluous and confusing elements. This is an effective approach to landscape photography, where interesting aspects of a distant scene can be emphasised and used to create a powerful composition. With a very distant subject, moving to a closer viewpoint is often simply not possible.

The restrained use of tone and colour is also a valuable way of keeping an image simple. Areas of well-defined tones which create bold shapes and outlines add considerable impact to a black-and-white shot, while a mass of fine detail with poorly defined shapes within the image can be far less satisfying.

In colour a picture is sometimes much more striking if it contains only a limited range of colour rather than the full spectrum. A picture in which the main subject is predominantly one colour juxtaposed against a background of a contrasting or complementary hue, can create a far more telling image than one with a variety of discordant colours.

This minimalist picture was taken in the royal palace of Jaipur, a place noted for its spectacular doorways. The simplest of shapes and virtually monochromic image has, never-the-less, produced a quite striking image. I used a long-focus lens to frame the doorway tightly from a fairly distant viewpoint; this has helped to make the image as two-dimensional as possible

USING SHADOWS

Shadows are an inherent part of the structure of an image; they help to define the shapes of objects and to give them depth and solidity. They also help to create the range and subtlety of colours in a scene. In most cases, however, shadows are considered, and used, simply as an underlying and largely unnoticed part of a composition. They can, however, be used in a more dominant way so that the shadow itself becomes a part of the subject.

Shadows are very effective in marking out bold lines or patterns within the image. They can also introduce an element of mystery or atmosphere, for example when details are partially obscured by shadows. Lighting which throws up shadows is often used in film-making to heighten tension and enhance a sense of drama.

An interesting shadow can often be used effectively in a composition as a means of creating balance or adding interest to an otherwise plain, even-toned area. A tracery of shadows cast onto the foreground of a picture from the overhanging branches of a tree, for instance, helps to create a feeling of depth and distance in a shot in the same way that a foreground object might.

A shadow is created by directional light, and in outdoor photography this means direct, unobscured sunlight. Even a thin veil of cloud can reduce the density of shadows so that they

become almost imperceptible. The long shadows formed when the sun is quite low in the sky can be the most interesting. In landscape photography, for instance, the effect produced when the contours of the land or trees cast long skimming shadows can be very striking.

Shadows in the urban landscape also add much to the interest and effect of pictures, since the angular qualities and boldly defined shapes of artificial objects produce intriguing effects in strong sunlight.

Studio lighting of course offers the most control over shadows and a spotlight, or even an undiffused reflector light, can strengthen still life and portrait shots. Backlit still lifes with shadows streaming towards the camera are effective when objects with interesting shapes are used; and a pattern of shadows cast onto a set-up often lends a feeling of atmosphere or theatrical effect.

Shadows are also a good way of adding interest to the background of portrait or nude shots. An example is the effect of shadows cast from a venetian blind onto a plain toned or coloured background. Shapes and patterns can be cut from large sheets of black card and suspended just out of shot and a spotlight used to project the shadows onto the background. A slide projector may also be used in this way, both as a tightly focused light source and as a means of projecting a shadow in the form of a transparency.

Left *A market in Marrakesh created this almost abstract arrangement of shadows as the sunlight streamed through the roof blinds. I chose a viewpoint and framed the image to reduce the amount of detailless shadow and exposed to produce tone and colour in the lighter parts of the subject*

Below *It is the long shadow created by the low-angled sunlight of a winter's afternoon which made this picture worth shooting for me. I chose a viewpoint which formed an almost straight line of the post and its shadow, and framed the image so that it divided the picture into a pleasing proportion*

LINES
AND SHAPES

The ability to see a photograph is a skill that most people need to learn. This is because the normal way of seeing things focuses our attention on the object or person itself and not just upon its visual qualities. Consequently, our reaction tends to be very subjective.

Often what we see is influenced by many things other than the purely visual elements of a scene; even our mood can affect our perception of a subject. A camera sees things entirely objectively and when a photograph turns out to be quite different from the way we remembered it is simply because we did not see the subject in the same dispassionate way as the camera.

A photographer's eye needs to be very cold and analytical — just like a camera lens. The first step in developing a critical approach is to look at a potential subject in terms of shapes and lines. If you take a good photograph, one of your own or from a book or magazine, and trace the main lines and shapes onto a piece of thin paper the resulting sketch will invariably have a pleasing and balanced quality in its own right. Learning to trace these lines in your mind while viewing a scene you are about to photograph will be a major step to taking better photographs.

If you imagine, say, a landscape picture where all the main lines are parallel, running horizontally across the frame — as they tend to do in landscapes — the result is likely to be a rather static image. If there is variation in the direction of the lines, if they curve, converge or if other lines bisect the horizontal lines then the image will have more excitement and movement. One of the reasons why trees are often such important elements in landscape photographs is because they form bold vertical lines in contrast to the rest of the image.

Lines can also be created by lighting. In sunlight both shadows and highlights can mask the natural lines of a subject and impose their own structure on an image. The effect of perspective can also make lines a more dominant feature of an image. When a wide-angle lens, for example, allows you to include both close foreground objects and distant details strong diagonal lines are often created, producing a dynamic visual quality in an image.

Strong shapes can have an equally striking effect in an image; repetitive shapes giving the impression of pattern for example, or an interestingly shaped object like a tree silhouetted boldly against the sky. There is no doubt that objects which have well-defined geometric shapes, like circles and triangles, bring a quite compelling quality to a photograph.

Shapes may also be formed by the positions of objects within the frame. Still-life arrangements, for instance, are often designed so that the objects within the frame make the shape of say a pyramid or an elipse.

Once you begin to be aware of the presence of shapes and lines within a subject then other factors, like choosing the best viewpoint and how to frame the image, become easier to see and your photographs will have a more balanced and harmonious quality.

Above *One of the many thousands of the Maldive islands, shot from a fishing boat in the Indian Ocean. This is a simple image of bisecting lines and shapes. The viewpoint was quite critical to obtain the most pleasing composition and I used a polarising filter to make the sea a dark, rich blue*

Below *In a quite different way this candid shot also relies upon the juxtaposition of shapes and lines for its appeal. The light-toned background of sea has helped by creating a semi-silhouetted effect*

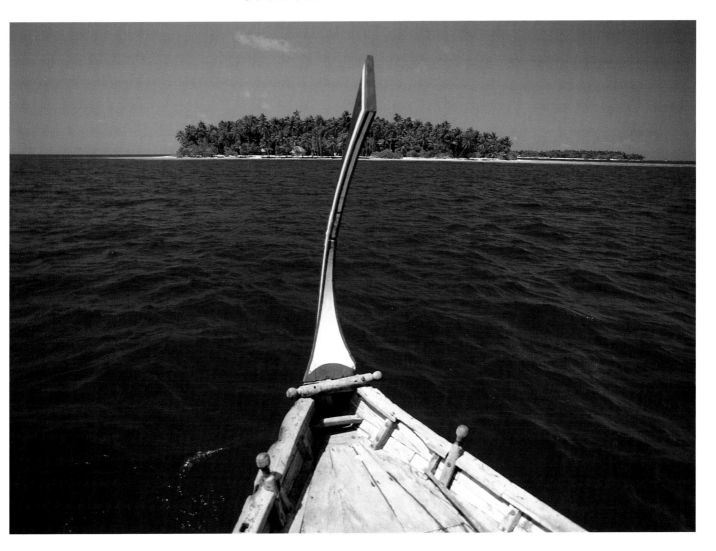

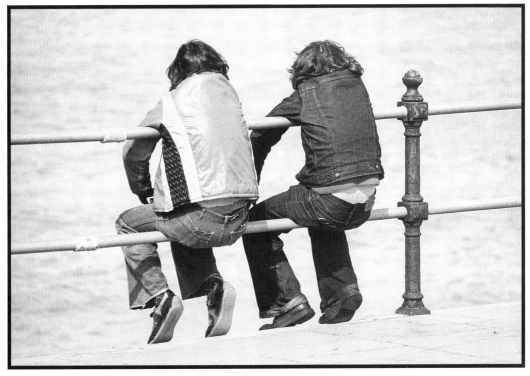

ABSTRACT IMAGES

The majority of photographs are inspired by, or based upon, a specific subject like a view or a person. To a large extent such pictures are appealing because the subject itself is interesting, as well as the way in which it is photographed. However, when the aim is purely to produce a striking photographic image the subject itself can become far less important.

This approach to photography also helps to focus attention on the visual qualities of the medium itself and encourages a new way of looking at things. In such pictures it is only the visual elements of an image which are significant — shapes, lines, patterns, textures and colours — and the ways in which they can be combined to produce an interesting photograph. The objects and details which create these visual qualities need not necessarily be of much interest in themselves; indeed sometimes the effect is greater if they are not even identifiable.

Abstract pictures also have the advantage that they are not dependent upon 'photogenic' things for a potential subject. Even intrinsically ugly objects and scenes can result in appealing pictures when seen in a highly selective way.

Many years ago I saw in a magazine a stunning set of pictures which were shot in a car-breaker's yard. The large-format transparencies had transformed rusting metal hulks into truly beautiful images of rich colour and texture. Had the medium used been oils or acrylic paints instead of photographic dyes the pictures might well have been acclaimed as great modern art. There can be considerable satisfaction in producing a powerful photograph from a subject which normally wouldn't warrant a second glance.

Sometimes when I want to try out a new piece of equipment or film I visit a builder's yard near my home. It is piled high with bricks, tiles, sewage pipes, corrugated-iron sheets and so on. I really enjoy wandering around looking for ways to use these items to produce an interesting image.

The approach to this type of picture is to use a combination of viewpoint, framing and lighting to isolate selected details from the scene and to present them in a way that focuses the attention on the visual elements and, to a degree, disguises the objects being photographed. A long-focus lens is often useful because it allows tight framing from a more distant viewpoint and this can often show the subject in an unfamiliar way. Even quite commonplace things become hard to identify when seen from an unaccustomed angle.

A wide-angle lens also has advantages because, used from a very close viewpoint, it creates unfamiliar perspectives and apparent distortions, making the image more ambiguous.

A sheet of rusting corrugated iron in a junk yard was used to produce this abstrct image. I photographed a small section quite close-up with a long-focus lens to create the most pleasing balance of colours and shapes and to make the image as ambiguous as possible

HORIZONS

In landscape photography in particular, one of the most significant elements of the composition is the division between land and sky. Inexperienced photographers often use the camera viewfinder rather like a gunsight, simply as an aid to aiming the camera. Because of this a high proportion of pictures have the horizon running through the exact centre of the frame. This is seldom desirable as it invariably creates a very divided and unbalanced image.

The 'golden rules' of composition state that the horizon line should bisect the image into a proportion of one- and two-thirds. Like most rules it is based on sound principles, and while there are many instances where it can and should be broken, it's a good starting point. I find, when shooting landscapes, that I spend more time deciding where to place the horizon than on other aspects of the composition, often making quite small adjustments until I feel happy with it. Remember too that a sloping horizon looks very noticeable and disturbing in a photograph.

In the majority of landscape pictures the dominant interest usually occurs in the foreground, the lower portion of the picture. In these cases the best place for the horizon is along the top third of the frame. However, the nature of the horizon line also ought to be considered. If it is broken by interesting shapes like trees, a dominant cloud or a building for example, the horizon may need to be lowered a little to avoid cropping into these details.

In a similar way, if the foreground contains important details the camera may need to be tilted down, raising the horizon, to include more of them in the frame. In such situations, and particularly with upright shots, the horizon can sometimes be pushed up almost to the top of the frame so that the emphasis is firmly on the immediate foreground. This technique works especially well when wide-angle lenses are used and the perspective effect is exaggerated.

There are occasions when the horizon is best placed very close to the base of the image. A dramatic sky, like a sunset or one with brooding stormy clouds for instance, can look very striking when it almost fills the frame. However, this device works best when the horizon has some interest, such as roof tops or distant mountains. It is also effective when a bold upright shape, a tree or a pylon perhaps, almost fills the frame vertically.

No horizon at all can be a solution to those days when the sky is a blank featureless tone or colour. On dull days, eliminating the sky has the effect of increasing contrast within the foreground details. A landscape without sky can be very striking, but the image needs to have a strong sense of design with bold shapes, textures and colours.

A centrally placed horizon can be the best solution if there is an element of symmetry in the image, when the interest within the sky and foreground area is fairly equally matched. An example of this is when trees and sky are reflected in water, or when there are colours or shapes in sky and land that balance each other.

Since it was the tree and sky which appealed to me in this wintery shot of the North York Moors the choice of a low horizon seemed natural. I used a neutral graduated filter to make the sky a darker tone at the top of the frame

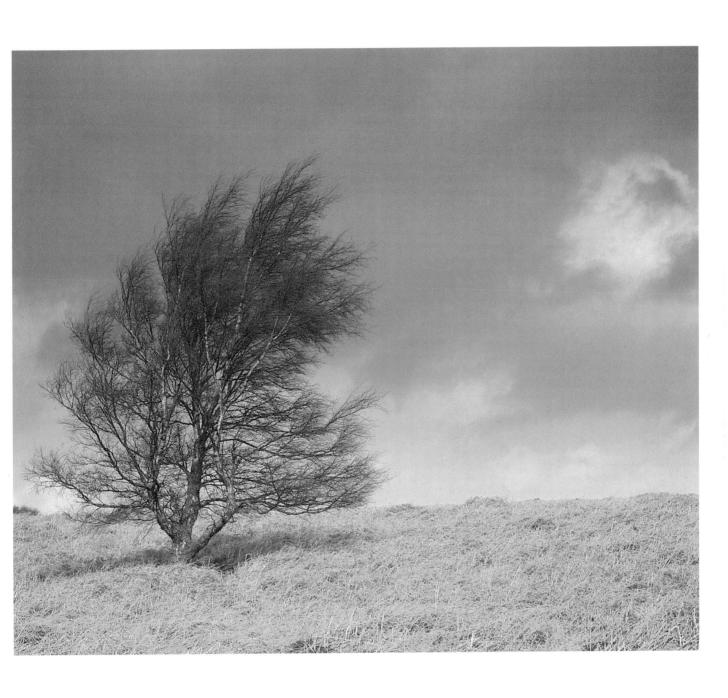

NATURAL CLOSE-UPS

The quest for bold and striking images is made more difficult because the usual photographic subjects tend to be rather too familiar. One simple and convenient way of discovering images with a fresh and original appeal is to look more closely at common objects. Close-up photography is a fascinating aspect of the medium and good subject matter for such pictures is seldom

hard to find. Natural forms in particular have a wealth of visual interest which can be used to create strong images.

The SLR camera is an ideal instrument for close-up photography because, with the aid of accessories like extension tubes, bellows units and macro-focusing lenses, it can be focused accurately on objects just a few inches away. More simple cameras can also be used with the help of supplementary lenses.

A tripod is a vital accessory for close-up work because it allows the image to be framed and focused more accurately; it also eliminates the risk of camera shake (which is accentuated when the subject is very close to the camera) and enables the use of slow shutter speeds and small apertures. Depth of field becomes very shallow at close-focusing distances, and it is necessary to stop the lens down to the smallest apertures to ensure the image is sharp throughout.

A walk through a wood or park will reveal many potential subjects. Apart from the more obvious, colourful subjects such as flowers there are things like funghi, fir cones, leaves, berries, tree bark and so on. Further afield, on a beach for example, you will find possibilities among sea shells, rocks, seaweed and pebbles. Look for objects which have interesting shapes and textures as well as colours. Many natural forms have inherent patterns which can be used very effectively in a composition.

In some cases it is best to photograph such subjects *in situ* in order to include part of the surroundings. With very-close-up pictures only the object itself will be shown, and it is often easier to collect photogenic items and take them home where they can be set up more conveniently on a table.

It is sometimes effective to use more than one item in a shot, juxtaposing different shapes, textures and colours like a miniature still life. Lighting too can be easier to control under these conditions. Daylight is ideal, and you can use small pieces of white card and hand mirrors to control the contrast, add light to the shadows and introduce additional highlights.

I shot this semi-abstract picture of the trunk of a silver-birch tree from only a foot or so away using an extension tube with the camera on a tripod. The ability to select a very small portion of a subject in this way allows a wide degree of control over the composition of an image

FOREGROUNDS

A photograph is only a two-dimensional image but it can give a convincing impression of three dimensions. One factor which is important in creating a feeling of depth within an image is the presence of distinctly separated planes. Very often, however, photographs have a limited recession of planes with the main subject being the nearest object to the camera. The inclusion of foreground details can make an enormous difference to the feeling of depth and distance in a picture, as well as adding interest and providing a powerful additional element of composition.

This technique can be exploited especially well in landscape pictures, since without foreground interest such images can easily have little sense of depth. When you see a potential picture it is a good idea to look behind you as well as ahead. The possibility of foreground interest is often overlooked and by stepping back it may be possible to include details close to the camera. Flowers, foliage, a fence, a gateway or a pile of logs, for example, can add that extra dimension to the picture. Sometimes a very low camera viewpoint allows you to include details close to the ground, like stones or fronds of grass.

Foreground interest can also enhance the impression of height. When shooting from a high viewpoint, the image will be much more dramatic if it includes something close to the camera, like a parapet or wall for example.

A wide-angle lens further emphasises the effect of depth and distance by allowing both very close and distant objects to be included in the frame. This has the effect of exaggerating the perspective and making distant objects seem smaller in relation to the foreground details. For pictures like this it is necessary to use small apertures if you want the image to be sharp throughout, since even with a wide-angle lens the depth of field will not be adequate at wider apertures.

It's not always necessary for the foreground details to be sharp. Sometimes, the use of differential focusing with a wide aperture establishes a soft screen of foreground interest with distant, sharply focused details shown in bold relief. The use of a long-focus lens will exaggerate the effect. Subjects like portraits and still lives can often be enhanced by the inclusion of soft foreground details.

On dull days and when the light is soft, as at dusk for instance, foreground interest helps to increase the contrast of the image. The impression of depth will also be heightened because the softer, and perhaps slightly hazy, details in the distance help to create a stronger impression of receding planes.

Shot at oyster fisheries in North West France this quite bleak landscape needed, I felt, the added interest of the bold foreground provided by the boat and landing stage. I used a wide-angle lens to take full advantage of the foreground and to exaggerate the perspective and feeling of depth. I fitted a polarising filter to make the sky a darker tone

DESIGNER PHOTOGRAPHS

There are many different approaches to photography and as many motives for taking them, from simple snapshots of family and friends to fine-art photographs and straightforward records of places and things. In each of these approaches there is usually a dominant feature which the photographer wishes to emphasise.

In the case of a portrait of a friend, for example, the main criterion is to capture an expression or gesture which reflects the character of the subject. With a reportage or documentary photograph the most important aim is to record a significant and truthful aspect of the subject, while with a fine-art photograph it is the quality and subtlety of the finished print which is the over-riding consideration.

Designer photographs are those in which the subject, form and even meaning of the picture are subservient to the purely graphic quality of the image. Such an approach to photography is not always appropriate, but it helps to develop a strong sense of colour and composition and can produce some stunning pictures.

This type of photograph is most readily created with still-life subjects, since each element of the image can be selected and positioned precisely within the frame. Objects with simple shapes and bold colours work best, against plain backgrounds and uncluttered settings which serve to emphasise the graphic quality of the arrangement.

Choose items with contrasting or complementary shapes and colours and look for ways in which they can be placed to make the most effective juxtapositions. Good ideas may be obtained by looking through some of the ads in the glossy magazines. Not that you should follow them slavishly, but you can often adapt the basic design of a shot to suit quite different objects.

It is often undesirable to accentuate the form of objects in such pictures, since they tend to be most effective when they have a two-dimensional quality. For this reason, a quite soft, flat lighting is usually preferable. The effects of perspective can be minimised by using long-focus lenses and more-distant viewpoints.

Photographs with a strong sense of design can be produced equally effectively outdoors — landscapes spring to mind — but it does need a very selective eye to organise the chaos of natural forms into the order upon which such pictures rely. Here too long-focus lenses and distant viewpoints help to create a more graphic, two-dimensional quality and will also allow you to isolate small details of a subject.

In the urban environment, designer photographs are easier to find. Juxtapositions of signs and the bold graphic shapes created by buildings, windows and doorways, for instance, often produce effective images. Looking for the design element in what appear to be random and chaotic subjects is an excellent way of developing a good eye for a picture.

This simple still-life arrangement was set up solely to create a pleasing composition of shapes and tones. Shot outdoors, diffused daylight has created a good range of tones and I used a piece of an old door found in a junk yard as a background

I was attracted to this picture because the subject itself was so uninteresting and yet the design it created had, I felt, a curious appeal. The flat grey sky and sea have given the image more interest and it is subtler than the more obvious effect which a blue sea and sky would have created. To keep the image as simple as possible I chose a viewpoint which made the rail coincide with the horizon line

PART FIVE

LIGHT AND COLOUR

BOLD COLOUR

Colour photographs which have an immediate impact are few and far between in relation to the vast numbers of colour pictures taken every day. One reason is that many such photographs are taken without enough thought, in the belief that if the subject is colourful and there is colour film in the camera, a good colour photograph will automatically result.

In practice, colourful scenes which attract this sort of response are almost guaranteed to end in a meaningless jumble of colour unless considerable care is taken. The most striking colour photographs tend to be those in which colour is used selectively and sparingly.

This does not mean that the colour cannot be bright and bold; rather it is that the variety and range of colour in an image should be restricted. Mixing different colours indiscriminately lessens the impact of each. Look for pictures which have a single predominant colour so that when the photograph is viewed the instant impression is of, say, green, red or blue. You could set yourself an assignment in which the aim is to take a series of pictures each one representing a different hue.

The area of dominant colour does not necessarily have to be large in the frame. Often the impact is heightened when a small area of intense colour is juxtaposed with an overall neutral tone or contrasting hue, like a red-sailed yacht on a deep-blue sea for instance.

Lighting has a marked effect on the colour quality. Although a bright sunny day may appear to bring colour to life in a scene, it is a softer light, such as an overcast day or open shade, which enhances strong vibrant colours. Hard directional light, like sunlight, creates deep shadows and highlights which, in effect, dilute and degrade the hues in a subject.

Exposure too is an important factor in creating bold saturated colours. Overexposure reduces saturation significantly; even half a stop with transparency film causes a noticeable weakening of the hues. A degree of underexposure, on the other hand, is often desirable, especially if the lighting is quite soft and there is an absence of deep shadows.

A polarising filter is a most effective accessory in helping to create bold colours, especially in outdoor photography. It is neutral-grey in tone, having no effect on the overall colour quality of the image. By rotating the filter in its mount you will eliminate much of the light reflected from non-metallic surfaces and make colours richer and more intense. It has a marked effect on things like blue sky, sea and foliage and even on dull days it can make the colours in an image significantly stronger.

Right *The remarkable reds of Fuji's Velvia film contributed to the quality of this shot of strawberries. I used the soft light of open shade on a sunny day to obtain the maximum colour saturation*

Left *Although the area of colour is much smaller in this shot of London's Lloyd's building it still has a quite striking effect because it is contrasted against a neutral background. I used a long-focus lens in order to frame the image area precisely from a fairly distant viewpoint*

INTO THE LIGHT

The way in which a subject is lit is invariably a crucial element of a photograph. It is possible to travel through the most exciting landscape or visit the most picturesque places and simply not see a picture if the light is uninteresting. In the same way, on days when the light is beautiful or atmospheric, it is possible to see a good picture almost everywhere.

What determines a good light is not always entirely straightforward. A dull cloudy day sometimes makes for moody and dramatic images, while a bright, sunny summer's day with a blue sky may seem perfect but it can often result in bland and uninteresting pictures.

When shooting outdoors you have only a limited degree of control over lighting effects, and you are largely at the mercy of the weather. In sunlight, however, the choice of viewpoint and the position of the subject have a significant effect on the quality of the light, and interesting photographs are often caught by shooting into the light.

Portraits can be particularly pleasing when photographed in this way, as the facial lighting is quite soft and flattering and the backlighting throws a pleasing halo of light around the subject's outline. This lighting also helps to ensure a good separation between subject and background. Be careful that the backlighting does not spill onto the face in a way which creates unpleasant highlights. It usually works best in this type of photograph when the sun is fairly low in the sky.

Exposure needs to be judged carefully, as a normal averaging reading taken from a backlit subject tends to indicate underexposure. It is best to take a close-up reading from the subject's face, excluding bright highlights from the area being measured. Backlit portraits sometimes result in excessive contrast, and it may be necessary to use a reflector or fill-in flash to reduce the brightness range of the subject.

Backlit landscapes can also be striking, since such lighting helps to reduce detail, simplifies the image and creates bold masses of tone emphasising shapes and textures. Early-morning and evening shots are especially effective. In colour the added warmth of light when the sun is low in the sky adds atmosphere, which can be further heightened if mist is present.

When sky is included in a backlit landscape it can help to use a neutral graduated filter to retain some tone. A degree of underexposure often adds to the effect of shots like this, but it is advisable to bracket exposures when shooting on colour-transparency film.

It is necessary to avoid light falling directly onto the camera lens when shooting into the light as this will cause flare. A deep lens hood is helpful, as is a compendium. It is often possible to hide the camera within natural shade.

I have made a useful accessory for backlit shots: a piece of coathanger wire about 25cm long with a small bulldog clip fixed to each end. One clip holds the wire to the camera body and the other supports a small piece of black card. The wire is simply bent until the card shades the lens most effectively without obscuring it.

This picture of a young Balinese girl was taken quite quickly and spontaneously without the opportunity to consider the lighting to any great extent. In fact, the backlighting has contributed a great deal to the shot creating some nice highlights on the hair and a light-toned background contrasting against her dark skin

CONTROLLING COLOUR

One of the reasons why black-and-white photography is so appealing to those who want to produce more creative and expressive work, is that it offers such a wide range of control over the tonal range and quality of the image. Colour materials have much less flexibility in this respect, and the automated processing and production of colour transparencies and prints means that the ways in which the colour quality of an image can be controlled at the time of exposure is far more important than with black and white.

This is particularly true when shooting colour transparencies, because even the limited degree of control which is possible when making prints from colour negatives is not available, and the effect required must be created before the shutter is fired. However, it is possible to influence the colour quality of an image far more than might be imagined and the blandness of a straightforwardly exposed transparency can be transformed into a rich satisfying image by the use of quite simple techniques.

Exposure is critical with colour-transparency films and can have a marked effect on the saturation of colours. A degree of underexposure will increase colour saturation while overexposure will reduce it. I like to bracket my exposures in quarter-of-a-stop increments and even this small amount can have a significant effect on subtle hues. For many of the photographs I take I like to have rich well-saturated colours and I tend

Right *This autumnal mountainscape was photographed in the French Pyrenees. I used a polarising filter to make the sky a richer blue and to increase the colour saturation of the foliage. I also used an 81C filter to further increase the strength of the reds and gave half a stop less exposure than indicated*

Below *In this shot of Pen y Ghent in Yorkshire I used a neutral graduated filter to retain the soft colour in the sky. I also made a bracket of exposures in quarter-of-a-stop increments and chose the transparency where the sky was as dark as possible but some detail remained in the foreground*

to select the densest transparency from the bracket which still shows adequate shadow detail. In pictorial terms a correct exposure is simply the exposure which creates the effect you want.

Colour saturation can also be increased by using a polarising filter. Contrary to popular belief they are not only useful for making blue skies richer on a sunny day. They can also have a dramatic effect on the colours of foliage, grass, water and indeed any reflective non-metallic surface, even on dull days.

The effectiveness of a polarising filter depends, however, upon the relative angles of the light, the subject and the camera. In some situations a polariser will have little or no effect on a blue sky, and it is necessary to use a neutral graduated filter to obtain a deeper colour. This filter will also improve the colour saturation of sunsets.

A graduated filter need not only be used for increasing colour saturation in the sky area; turned upside down it can be equally useful for giving foregrounds — like grass or blue sea — a deeper colour. When shooting into the light with a blue sky and white clouds I often use both a polariser and a neutral graduated to retain more colour and detail in an area which would otherwise be almost bleached out.

Some photographers shun the use of graduated filters and I would agree in the case of the coloured versions which can easily appear garish and unnatural. However, I see no difference between using a neutral graduate to make selective areas of a colour transparency darker and using shading techniques to improve the image quality when making a black-and-white print.

In some circumstances a polarising filter can make the image appear cooler, or slightly more blue, overall. This is partly due to the greater intensity of blue skies and to the reduction of highlights and I use an 81C filter in combination with the polariser to overcome this.

With landscape photographs in particular I often use a warm filter to improve the colour quality: an 81B or 81C when shooting on dull days, and in summer sunshine when the sun is high in the sky. Seascapes and mountain scenes are especially prone to a blue cast because of the high proportion of ultra-violet light. Even a slight blue cast can make colours appear degraded. As a general rule, a warm colour cast is less noticeable and preferable to a bluish cast. Don't overdo the use of warm filters when shooting portraits as excessively warm skin tones can look unattractive.

Sometimes a colour-correction filter can be used to intensify one particular colour in a scene. When photographing a woodland scene with autumn colours, for example, a pale-red filter like

A polarising filter was also very effective in this shot of Hawk's Nest Bay on the US Virgin Island of St John. It has made the sea a much richer and more translucent colour. Again, I gave half a stop less exposure than indicated

a CC10R could give the foliage an added degree of saturation without having a noticeable effect on the other colours in the image. When shooting at dusk or dawn, when the light has a bluish or slight purple bias, I sometimes use a pale-blue filter to make the inherent colour cast a little more pronounced.

When using studio lighting you can use colour gels over the light source to alter the colour quality of the image. A blue filter placed over a light used to illuminate a blue background, for example, can give it an added intensity. Try different coloured gels over two or more lights to produce more dramatic and theatrical effects.

Making colours less saturated by over-exposing is more difficult because most films have less tolerance to overexposure than to underexposure. There will be a noticeable loss of highlight detail if you overexpose by more than about half a stop, unless the subject has low contrast, like a misty landscape, for example, or a high-key portrait. In some cases, a pastel filter can be used to reduce contrast and colour saturation effectively when combined with a degree of overexposure. Fast films tend to have an inherently lower contrast and colour saturation than slow fine-grained films. This can be further reduced by under-rating the film by up to one stop and asking for the film to be 'pulled' during processing to compensate.

AVAILABLE LIGHT

A flash gun is often considered the automatic choice in situations which are lit predominantly by ordinary artificial light. However, a flash gun has the disadvantage that, in providing its own relatively powerful lighting, the ambient lighting of the scene is often completely submerged. This results in a loss of atmosphere and a transformation in the appearance of a subject. Restaurants or domestic rooms, for instance, are often almost unrecognisable when flooded with flash light.

In addition, there are many subjects — like street scenes at night, concerts and large interiors — which simply cannot be lit by flash because they are too far away or cover too wide an area. It is then necessary to make use of the available light.

When shooting colour it is possible in theory to make corrections for the difference in colour balance between artificial lighting and that for which the film is balanced. In practice, however, it is not entirely straightforward.

There can be an enormous difference in the colour temperature of the various types of light sources, ranging from the green-blue bias of fluorescent lighting to the orange tint of some street lighting and the yellow glow of tungsten-filament lamps. To complicate matters there is often a mixture of light sources in a given scene.

If you are concerned with obtaining as true a colour as possible it is safest to shoot on colour-negative film so that corrections can be made by filtering at the printing stage.

For pictorial purposes the atmosphere of a shot is usually enhanced by the colour shifts created by different light sources and this will frequently add to the quality and effect of a picture. Stage lighting, for example, contains such a mixture of filtered colours that it is often best to use daylight-type film although the light sources themselves are usually tungsten or halogen.

The greatest problem with available-light photography is generally excessive contrast. Pools of concentrated light and areas of dense shadow can create unattractively harsh images, known in black-and-white photography as 'soot and whitewash'. You may find it easier to judge the contrast of a subject by viewing it through half-closed eyes.

The easiest way to avoid high contrast is in the way the image is framed. Choose a viewpoint and angle which allows you to include the minimum amount of shadow area and to exclude the brightest highlights, such as the light sources themselves.

Exposure must also be carefully considered. Take care to ensure that light sources do not affect the exposure reading as this will cause underexposure. A safe method is to take an average of readings made from both the lightest and darkest areas of the subject.

In some situations, like street scenes and illuminated buildings for instance, the contrast can be reduced by shooting before it is completely dark. With subjects fairly close to the camera the contrast can be reduced by using a small amount of flash to lighten the shadow areas in a similar way to the fill-in flash technique described on pages 136.

This night-time shot of one of Tokyo's shopping streets contains a wide variety of light sources with the green bias of fluorescent tubes dominating the foreground. I used a long-focus lens to frame the image tightly and to eliminate dark undetailed areas

FREE-FORM PHOTOGRAPHY

In most circumstances a photograph represents a specific subject, something which exists independently of the photograph you take. It can be highly interesting and challenging to make images from very transient, abstract things such as shadows and highlights, and fleeting colours and forms – in fact, painting with light.

One way of doing this is to use a variety of translucent objects and reflective surfaces to form abstract patterns of light and colour. A simple example is the effect created when sunlight filters through, say, a wine glass on a café table.

You can use either daylight or artificial light, or indeed a mixture of the two. Virtually any light source can be used in this way: a torch, slide projector or desk light for instance. The varying colour qualities add to the effect. A magnifying glass or glass sphere can be used to focus a light source, and small hand mirrors can be positioned to form several beams of light from a single lamp. Paper may be curled into shapes to throw soft-edged shadows and to make subtle gradations. Colour can be introduced selectively into the image by placing coloured gels in front of the light source, and pieces of coloured card can create subtle tinted reflections, while translucent objects can be painted with transparent dyes.

The surface upon which your images are projected can be plain white paper, either laid flat or rolled into a curve, or something textured like corrugated card for example. You could also use a 'real' object in the composition to provide a focus of interest. The ambiguity of images like these can be heightened by the use of differential focusing or very selective focus with shallow depth of field. A completely out-of-focus image could make the results even more abstract.

The images so produced will tend to be small, so close-up equipment such as extension tubes or a macro-focusing lens will be an advantage. A tripod will also be necessary to allow the use of small apertures for greater depth of field and to enable slow shutter speeds to be used.

Another way of making abstract images is to use smoke. Smoke curling upwards from, say, a lighted cigarette when backlit against a black background can create some amazing shapes. If coloured gels are added to the light source and multiple exposures are made, varying the colour each time, a wide range of effects can be achieved.

A further variation is to shoot a coloured image in this way on transparency film but to process it as a negative. The resulting transparency will have the colours reversed but shown against a white background. Two or more of these images could then be used as slide sandwiches in the method described on page 182.

Coloured dyes in water can also be used in a similar way to produce abstract swirls of colour. A fish tank filled with clear water is the main piece of equipment required and a means of diffusing the lighting. A piece of tracing paper taped over the back of the tank is ideal. Daylight could be used by placing the tank against a brightly lit window, or it could of course be lit by artificial lighting equipment.

All that is needed is to drip small quantities of the dyes into the tank and to let them slowly descend and mingle with the water. Do not use too much dye as the colour can quickly become

Two small mirrors, a lens, a prism and a variety of coloured filters were used to project this abstract light pattern onto a piece of folded white paper from a desk lamp and the light from a window. The resulting image was quite small in area and I used an extension tube to take a close-up shot

too dense, especially when several different hues mix together. Long exposures of several seconds or more add a further interesting element and you could also experiment by moving the water gently, perhaps by adding an effervescent tablet for instance.

If you use the technique of processing transparency film as a negative you will obtain reversed colours against a black background. Images of this type can often be combined very effectively with other less abstract ones using the multiple-exposure techniques and projected images described on pages 24–5 and 32–4.

It is even possible to create abstract images without the use of a camera. You can make negatives and transparencies by mixing dyes and pigments onto a glass-slide cover. You will need a selection of coloured transparent dyes: the types used for hand tinting and watercolour inks are ideal. Also required is a selection of small quantities of detergent, transparent glue, household bleach, a palette for mixing and eye droppers. A light box and magnifier will also make the process easier to judge and control.

The images can be created directly onto the glass-slide cover by letting minute quantities of the dyes and chemicals drip and mingle onto its surface. The detergent and bleach will cause the colours to form interesting swirls and textures. Transferring the dyes from one glass slide to another, by pressing them carefully together, can also add a further element of texture and shape.

You should judge the density and depth of tone and colour as if it were a conventional negative since ultimately you can print the slide in the normal way. The resulting image may be printed as a transparency onto Cibachrome or a similar material, or as a negative onto an appropriate colour paper. Slides like these can also be used to make effective black-and-white prints, as part of a slide sandwich or for the back-projection technique described on page 32.

A fish tank, a diffused light source and a selection of coloured dyes were the only ingredients for this abstract image. I set the tank of water in front of a diffusion screen lit from behind by a flash head. With the camera set and focused on a predetermined plane, I dripped small quantities of dyes into the tank using an eye-dropper, watching and waiting until the colours and shapes created a pleasing effect

LOW-LIGHT PHOTOGRAPHY

Many photographers only consider taking their cameras out on bright days when the sun is shining. Such conditions, however, all too often result in bland and uninteresting photographs. If you look at the pages of good magazines and books you will see that a high percentage of the more striking photographs are taken when the light level is very low, in what might at first be considered poor conditions for photography. Images produced in low light are frequently more atmospheric and mysterious, and the tones and colours which are created tend to be more unusual and interesting.

When shooting landscapes I often like to wait until dusk or to go out before the sun has risen. Even on dull cloudy days, pictures taken at this time can have a very pleasing quality. Exposure times will of course be very different to those used in normal daytime photography; I will often use exposures of 30 seconds or more. For this reason a tripod and cable release are essential items of equipment.

It's usually necessary to take care over exposure readings in such conditions because the sky tends to be much brighter than the landscape and it is easy to underexpose the image. It's best to aim the camera down while taking the reading to minimise the amount of sky included. For the same reason, it is also often desirable to use a neutral graduated filter to retain detail and colour in the sky.

If you find that your exposure meter is not sensitive enough to give a reading in very-low-light conditions a useful trick is to set the film speed to a much higher setting than the film you are using, say ISO 1000 instead of ISO 100, and then simply multiply the exposure indicated by ten. In this way a reading of, say, half a second would indicate a five-second exposure. Don't forget however to return the film-speed setting to its correct position after you have taken the shot.

Longer exposures are only feasible if the subject is static. With a moving subject you will have to consider using a faster film, as in reportage photography for example, when photographing people in dimly lit interiors or in city streets at night. Here film speeds of ISO 1000 or more might be necessary as well as the use of wide-aperture lenses.

Remember too that professional laboratories can push-process transparency film, up-rating the ISO number by two stops or more. There will be a considerable increase in grain when using such films, and from the push-processing, but this can often add atmosphere to reportage pictures and give the images a more documentary quality.

Above *I took this photograph of Tokyo's famous Ginza Street just before it became really dark; some light remained in the sky to show the outline of the buildings*

Below *Two ordinary light bulbs were the sole source of illumination in this shot of a cellar full of Armagnac. Since it was an entirely static subject and the camera was mounted on a tripod it was possible to stop the lens down for good depth of field and give a ten-second exposure*

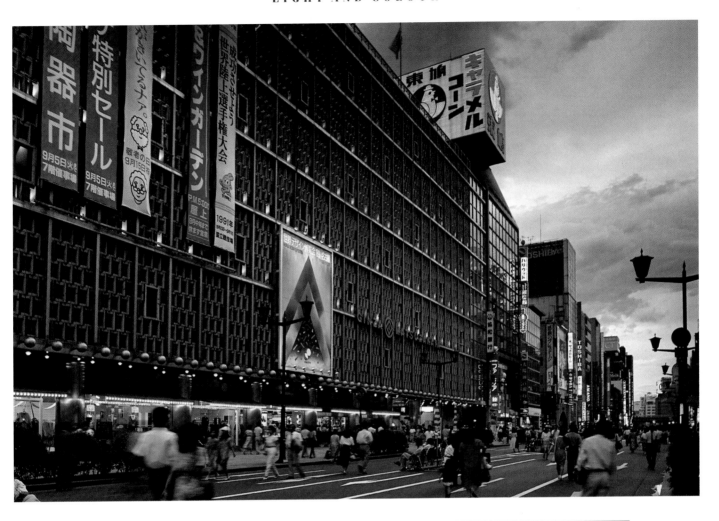

WINDOW-LIGHT PHOTOGRAPHY

Portraits and still lifes are generally considered to be subjects more suitable for studio photography under artificial lighting, but such photographs can also be lit very effectively indoors using the light from a window. Indeed, in professional studios, lighting set-ups are often designed to simulate the effect of window light.

The first requirement is of course a room which has enough space and is lit by at least one good-sized window. Ideally it would be north-facing since it will then have a more constant quality and will not be subjected to direct sunlight. However, any window will do as diffusers can be used to control the quality and to soften the light.

Because the light source itself, the window, is fixed the angle and direction of the light must be controlled by varying the camera and subject positions. In this way you can switch from side to frontal and even back-lighting with relative ease.

This means that you will also need to change the position of any backgrounds you use. For small subjects like a still-life arrangement simply use large pieces of board or card which can be propped against a small stand or tripod.

For portraits, however, you will need larger areas of background; cartridge-paper rolls obtainable from professional dealers are ideal and are available in a wide range of colours. Light stands or spring-loaded poles with brackets designed to hold paper rolls can also be bought, making it a relatively simple matter to change the background position to suit the camera viewpoint.

You will find that when the subject is quite close to the window the lighting quality will be fairly soft and can be made even softer by hanging diffusion material over the window. This can be specially made frosted acetate, sheets of ordinary tracing paper taped together or even a white nylon curtain.

Even with a well-diffused light you will find on occasions that the shadow areas of the subject will be too dense, especially when the light is directed from one side. These shadows can be made lighter by placing a white reflector close to the shadow side of the set-up. Large sheets of inch-thick polystyrene sold for insulation purposes, and which can be bought in most DIY shops, are ideal. It is highly reflective, very light and inexpensive. It is useful to paint one side matt-black and this can be used if you want to create a more dramatic, shadowy quality.

Exposures will inevitably be longer since window light is considerably less bright than that outdoors, especially when it is diffused. With static subjects like still lifes you can simply use slower shutter speeds but with portraits it may be more practical to use a faster film. In any event a tripod will be essential to ensure there is no camera shake and it will also make framing and focusing the image easier and more accurate.

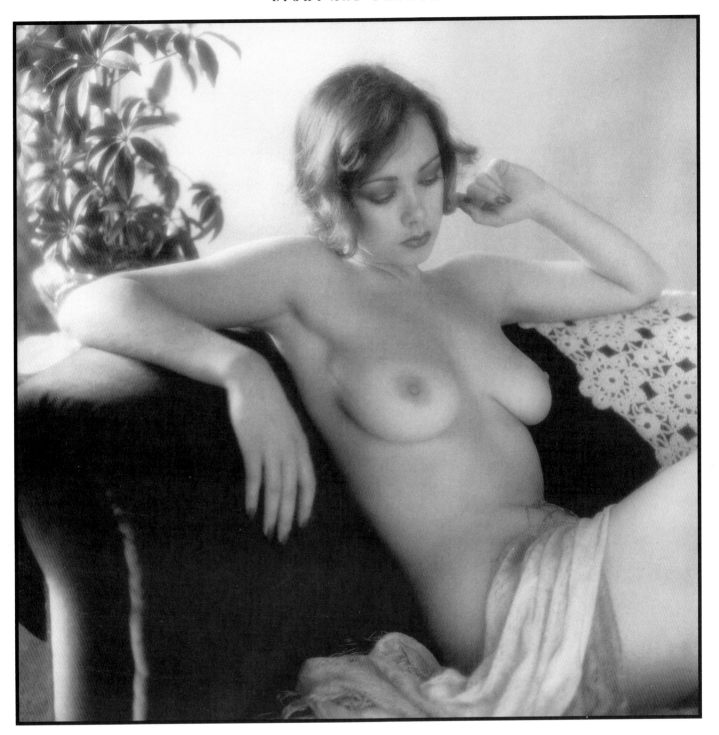

Left *The soft, directional light for this portrait of a child was provided by a large north-facing window to one side. I found that if I used a white reflector placed close to him on the opposite side it helped bounce some light back into the shadows and reduced the contrast*

Above *I used a roll of background paper on a moveable stand for this nude photograph. This enabled me to position the model to obtain the best lighting effect from the window and then place the background behind her. I used a large white reflector board close to her to lighten the shadows*

BAD WEATHER

If I could choose the ideal day to go out on a photographic expedition it would be one of those mellow autumn days with a clear bright sun and some thick white clouds dotting a deep-blue sky. The success rate on a day like this is likely to be high, and there are few potential pictures that will not produce a satisfying image in these conditions.

However, when I look through my past efforts I'm forced to admit that a high percentage of the pictures I like best are taken on those dire days when I was tempted to stay indoors. You will probably not take so many shots on such days, but those you do take tend to be quite striking.

Fog is a good example of this. It can be very atmospheric, helping to create bold and simply designed pictures by subduing background details and emphasising shapes and lines. I like the effect of fog and mist in woodlands when the shapes of trees are isolated from their surroundings. If sunlight is present, it can filter through the foliage in shafts of light.

Early morning, when the sun is low in the sky, is the best time of day for misty pictures. High viewpoints with distant views of the mist lying in hollows in the landscape can show the effect of the recession of planes. Very soft and subtle colour effects are attainable in these conditions.

Exposure will have a marked effect on the mood and quality of the image, and it is best to bracket exposures quite widely. Quite often exposures over a two- or three-stops range produce different, but equally acceptable, transparencies. Snow and heavy frost also help to simplify images by emphasising shapes, textures and patterns. Close-up shots taken on a frosty morning can be particularly striking.

Very overcast days, when clouds are dense and showing rich shades of grey, can help to create dramatic landscapes. A neutral graduated filter can be used to retain the rich tones in the sky while at the same time allowing you to give full exposure to foreground details. Lack of

contrast is sometimes a problem when shooting on dull days. This can be overcome by finding foreground details of a contrasting tone or colour to increase the brightness range of the image. Wide-angle lenses also tend to help in this respect whereas shots taken on long-focus lenses can easily be rather flat.

Rain too has its good points, especially in the urban landscape when wet streets add contrast to the image and introduce reflections. Street lights at dusk can be particularly effective in this way.

Left *A fall of snow invariably creates interesting effects. Not just from the pretty-postcard point of view but also because it can help to simplify an image and create bold graphic shapes from quite ordinary subjects, like this bowling green. I took my exposure reading from a non-snow-covered piece of mid-toned pathway to give a more accurate exposure*

Below *On a day when the visibility was down to less than one-hundred yards it seemed unlikely that I would find much to shoot at all. But this shot in the Forest of Lyons owes its quality and atmosphere to the fog*

SINGLE-SOURCE LIGHTING

One of the major steps in extending your abilities as a photographer is to escape the limitations imposed by using only natural light, and to discover the additional opportunities offered by studio or artificial lighting. Some people are probably deterred by the imagined complexity of lighting techniques and also by the possible cost of setting up in this way. Both of these fears may be overcome by beginning with the simple and inexpensive use of single-source lighting.

The light source can be chosen from a quite wide range of possibilities. A small flash gun is part of many photographers' basic kit and can be used successfully, with some limitations, for a range of subjects providing it can be connected by a synch lead to the camera and is not limited to hot-shoe use.

A larger mains flash unit is even better and one fitted with a modelling lamp allows greater control over lighting effects. A simple photoflood in a reflector mounted on a tripod stand is quite inexpensive and is ideal for many subjects. For still-life arrangements and close-up portraits, even something as modest as an anglepoise light fitted with a photoflood lamp can be used. While electronic flash enables you to use daylight-type film, photoflood bulbs mean that you must use artificial-light film when shooting in colour.

The lighting quality of an unobscured bulb in a reflector can be effective for subjects where a harder, more contrasty image is appropriate: a strongly lit character portrait for example, or a still life where a bold texture is required.

In many situations, however, you will want a softer, diffused light with less-boldly defined shadows. A simple and inexpensive method of achieving this is to make a tracing-paper screen: a simple wooden frame covered with tracing paper or the special plastic diffusion material obtainable from professional photographic stores.

The size of the screen will depend upon the type of subjects you intend to photograph and the degree of diffusion required. A frame about two feet by three allows you to undertake quite softly lit head-and-shoulder portraits and still-life arrangements. When the screen is placed close to the subject and the light source positioned several feet behind it, the quality of light will be very soft and diffused with barely discernible shadows. When the screen is moved further from the subject and closer to the lamp the light will become harder and the shadows more strongly defined.

You can control the density and depth of the shadows thrown by your light source by the use of reflectors. Sheets of white polystyrene sold for insulation purposes are ideal but large pieces of rigid white card can also be used. If you paint one side of the reflector matt-black it can be used to make the shadows stronger as well as lighter. You will discover — by varying the angle of lighting, the degree of diffusion and the use of reflectors — that a very wide range of lighting effects can be achieved from just a single light source.

A single slightly diffused flash head was used from slightly behind the model for this male nude shot. As I wanted a quite contrasty image I did not use a reflector and I calculated my exposure to give good detail and texture in the lighter parts of the body

FLASH
AND DAYLIGHT

A flash gun is part of every enthusiast's camera outfit and is usually one of the first accessories acquired. It tends to be used primarily as substitute lighting when the ambient light is not bright enough to be of practical use — taking pictures at a party in a dimly lit room for example. However, a flash-gun's potential as a creative tool is seldom explored, overlooked in the search for convenience and compromise. It is in fact a very useful source of supplementary light, and can be used to create interesting effects as well as improving the quality of natural light.

One of the flash-gun's most practical applications is to control the contrast created by daylight. Pictures taken against the light, with the subject fairly close to the camera, are a good example of this. With a portrait, for instance, the exposure which will reproduce skin tones accurately will overexpose the lighter details, the background and backlit hair, recording them as bleached-out tones with little colour or detail. Using a flash-gun to illuminate the model's face allows the overall exposure to be reduced and greatly improve the highlight detail.

The exposure can be calculated quite easily by considering it in terms of two separate but simultaneous exposures, one for the flash and another for the daylight. The first step is to take a general reading of the scene, making no allowance for the backlighting, and set this on the camera. Let's say this is 1/250 sec at f5.6 for example. Using the flash-gun guide No., or a flash meter, calculate the correct exposure for the flash. Say this is f8 (the shutter speed is not relevant since it will not affect the flash expo-

sure). As a general rule you will want to underexpose the flash by about one stop. To give the full exposure will result in an overlight, artificial look. Because of this, reset the aperture to f11 and, to retain the correct daylight exposure, reset the shutter speed to 1/60 sec.

Although the direct light of a flash tube can be used successfully the technique is less likely to look unnatural if it is diffused or bounced from an umbrella reflector. It's also better if the flash is positioned slightly to one side of the camera, as this will create a more pleasing fill-in light with a degree of modelling.

The same basic technique can also be used to improve the lighting quality of dull overcast days when shadows are formed under the model's eyes and chin. With a fairly powerful flash you can also give the impression of sunlight on dull days. For this the flash must be undiffused so that it casts a hard-edge shadow like sunlight. The balance of the two exposures for this effect must be reversed so that the full, correct exposure is given for the flash and the daylight exposure is about one stop underexposed. Place the flash gun quite high above the model's head so that it is at an angle compatible with sunlight.

I used a Norman portable flash unit fitted with a soft box diffuser to light the model independently of the sunset. Placed quite close to her, at nearly right-angles to the camera, it has created a good degree of modelling. Having selected the right aperture for the flash exposure I then calculated the shutter speed necessary to give the correct exposure for the background

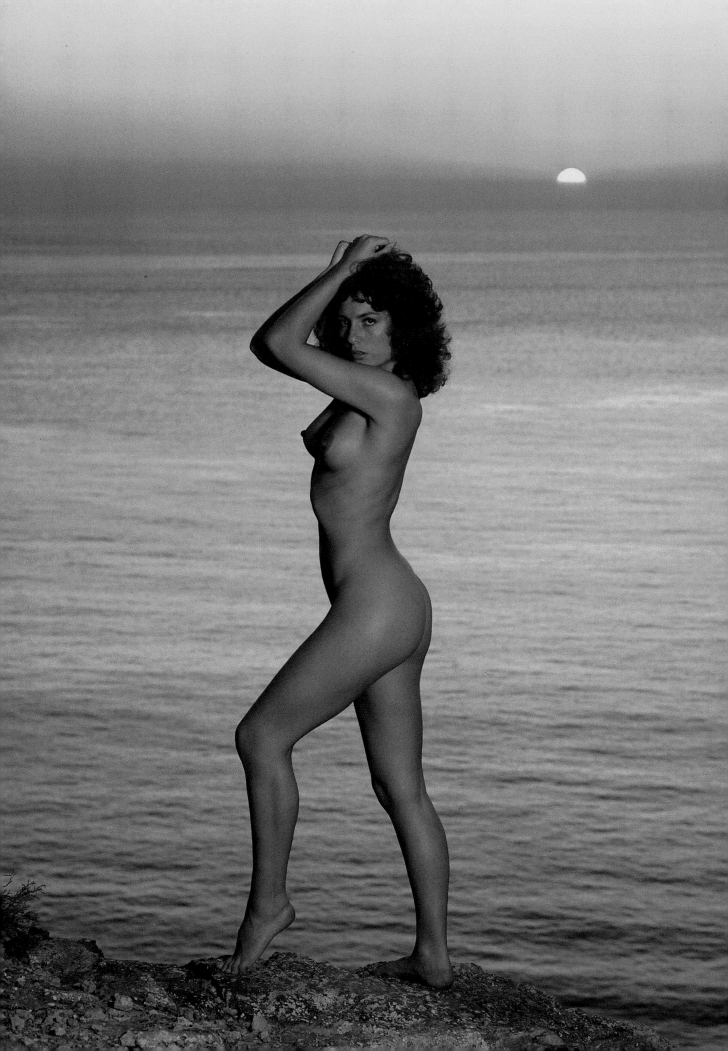

The method is also useful in taking more obviously contrived and theatrical pictures in an outdoor setting. This approach is quite fashionable and is frequently used by photographers like Anne Liebovitz and Terry O'Neill for personality portraits. In this case the flash needs to be set well to the side of the camera so that it creates pronounced modelling. An additional flash can also be used to one side and behind the model to provide rim lighting.

A very dramatic effect can be obtained by reducing the daylight exposure considerably, by three stops or more, so that the background and surroundings appear dark and moody with rich tones and colours. By using faster shutter speeds the daylight exposure will be reduced but the flash exposure will be unaffected.

This technique need not be limited to portraits; any subject close enough to the camera for the flash to illuminate is suitable. Food shots on location are often lit in this way, for instance. It can also be applied to subjects like landscapes where there are foreground details which can look more interesting or dramatic when lit artificially. Colour gels can be used over the flash to alter the colour of foreground objects leaving the remainder of the image unaffected.

A further variation is to use opposing colour filters over both the flash and the camera lens. By placing, say, a red filter over the flash and a cyan filter of the same density over the camera lens, the foreground details will record with a normal colour quality but the background, unaffected by the flash, will have a red colour cast.

Very interesting effects can also be produced with flash and daylight when a moving subject is photographed. Where daylight predominates, the moving elements of the scene will be blurred, but in the areas where the subject is lit predominantly by flash the image will be sharp due to the very brief duration of the flash. The degree of blur can be controlled by the choice of shutter speed. As well as photographing a moving subject this technique is good for making striking abstract effects when the camera is moved during the exposure.

PART SIX

THEMES

PHOTO ESSAY

Most photographs are produced with the intention of being viewed as an individual picture — an image which stands on its own. When a photograph is reproduced, however, in magazines and books it is more commonly used in conjunction with other images, perhaps four or five photographs laid out on a double-page spread for instance. Much of the skill involved in book and magazine design is in the art-editor's ability to select photographs which enhance each other when used in this way.

To take a series of pictures with this in mind is a challenging and rewarding project, and can do much to help a photographer view his work objectively. Approaching a subject in this way also helps you to explore it more fully.

When a single image is not the prime concern it is often possible to be more creative in the way you photograph a subject, making your pictures perhaps more abstract and evocative. When you explore a subject and illustrate it with a sequence of images you can afford to focus attention on smaller details. You effectively build up a composite image which is often even more telling than an outstanding single photograph.

Choosing a suitable subject for such treatment is largely a question of finding something

These two photographs were part of a series making up an essay on the Champagne wine harvest. One shows the harvesting of grapes and the other a much later stage when the bottles are turned in their racks to loosen the sediment and cause it to fall towards the neck from where it is later removed. I made a conscious effort to find pictures which not only revealed important aspects of the subject but which also have a degree of visual variety and will look good together on a page

visually stimulating and of personal interest. It could, for instance, be a quite factual subject like a favourite place, a village perhaps, a market or a particular landscape. On the other hand, it could be a far more abstract subject like an essay on autumn, a day of the week or simply a feeling like loneliness or happiness.

The key to a successful photo essay is in producing a series of images which gel, which say more about the subject collectively than individually and which also work well together. Use different viewpoints to produce longshots, medium range and close-ups and change lenses to give you broad views of a scene as well as isolated details. When shooting in colour try to produce images which have varying colour qualities, a cool blue image juxtaposed against a warm-toned picture for example.

You should edit your pictures fairly ruthlessly. If you have several good pictures showing much the same thing, then reject all but one and if a good picture simply doesn't fit with the others however you use it, reject that too.

When you have completed your photo essay it could be used to make an effective arrangement of framed pictures on a wall or even grouped together in a single frame (see page 188). A photo essay of the right subject could also be used as an illustrated article (page 142) when well captioned and accompanied by some informative text.

ILLUSTRATING A FEATURE

It's said that a photograph is worth a thousand words. I would doubt that it's always true, but it certainly can be said that a photograph or two *and* a thousand words can have a considerable value. Most photographers have ambitions to see their work in print and I am often asked what is the best way of achieving this. One approach which I would recommend, for those willing to invest a little time and effort, is to produce an illustrated feature.

The magazine business has a constant need for publishable material, especially now there is a growing number of free magazines. The difficulty for many of the smaller magazines is that their budgets are often not large enough to commission all the features they publish and they frequently buy existing photographs and articles from agencies.

A ready-made package of photographs with accompanying text is far more likely to find a market than a set of photographs alone, or indeed an unsupported article. Most people have knowledge or experience of certain subjects which, if presented in the right way, will be of great interest to others. An illustrated article is simply a way of exploiting this situation.

Many different topics can be turned into an interesting illustrated feature. A favourite country walk for instance, a local artist, a traditional craft, a trip abroad to an unknown area or a stay in an unusual hotel. You, or a friend, might possess a special skill, like making home-made wines, pottery — and what about photography?

It is vital to first identify your potential market. Study the magazines in the local library or on a bookstall. Make notes of those whose interests coincide with your areas of knowledge and experience. Do they use colour or black-and-white photographs; how many are usually reproduced and what is the average length of their articles? Note the name of the editor or features editor. Don't waste time on the glossies unless you have something outstanding in some way since these more prestigious magazines have staff writers and regular contributors. They also prefer to commission their own photographers.

Most people are quite capable of writing an interesting thousand or so words on a subject which they know well or which is of special interest to them. If you really don't feel that writing is for you then team up with a friend or colleague who likes to turn a word or two.

Ideally the photographs should illustrate the salient points of the text but in practice a good photograph will tend to get used even if its relevance is a bit tenuous. Make a picture list of the things you feel should be illustrated and that would make a strong image. Try to shoot pictures in both horizontal and upright formats; this makes it easier for the designer who lays out the pages. Give them plenty of choice but edit them selectively and make sure you provide good accurate captions.

Finally present your work well: a clean, double-spaced typed manuscript, neatly trimmed and spotted black-and-white prints and card-mounted (not glass) colour transparencies in viewpacks. Colour prints are not widely used.

A crowd of spectators photographed while watching the races at the Pushkar camel fair in Rajasthan was just one of a number of photographs taken to illustrate an article about the event

TIME SEQUENCES

One of the special qualities of photography is that it isolates a brief moment, creating what was one graphically described as 'a slice of life'. Painters will often make the point that a photograph can never say so much about a subject as a good painting, because the latter is made over a period and the passage of time is blended into the image. Of course it's true that a single photograph can only depict a subject as it appears during the fraction of a second which the exposure takes, but a sequence of photographs is an entirely different matter.

Natural-history film makers often use time-lapse sequences to show a plant growing and blooming in the space of a minute, or clouds flowing like a river over a mountain range; these images can be stunning. The same principle can be applied to still photography, perhaps not so dramatically but none-the-less very interesting and revealing.

I was once commissioned to take a series of photographs of a small square in Paris to show how it changed during a 24-hour period. It was fascinating to see the different activities and the changing quality of light shown graphically in a sequence of pictures laid out side by side. I took them at regular intervals from a number of different viewpoints framing the image in the same way each time. On another occasion I photographed a hilltop village in Spain at hourly intervals from dawn to sunset to show the way the lighting quality altered as the sun moved through the sky.

I remember too seeing in one of the Sunday colour magazines a series of self-portraits of a photographer who was trying to lose weight. He photographed himself at weekly intervals throughout his diet. The pictures were lit in exactly the same way with the same pose and against the same background; this too was a most graphic and absorbing record of the passage of time.

Imagine photographing a child from baby-hood to adulthood in a similar way. It would create a truly memorable family record although it would take some discipline and determination to carry it through — not to mention co-operation.

I have always intended to find a pleasing landscape near my home and photograph it at intervals throughout the year to show the effects of the seasons, but somehow I have never yet got around to doing it. I thought too that this would make a good subject for a calendar. A sequence of such pictures would also be a fine subject for a photo essay or to hang as a framed group on a wall. A little thought will, I'm sure, yield many more ideas for a time sequence and for different ways of approaching it.

These two pictures of a group of trees in Ashdown Forest were part of a series taken for a book on the English countryside photographed through the seasons. During the course of the photography I went back to a number of the same locations at different times of the year and it was fascinating to see the changes which took place

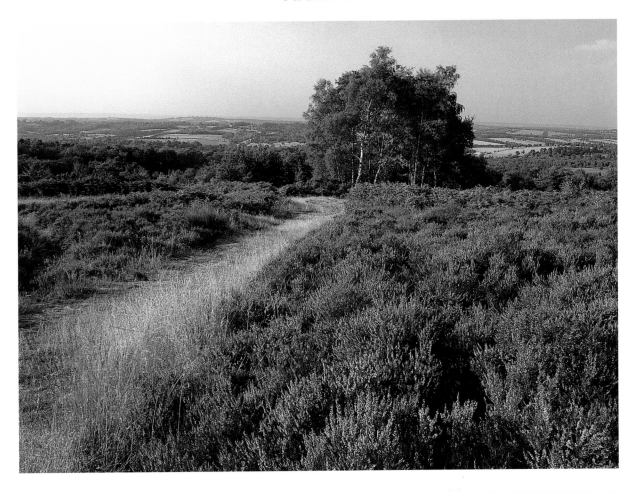

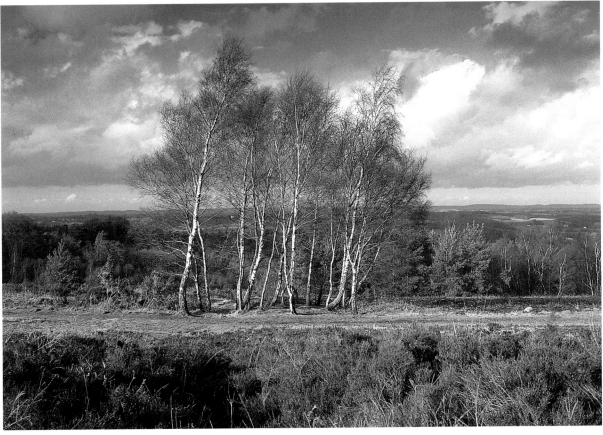

TRICKS OF THE EYE

One of the things I enjoy about being a professional photographer is that occasionally a client will ask you to take a photograph which, at first glance, seems impossible to achieve. You then have to sit down and think of ways in which the effect he wants can be created. The process of photography allows a great deal of cheating to be done and, because there is a general belief that the camera cannot lie, many quite simple tricks of the eye appear quite convincing.

I was once asked to take a series of photographs to illustrate common dreams, one of which apparently, is to find yourself flying — like a bird, not in a jumbo jet. The budget for the shot was quite limited and I considered a number of ideas, including a complicated montage, before a very simple solution dawned on me. I asked the gym master of my son's school if I might borrow the trampoline. We set it up outside with a view of trees behind. He obligingly donned a business suit and bowler hat and, carrying a brief case and rolled umbrella, went through a series of convincing flight paths a few feet above my head. Shot on a wide-angle lens from a low, close viewpoint with just the tree tops peeking into the bottom of the frame, the results almost fooled me, let alone anyone who didn't know the secret.

Another shot I was asked to take was an ad for a pharmaceutical company, the manufacturers of a new drug which was so effective that only half the normal dose was needed. The art-director's idea was to take a shot of a pill bottle half full of tablets, but — here's the twist — half full vertically instead of horizontally. At first I considered glueing the pills together with an invisible adhesive, and then the obvious solution struck me. I glued the base of the half-filled pill bottle onto a piece of card and turned it on its side. The resulting photograph was turned through ninety degrees. Although in retrospect it seems very obvious it's surprising how many people asked me how it was done.

There are many similar, quite simple deceits of this kind. Perspective effects can be used to play visual tricks, like the shots of a person holding up the Leaning Tower of Pisa, for instance. The distortion of scale caused by manipulating perspective can also make objects look dramatically larger or smaller than they really are. By supporting objects on glass and hidden pieces of wire, things can be made to appear suspended in space.

This type of approach does not necessarily have to deceive, it can also be used successfully to simply surprise or shock. I remember seeing a great picture in a girlie magazine of a naked girl standing in a full tube train with business men reading their newspapers, elderly ladies with their shopping, all apparently unaware of her. The photographer had simply assembled a group of friends together with his model during a quiet period at a tube station, waited for an empty compartment to come along and shot his picture between stations.

A cork popping from a champagne bottle might seem a daunting brief for a photograph. This shot was, however, simplicity itself. After having first emptied the bottle(!) I drilled a hole in the base. I set up a spare tripod in my garden and taped the bottle to it in a convenient position and pushed a hosepipe through the hole. Having set up my camera on another tripod and found the best viewpoint I placed the cork on the end of a thin rigid piece of wire which could be stuck into the ground and hidden behind the cork. I used a flash gun to backlight the set-up and create the highlights on the water and then simply turned the water on while I took a sequence of shots

VISUALISING AN IMAGE

In the Sixties and early Seventies, book designers preferred photographs to illustrate the covers of paperbacks. The style has mostly changed back again to typography and graphics. For several years, however, I spent a great deal of my time taking photographs for a number of publishers and designers and it was enormous fun. I remember one occasion when a reconstruction of a medieval black-magic ceremony, shot on location in local woods, resulted in press reports suggesting all manner of evil doings.

The usual procedure was that I would be given a book to read and asked to put forward several ideas for pictures that related to the title or passages in the text. I was then commissioned to photograph the one considered to be the most appropriate. In comparison with the usual forms of commercial photography this was a field in which the opportunities for imaginative images were far greater than many others.

The translation of ideas generated by a book, a piece of advertising copy, poetry or music into a visual form can provide stimulating and challenging projects for photographers. It also encourages you to think in an entirely visual, practical way.

It is often easier to be inspired by something for which you have a special liking, a particular piece of music perhaps, or a favourite novel. There are different ways of approaching such a project. You could, for example, consider it in the terms of a book jacket or a record sleeve.

In this case the image might be most telling if it has a fairly literal interpretation of the actual title. Consider, say, the possibilities afforded by Orwell's *Animal Farm* or Vivaldi's *Four Seasons* — it's hard not to have potential images flooding instantly into your mind.

The success of such pictures, however, often depends on a degree of subtlety or slightly obscure connotations rather than a slavish rendition of the initial mental image. It also depends on the execution of the idea. The Silk Cut cigarette posters, for instance, could hardly be more obvious but they succeed purely because of the visual and technical qualities of the photograph. Another way of visualising an image based on a specific source, such as a passage of text or music, is to create an image which has the feeling or mood of the original rather than a literal interpretation of its title.

The advertising business is perhaps the most voracious consumer of visual ideas. Selling a product is no longer simply a question of showing what it looks like; as they say — you must sell the sizzle, not the sausage.

You can learn a great deal about different approaches to the art of visualising by studying the ads in the glossy magazines. In recent years there has been a trend towards almost-abstract images, and the Benson & Hedges cigarette ads are an obvious example. Here the connection between the product and the illustration is one which it would take a psychologist to unravel. I'm not sure how well such ads contribute to sales but I do know that some powerful images have been produced and their creators have had, I suspect, a great deal of fun in visualising and photographing them.

This shot was taken as a cover illustration for a novel on the theme of thwarted love. It was not used as it was deemed a bit too macabre and a rather more romantic picture was finally chosen

LOCAL HISTORY

Photography has many applications but one of the most interesting and valuable is in preserving accurate records of the past. Of the numerous historic photographs which are kept in museums, art galleries and private collections the majority consist of those which document our social history. Indeed many of the most valued photographs are not essentially fine art or of earth-shaking events but of ordinary life and people.

The changes which now take place in our society are so rapid and far-reaching that a feeling of nostalgia develops for a decade within a few years of its expiry. Already the Sixties have acquired the same legendary status which the Thirties had for previous generations. Recent history has become, in many ways, as interesting to people as that of centuries past, and even photographs which were taken only a few years ago now possess considerable interest and social significance.

This situation can provide rewarding and stimulating projects for a photographer, exploring the changes and developments which occur in his locality. When I first began as a professional photographer, I took some photographs for *Country Life* magazine of the Eastenders who travelled down from London to work in the hop fields near my home. Now the hops are harvested by machines and although I didn't realise it at the time I was recording a piece of genuine history.

A friend of mine took some photographs of the giant bonfires which lit the woodlands in the aftermath of the hurricane which devastated southern England in 1987; these too, I'm sure, will have a lasting value and interest.

Scarcely a month passes without some irrevocable change taking place in a particular environment. Often its significance is not fully appreciated at the time, and only later is it realised how valuable for future generations a good photographic record would have been before it changed for ever.

A regular look through the local press together with an eagle-eye for things going on will provide you with a steady source of ideas: a building site, for instance, which will destroy long-established woodland, the 'renovation' of an historic building or a traditional craftsman retiring with no one to take over.

Such photographs take on a much greater value and attract more interest when they are well-crafted images with a genuine pictorial value. Don't just settle for straight record shots but look out for the unusual angle, moody lighting and the well-composed picture. I'm willing to bet that such photographs will outlast the arty nudes and abstract landscapes that might win the accolades this year.

One of my first published photographs in a national magazine, Eastenders working in the Kentish hop fields. It's a bit sobering to realise that some of my earlier efforts are now beginning to have historical interest

TEXTURE

Photography has an almost uncanny ability to reproduce textures so convincingly that sometimes you almost have to touch an image to determine that it is not real. Still-life photographers in particular exploit these qualities to the full and images of subjects like food, fabrics, jewellery and furniture fill the pages of the glossy magazines with often breathtaking quality.

Image quality is the keynote for photographs which rely upon the element of texture for their impact. Impeccably sharp images and critical exposures are needed to reveal fine detail. For this reason, large-format cameras are often the choice for such work, the 10×8 monorail being the workhorse of the studio still-life photographer. Fine work can, however, be produced on smaller formats; much of the wonderfully evocative food photography of Robert Freson, for example, is shot on 35mm equipment.

Lighting quality is the first consideration. As a general rule the light source should be at a fairly acute angle to the textured surface. The aim is to create tiny shadows and highlights from the reliefs and indentations which create the texture. A soft, large-source light, like a north-facing window, is often the most effective, since although it can be used to create bold relief the shadows it produces will be soft-edged and not too dense.

Image sharpness is also vital. A slow fine-grained film will reveal the most detail and produce the highest image quality. With quite close-up subjects, like still lives, it is necessary to use small apertures to ensure adequate depth of field. A tripod is also needed to eliminate the possibility of camera shake and to allow the use of slow shutter speeds.

Exposure too must be accurately determined to produce a full, rich range of tones and colours. A degree of underexposure will often enhance the impression of texture and such pictures benefit from bracketed exposures (page 29).

You can experiment with texture photography quite easily around the home. Small still-life set-ups enable you to control the lighting and composition and many everyday objects are ideal for such pictures. Foods, like fruit, vegetables and bread; kitchen utensils and containers, like wicker baskets, wooden chopping boards and terracotta pottery can all be used in a wide variety of arrangements rich in colour and texture. Studio lighting is not necessary, although its use will allow a wider range of effects. Indoor daylight, by a large window or in a conservatory, is ideal (pages 130–1).

Texture is also an element that can be exploited in much outdoor photography, since landscape subjects often have a strong textural quality. Low evening sunlight frequently reveals a rich vein in features like ploughed fields, rocks, wet-sand beaches, weathered wood and so on. Winter is an ideal time for such pictures since the landscape has a more rugged and harsher feel and sunlight is more acutely angled.

Low-angled evening sunlight glancing across the vineyards on the slopes below the château of Monbazillac has created a strongly textured image

SENSE OF PLACE

One of the prices we pay for progress is that places begin to look more and more like each other. I remember well one of my first trips to an 'exotic' location; it was Honolulu and looked to me remarkably like Benidorm — with an inferior beach. It is surprising how many far-flung romantic-sounding places don't actually look very different even if, in reality, they are. A photographer friend recently complained to me of having to shoot photographs for a company report in South America amid countryside which reminded him of Gloucestershire.

One way of taking pictures which declare their origins in no uncertain terms is to concentrate on well-known landmarks: the Eiffel Tower in Paris, the Houses of Parliament in London and the Sydney Harbour Bridge, for instance. Such pictures are always in demand by publishers and photo libraries but unless the image has a particularly unusual quality — the lighting for example or an unfamiliar viewpoint — they can be less than satisfying in a photographic sense.

The solution lies in a more detailed and perceptive approach. It's rather like good travel writing in that personal observations and experiences can convey a greater sense of place than straightforward information in a guide book.

What sort of things should you look for? Your own interests are a good starting point: you may have an interest in fashion and notice differences in how people dress, the colours, fabrics, patterns, jewellery and hats that are worn. Transport too is often a revealing aspect of a particular place; in a city, buses, taxis and trains are often very distinctive. The inclusion of one of New York's yellow cabs in a street scene would help to identify its origin when buildings and people alone would not.

Shops, advertising, street signs and ephemera can also show characteristic traits, sometimes simply because the language is identifiable but also because of distinctive design as in Indian film posters and English telephone boxes. Sometimes a striking picture results from a close-up, tightly framed image of such things, in other cases it can simply be an element of the composition.

In landscape and countryside shots the inclusion of buildings like farms and cottages can even identify the region of a country: the timber-framed houses of Normandy or the red-tiled stone houses of Provence come to mind. The aim of pictures like these is not necessarily so that everyone who looks at them will know immediately where they were taken but that they will sense something of the particular atmosphere and character of that place.

This is perhaps a rather obvious and even clichéd depiction of Las Vegas and for many people it would be so instantly recognisable as to scarcely need a caption. However, the lighting and colour quality, I feel, gives it some photographic interest and merit

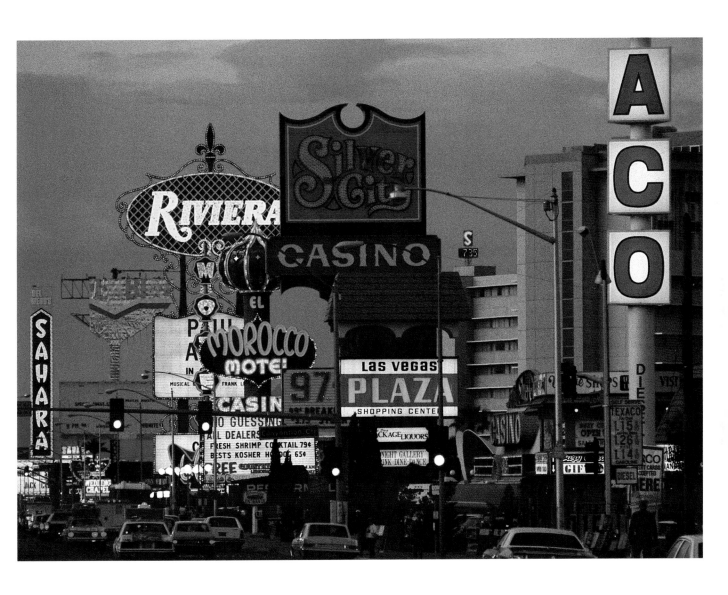

HOLIDAY RECORD

Looking at each other's holiday snaps has become one of the social niceties, like sending Christmas cards and writing thank-you notes. I wonder just how many people actually enjoy looking at someone else's holiday pictures, and indeed how many are pleased with their own. I've had some pretty shameful efforts and looking at them years later have wished that I'd taken more time and trouble. Holidays are important milestones in one's life and a good record of one provides fond memories for decades to come.

A little effort is the main thing needed to take a satisfying series of photographs which everyone will enjoy looking at. 'Series' is the operative word because many holiday snaps are taken in isolated bursts with a dozen or so, all rather alike, in one location and then, several days later, another dozen somewhere else. It's far better to use your camera little and often, like a note book or diary. The pictures don't need to be masterpieces, just nicely framed and composed.

Travelling shots can be fun, loading the car, at the airport or on the ferry. When taking a shot of your hotel or villa wait for a good day and time it so that the lighting is at its best and the scene is tidy. On the beach, find a good viewpoint and wait until the sea is really blue and the sand not littered with people or debris.

Look for those evocative little details: signs, shop windows, local transport, street life, fishing boats or close-ups of tropical plants. If you have a special meal like paella or a *fruit de mer*, shoot a still life before you attack it. Make sure you get some local colour into your holiday record, visit a market for example and look out for fairs and festivals.

With pictures of friends or family, avoid those stilted full-length shots of people staring selfconsciously into the lens. Wait until your subject is relaxed and enjoying him or herself and take your shots spontaneously. Get in quite close and fill the frame and make sure that the background isn't distracting or messy. Avoid those pictures where someone stands in front of a well-known landmark; unless it's done in a jokey, tongue-in-cheek way it will just look awkward and silly and neither the subject or the landmark will look at their best.

It's nice to include shots of people you meet, the barman in the hotel or the couple next to you at the pool. Casual portraits like those described on pages 60–2 take little time to shoot and are a nice way of keeping in touch as well as helping to make a more complete record.

This simple portrait, lit by bounced flash, provides the sort of photograph which not only helps to recall a memorable meal or occasion but also adds interest and variety to a holiday record

ASPECTS OF
ARCHITECTURE

Architectural photography is a quite special-ised field among professionals and one which can be both challenging and absorbing. Unless you have the opportunity to see some of the more glossy architectural magazines it is easy to be unaware of the many creative and exciting images which are produced by photographers working in this area of the medium.

For the amateur photographer, it is a very accessible subject and well within the capabilities of quite basic camera equipment. Changing styles of architecture over the centuries mean that there is great diversity of subject matter and the current trends towards aggressively designed structures can provide opportunities for bold and striking images even if the buildings themselves are of questionable taste or environmentally unwelcome.

The most obvious approach to photo-graphing a building is to include the entire structure in the frame. This type of photography is aided by the use of shift lenses or view cameras with rising fronts. There is, however, consider-able pictorial potential in focusing attention upon details of a building and a series of such images is often more revealing than a single photograph.

A long-focus lens is an advantage for pictures of this type because it enables you to isolate a small area of the subject from a distant viewpoint. A tripod will also be invaluable to ensure sharp images and to aid precise framing.

It is the basic visual elements of texture and pattern, colour and form which are the key to successful pictures of architectural details. Even something as simple as windows in an office block or the carved stonework of a medieval church can produce a very satisfying picture when the viewpoint, lighting and framing are well chosen.

Explore alternative viewpoints to see how different, contrasting elements of the building can be juxtaposed, how patterns can be created and perspectives altered. Lighting effects too will be greatly affected by the choice of viewpoint, especially on a sunny day. At dusk, when buildings are lit by artificial light and residual daylight, some exciting colour effects are possible.

The use of mirrored glass, chrome, painted-steel tubing and textured concrete makes modern buildings a virtual treasure-trove of bold graphic images. Complexes like the Pompidou Centre in Paris, or the recent developments in the City of London and Docklands could provide days of fruitful photography and make ideal subjects for the photo-essay project (pages 140–1).

The region of La Mancha in Spain is known for its villages with beautiful squares. This shot is a detail of the arcaded Plaza Mayor of Templeque: I took it on long-focus lens from a fairly distant viewpoint to reduce the effect of perspective and to emphasise the graphic quality of the image

INSTRUCTIONAL PHOTOGRAPHY

Although photography can be an immense source of pleasure for its own sake it is also satisfying to use your skills for more practical purposes. One valuable aspect of photography is its ability to describe and explain things in a clear and understandable way. Indeed photography now plays a major part in education, actually showing how something is done or what it looks like rather than relying on a verbal description alone.

There is a fine series of books by the author and photographer Roger Phillips who has fully exploited this aspect of the medium with photographs which identify all the various species of trees, flowers, vegetables and so on. Clarity is the essence of such pictures; they should be lit in such a way that textures, colours and shapes are fully revealed and important details are not obscured by shadows.

Backgrounds should be chosen to enable the subject to be seen clearly with shapes and outlines in bold relief. Where a series of pictures is involved it is important to retain a degree of continuity, keeping the camera viewpoint, background and lighting the same. It is often important to include a reference to indicate the size of the object being photographed, like a metric scale for example.

Describing a process or a technique can also be done very effectively with photographs. When repairing a piece of equipment, stripping down an engine for example, a series of photographs showing each stage as items are unscrewed and removed will make the process of re-assembly much easier. In such cases an overall establishing shot can be taken first to locate all of the key features followed by close-up images of details to show specific steps. It is best to retain the same viewpoint throughout but not at the cost of showing something clearly. In some circumstances the same stage can be shown from two different angles to give a clearer view.

A friend of mine lives in a rather remote place in the country and has hit upon the neat idea of producing a series of photographs to supplement the written instructions which he sends his visitors — no one has managed since to get lost.

A useful extension of this idea is to photograph the stages in favourite country walks to pass onto friends. Quite often written directions are rather ambiguous and photographs make following a route virtually foolproof. A set of appealing pictures taken in this way with some accompanying text is quite likely to be of interest to a local magazine.

Carrying out a project of this type is a valuable means of learning to be very objective about the pictures you take and to consider carefully the most informative and revealing angles and viewpoints.

This shot of Win Green in Wiltshire was one of a series taken to illustrate a book of country walks. Pictures like this, taken at important stages in a walk, can eliminate any ambiguities which might be created by verbal directions alone

HUMAN LANDSCAPES

Pictures of people usually fall into the categories of reportage, portraits, fashion or glamour but there is considerable potential in photographing the human figure in a much more abstract and impersonal way.

Many photographers are attracted to the idea of nude photography but are deterred by the difficulty of finding suitable models and by the expense of hiring professionals. These problems are greatly reduced with a more abstract approach, since almost anyone can be used successfully as a subject for photographs of this type. In this context nudity does not necessarily mean the full-frontal variety favoured by the *Sun*'s page three and the girlie magazines. Bill Brandt produced a memorable image using the soles of a model's feet.

If you view the human body as an abstract form it takes on an entirely different aspect and instead of arms, legs and torsos being personal attributes they become simply interesting contours, textures and forms just like a landscape. Imagination is really the only limitation to the way in which the body can be photographed, and to experiment with different lighting effects, viewpoints and angles is a very instructive means of learning to use the medium of photography more fully.

Studio lighting gives you more scope for creating different effects, but pictures of this type can be shot very satisfactorily in natural light, window-light indoors for instance or in outdoor locations. Look for ways in which different shapes and textures are revealed by altering the model's pose, the direction and quality of the light, the camera viewpoint and the way in which the image is framed. The permutations which can be achieved by varying these factors are almost endless.

Changing lenses also gives you a wider range of effects: for instance, the exaggerations of perspective created by a wide-angle lens and a close viewpoint; and the compression of depth and unfamiliar juxtapositions which can be achieved by using a long-focus lens and a more distant viewpoint.

While colour photographs of abstract nudes can be very striking, it is a subject which lends itself especially well to the black-and-white process. This is partly because the lack of colour removes the image further from reality and also because the degree of control over the quality and effect of the image is even greater than with colour materials. Such photographs are often good subjects for the toning and posterisation techniques described on pages 168–70.

This near-silhouette was illuminated by a single light directed at the background paper and bouncing back to create just sufficient highlights on the body's profile to reveal a degree of shape and form

A slightly diffused light source was placed behind and slightly above the model, who was lying on her stomach, to create the bold outline and contour of this abstract nude. I used a black reflector to ensure that the unlit parts of the body recorded as a pure black and the print was made on a hard grade of paper for maximum contrast

PART SEVEN

APPLIED PHOTOGRAPHY

PHOTO COLLAGE

There are a variety of ways in which several photographic prints can be combined to create a piece of artwork. Such images take on a character and mood entirely of their own and often bear little resemblance to the subject matter of the original photographs. Bob Carlos Clark is a photographer who has built an international reputation largely on his ability to create elaborate montages from several black-and-white prints. These are often toned and tinted to create images of wild and sometimes disturbing fantasy. Considerable skill is needed for this type of work but such similar techniques can also be used to produce very effective images on a less ambitious level.

You will need a sharp scalpel knife with spare blades, a cutting surface, a steel straight edge, fine sandpaper, mounting board and a good adhesive like cow gum or spray mount.

One of the easiest ways of combining photographs in this way is to make a print pattern. Choose an image with a bodly defined shape or design and make four prints of identical size, with two the correct way round and two reversed. These can be cut and joined in ways that create curious and effective patterns in kaleidoscope fashion. One method is to join them so that they form quarter segments of a rectangle; a quite different effect can be created by joining them in a line to create a panoramic shaped image.

The join will be less apparent if you chamfer the edges of the prints where they are to be joined with fine sandpaper before sticking them onto the mounting board. Once you have cut the first print it can be laid on top of the next print and registered to ensure that it is cut along precisely the same line.

Like many such techniques you can often find existing pictures from which to make collages but it can be more satisfying, and the results more pleasing, to shoot images with the final result in mind. A simple but very effective example is to shoot a boldly shaped image in which a strong vertical or horizontal line runs diagonally across the print.

With a full-face portrait it can be amusing to make two identical prints with one reversed. When cut vertically through the centre of the model's nose and joined the lack of symmetry in the human face can create two quite unfamiliar new faces.

A more elaborate collage can be made by using a large print as a background image and cutting around other images to build up a composite picture. Such an image needs to be carefully pre-planned and photographs specially taken so that elements like perspective, scale and lighting are compatible. It helps to make a rough sketch of your idea first.

Spare en-prints of family and holiday snaps can often be given a more satisfying and interesting presentation by cutting and joining in a similar way. You can also incorporate other ephemera like postcards, tickets and labels for example. In this way personal photographs and mementos could be pasted onto a background of an enlargement of a scenic shot you have taken or a tourist-office poster.

Above *An interesting pattern has been made by taking a photograph with a strong diagonal composition and making four same-size prints, two of them reversed. I then simply mounted them together. A panoramic image could also be made from the same prints by joining them alternately in a line*

Below *This rather tongue-in-cheek collage was made by cutting out and mounting together five different prints*

TONING AND TINTING

Modern photographic materials have made it a simple matter to produce good-quality colour prints, and black-and-white photography has tended to become less popular. It's not so very long ago, however, that black-and-white photography was the norm and the only way that colour images could be produced was by toning and tinting.

Many of the older processes are now being revived by photographers who want to find an alternative to the unremitting realism of modern materials. Photographers like James Wedge and Bob Carlos Clark have breathed new life into the old art of tinting and toning, and processes like gum bichromate, platinum prints and bromoil are being rediscovered by a new generation of craftsmen.

Some of these processes are both expensive and difficult to control, but chemical toning and hand tinting are techniques which most people who can make black-and-white prints will be able to use to create more personal and unusual photographs.

Toning is a simple process: a wide range of colours can be produced from black-and-white prints made on ordinary bromide paper with a process which can be carried out in daylight. Sepia toning is the best known of these and there are a variety of easy-to-use ready-made chemical kits available from good photographic stores.

The starting point is a good-quality black-and-white print which has been fully developed, thoroughly fixed and well washed. The two-bath toner requires that the print is first bleached, then washed and finally redeveloped to create the sepia tones. These can range from pale yellowy browns to rich velvety purple tones. The effect depends upon the variety of toner used, the contrast and tonal range of the black-and-white print and the brand of paper on which it was made. Both resin-coated papers and the traditional fibre-based papers can be used successfully for toning.

Many other colours can be obtained by chemical toning ranging from blue and green to red, purple and yellow. You may buy a complete kit of chemical bleaches, toners and dyes from good photographic stores called Colorvir. These can be combined in many different ways to produce a wide range of effects with different colours possible on the same print. You can also produce pseudo-solarisation effects with these chemicals which create partly reversed images. A good instructional guide with the kit describes the various effects that can be achieved.

Different colour toners can also be combined in the same image by using a masking medium to protect selective areas of a print while other parts are toned.

Above *I used water-colour dyes to tint selective areas of a sepia-toned print to produce this photograph*

Right *I achieved this effect with the Colorvir kit using the pseudo-solarisation bath*

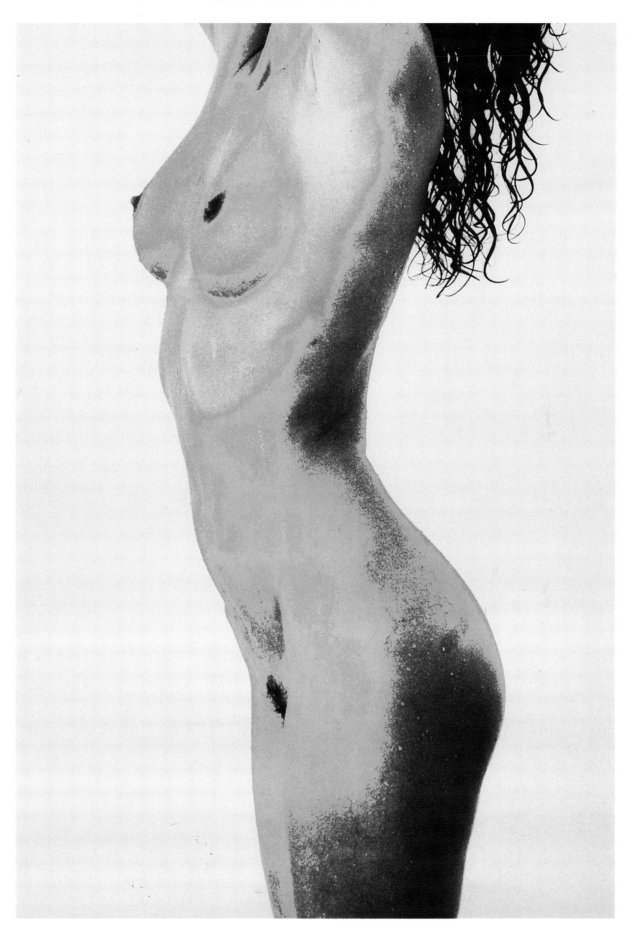

Hand-tinted photographs were produced in the early days of photography with the intention of simulating real colours and effects. There is little point in using the technique now in this way, and the present appeal of hand-tinted photographs is because they help a photographer to escape from the true-to-life qualities of modern colour materials.

As a general rule the basis for a hand-tinted photograph is a fairly light-toned, black-and-white print of lower-than-normal contrast. Many colourists like to work on sepia-toned prints to avoid the dense black shadow tones of a conventional black-and-white image. It is also easier to work on matt or semi-matt prints in preference to a glossy surface. Both fibre-based and resin-coated papers can be tinted success-fully but the less experienced would probably find the latter easier to work on. It is helpful to have a spare print in order to test colours first.

Both oil colours and transparent water colours can be used but the latter are easier to work with and allow more of the photographic quality of the image to show through. You will need a selection of sable brushes, a palette, cotton buds and wool balls and some photo-graphic blotting paper.

The prints should be soaked first in water and blotted dry before taping by the edges to a board. It's best to work on the larger areas of tone first, mixing your colours and testing on the spare prints. Very large areas of pale colour can be applied with a cotton-wool ball. Keep the surface of the print free from excess colour by frequent blotting and finish off with the smallest details and the densest colours.

You will need to be careful in choosing a suitable image for tinting. Unless you are particularly skilled with a brush it's best to avoid pictures which have a mass of fine detail and intricate outlines. Don't be deterred if your brush work is poor since striking effects can be achieved with a minimal application of colour and small areas of hand colouring can often be combined successfully with a colour-toned print.

I used a simple blue toner to produce this seascape from a black-and-white print

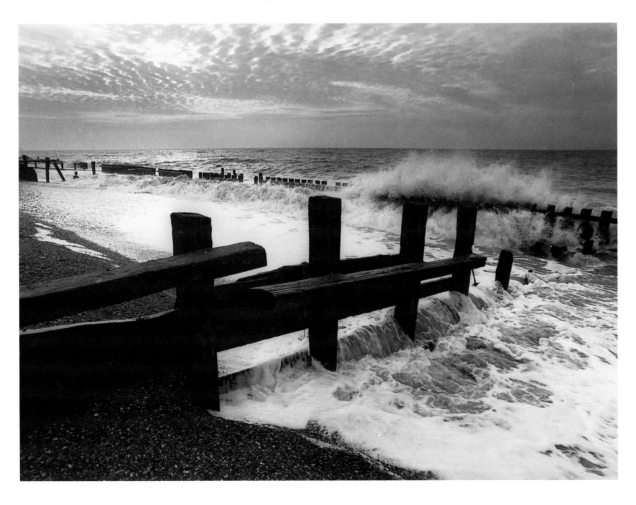

DECORATIVE PHOTOGRAPHS

Most people have favourite photographs amongst those they've taken, but too often such images are relegated to a drawer — once seen and soon forgotten. There are so many useful and decorative things which photographs can be used to make that it is a pity to waste a good picture in this way. Using photographs as part of the decor in a room at home or an office is discussed on pages 188–9 but there are other ways in which a favourite picture can be given a more lasting life.

Calendars and greetings cards are perhaps the most obvious uses for photographs and producing your own can be very satisfying as well as being a more enjoyable and personal gift for the recipient.

The most basic consideration when using a picture in this way is to find a satisfactory method of combining the image with the message or calendar. It is possible to buy ready-made mounts for both cards and calendars making it necessary only for the print to be slipped in or mounted with adhesive. Most good photographic dealers will be able to supply these items.

If only one or two greetings cards are wanted you can use transfer lettering directly onto a photographic print. It is best to mount the print first on to thin card since an unmounted photograph is not rigid enough to stand without flopping a little. Spraymount is ideal for this and the edges can then easily be trimmed flush after mounting.

Another method is to make up a message to the size required on white card using transfer lettering and then have it photocopied. This can then be mounted back-to-back with the selected photograph, trimmed flush and folded. In this way you can have the photograph on the outside and the message in the centre or vice versa.

If a sufficient quantity of cards or calendars is wanted, many professional laboratories offer a service where a photographic image can be combined with a piece of artwork, which can be prepared using transfer lettering. There is a basic charge for making up the combined negative but once this has been done the cost of the prints is much the same as ordinary en-prints with generous discounts for quantities.

A very simple idea for a party invitation easily executed and quite cheaply produced by having a quantity of en-prints made from a colour negative

For those who make their own prints it is possible to buy masks with calendars and messages on a negative so that by double printing it can be combined with your selected negative or transparency in the darkroom. A good photographic dealer will be able to supply these.

If you plan to take photographs especially for a card it can be possible to include the message when taking the shot. A nicely hand-written message on a piece of card could be added to a still life, of flowers perhaps, for a very personalised birthday card.

Photographs can also be used effectively to decorate small containers, like a pen holder for a desk or a small box for a dressing table. Spraymount or rubber solution can be used to fix the print in place and the surface can be protected by coating with a photographic varnish or by using adhesive plastic film. Other small gifts which can be decorated easily with photographs in this way include book marks and notebooks.

Some photographic laboratories offer a service where a photograph can be professionally laminated onto place mats for a table setting, but if you have some handicraft skills it would not be difficult to produce things like these yourself.

For those with their own darkroom, and willing to experiment, many more opportunities can be taken by using liquid emulsion which can be coated on to almost any surface allowing a black-and-white negative to be exposed directly onto it. It is also possible to buy fabric coated with black-and-white bromide emulsion making possible things like photographic cushion covers and wall hangings. Some of the old processes like salt prints described on pages 175–176 can be used to coat various materials with a light-sensitive emulsion for direct printing by contact.

If you make your own prints it is also worth considering using special techniques like toning, tinting, posterisation and multiple exposures to create images of a more graphic quality. These techniques are described fully on other pages referred to in the index.

Although ideas like these are a good way of making use of existing photographs it can be even more rewarding to consider the end product first and create an image especially for it. In this way you can be more adventurous making highly personal products with strong visual appeal.

Right *The easiest way to combine lettering with a photograph on a greetings card is to incorporate it within the subject. Writing on this paper bag was the simplest way possible and it gives the card a nice personal touch*

Below *A laminated black-and-white or colour photograph makes a quite practical alternative to fabric place-mats for a table setting. If a fairly abstract image is used, like this shot of a sawn tree stump, it can even create a talking point over dinner!*

ALTERNATIVE IMAGES

Since the discovery of the photographic process over 150 years ago, there have been some astonishing advances in both the quality of the images created and the ease by which they can be produced. Modern film and printing materials are now virtually foolproof, requiring only a simple process to convert a latent image into a print or transparency with tones and colours matching the original subject in an almost uncanny way.

The disadvantage is that the results produced by modern materials can have a rather uniform and characterless quality and make it more difficult for photographers to put their own stamp on an image. For this reason many modern photographers have reverted to some of the old techniques in order to create more personal and interpretive pictures. Some, like platinum printing for example, are both expensive and difficult to control but others are well within the capabilities of a keen amateur with a modest darkroom.

Three processes which can be used effectively to make monochrome prints from either black-and-white negatives or colour transparencies are gum bichromate, kallitype and salt prints. They involve making up a fairly simple chemical solution with which you can coat a range of materials from cartridge paper to fabric. The paper used for watercolours is ideal. These emulsions are not very sensitive and must be given long exposures to sunlight or an ultra-violet lamp. For this reason they are not suitable for enlargements; a negative must be made to the size required and the print subsequently made by contact.

The best material for the negative is to use a

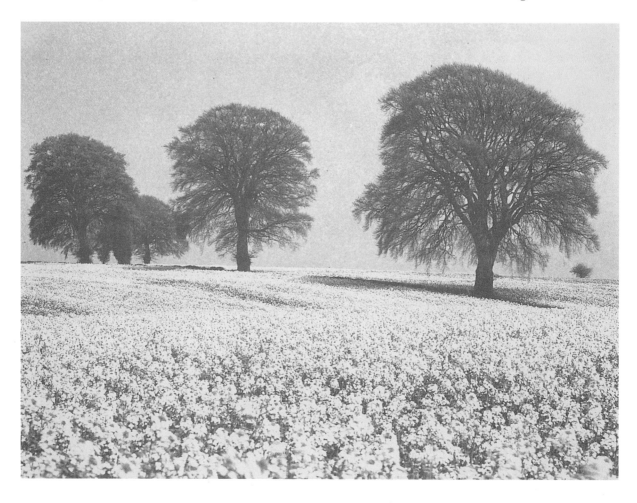

sheet of black-and-white film, the type used for large-format cameras. With a colour transparency as the original you can enlarge this onto the film to produce a direct negative. With an original negative you need to make a positive first.

An alternative to using sheet film is to make the enlarged negative on single-weight bromide paper although this will need a longer exposure. Rubbing oil or vaseline into the back of the negative will make it more translucent. It is also possible to strip the emulsion from a print made on resin-coated paper. As a general rule it is best to make the negative of fairly high contrast.

The printing material is made by coating the emulsion as evenly and smoothly as possible, using a soft brush or sponge. This can be done in tungsten light, not fluorescent, and allowing it to dry in a dark place. Before coating it is best to tape the paper to a support, a piece of hardboard cut slightly larger than the print is ideal.

From gum-bichromate prints the chosen paper should be sized first using a solution of 28 grams of powdered gelatin to 250cc of water. Allow it to set and then remelt before application. It must be dry before the sensitive emulsion is applied. For salt prints and kallitypes a smooth-surfaced, hot-press watercolour paper is best.

The dried printing paper and the negative should be taped together, emulsion to emulsion, along one edge and held firmly together for the exposure under glass. A simple clip picture frame can make an effective printing frame.

The exposure is determined largely by trial and error so you will need some spare coated paper for tests. Daylight can be used but it is not constant, and a UV lamp (the type used for window displays) or a sun lamp will give more readily repeatable results and not need such long exposures.

With a salt print the image visibly darkens during the exposure and after about 15 minutes you can lift one edge of the negative to watch its progress; but remember that it will become much lighter after processing. As a rough guide, with a UV lamp prints will need an exposure of between fifteen minutes and half an hour using a film negative. The processing is carried out by simply washing gently in tap water at about 20°C until the lighter, less exposed, areas of the image have cleared.

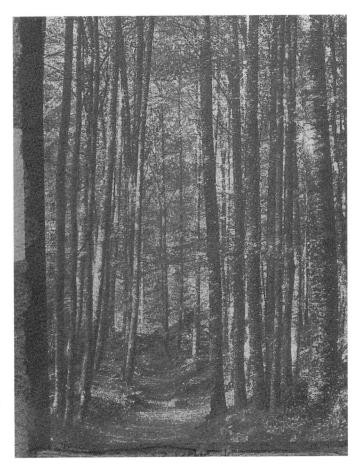

Left *Cyanotype is perhaps the easiest of these old processes to control and the rich-blue image colour and relatively high contrast suits subjects like this landscape very well*

Above *I used the gum bichromate process for this woodland scene. It is one of the trickier of the old processes but can produce a very pleasing quality and you can select your own image colour*

The rich sepia tone of this print was produced by the Kallitype process

The emulsion for a salt print is made by dissolving 8 grams of potassium ferricyanide in 100cc of distilled water and, separately, 20 grams of ferric ammonium citrate in 100cc of distilled water and storing in two brown glass bottles. Mix a small, equal, amount of each just before use. This emulsion produces a cyan-blue image.

The emulsion for a gum-bichromate print requires two separate, saturated solutions to be made of powdered gum arabic and potassium bichromate. You will also need a selection of powdered watercolours or poster paints. Before coating the paper, mix equal parts of the two solutions together with the powdered pigment of your choice; this will create the finished colour of the image.

The exposed gum-bichromate print is processed by washing gently in running water until the excess pigment clears from the highlight areas. It is sometimes necessary to carefully swab with cotton wool or spray the surface of the print to aid this process.

The kallitype emulsion is made by making three separate solutions of the following, each in 100cc of distilled water: 30 grams of ferric-ammonium citrate, 5 grams of tartaric acid and 15 grams of silver nitrate.

A small quantity of each of the three solutions should be mixed together in equal proportions in the order indicated just prior to coating the paper. It's best to use plastic gloves as the solution will stain your hands and you should be careful not to inhale the silver-nitrate powder as it is toxic. After an initial wash to clear the image the kallitype print requires a ten-minute fix in a normal black-and-white print fixing bath and then a final wash in running water for twenty minutes or so.

It is possible to purchase ready-to-use kits for each of these processes together with some useful hints and tips from the following supplier: Vintage Image, PO Box 27, Penzance, TR18 2XD, England.

MONTAGE PRINTING

Making your own prints is not only very satisfying, it also allows you to exercise a great deal more control over the quality and nature of your photographs, particularly with black-and-white materials. It is remarkable just how much better a finely controlled print of a negative can be when compared to a straight, unmodified image.

Printing techniques allow a photographer to do more than just get the best from a single negative, however. It is also possible to produce prints from two or more negatives, thus creating images of a more abstract and individual quality. Some photographers, like Jerry Uelsmann, have developed this to a level where very complex fantasy images are constructed from many different negatives in an almost realistic way.

The basic technique is not difficult, provided you adopt a methodical way of working. In its simplest form a montage print involves making two or more exposures from different negatives on to one piece of bromide paper. It is easiest to do this if one image is essentially light in tone and acts rather as a background to subsequent images. The darker details of one image will dominate the lighter tones of another. It is possible with shading techniques, however, to blend and combine images from several different negatives in a very convincing way.

Adding a more interesting sky to a landscape shot is one of the easiest types of montage providing the horizon line is fairly uncomplicated, like in this shot of an isolated tree

The first step is to select your negatives; just two is perhaps enough until you gain experience. While you will probably be able to find suitable images from existing pictures it is always better to visualise the final result, making a working sketch and to shoot images especially for the montage.

For a first attempt, it would be best to find images where quite bold shapes or details of a darker tone on one negative can be superimposed on lightish areas of another image. Alternatively choose two images which can be joined together along a fairly natural line. A good example of this is when a dark dramatic sky is combined with a landscape foreground from another negative.

Place one of the negatives in the enlarger and adjust it to the size required. Place a piece of white paper in the masking frame and make a tracing of the dominant features of the image, at the same time noting where it might need to be held back, or shaded, to blend with the subsequent images. You can now make a test strip from this negative to determine the correct exposure.

Replace the first negative with the next and, using the tracing, adjust its degree of enlargement to fit the first image, moving the easel around to obtain the desired juxtaposition. Make a tracing of this image and note the areas where the two images will overlap to see if and where shading will be needed. A test strip can now be made to assess the exposure for this negative.

Where two or more images overlap, the cumulative effect of their exposures will make that area of the print much darker than the test

strip. Shading the joined area of each negative for half the exposure time will retain the correct density. By holding back one negative proportionately more you can make the other more dominant.

A piece of black card cut roughly to shape and supported on a piece of wire is ideal for shading small isolated areas, but your hand curved to the right shape is often the easiest way to hold back larger segments of the image. During shading keep the card moving gently to make the edges of the shaded area blend gradually into the rest of the image.

When you have sized, traced and made test strips from all the negatives you are using you are ready to make a first attempt at a montage. Expose the first negative noting where and for

how long it was shaded. Mark one corner of the paper so that it can be replaced in the easel in the same position. I just fold over the top left corner. Remove the paper from the enlarger and store it in a light-tight box and replace the first negative with the next. After resizing and adjusting the position by using the tracing, repeat the operation. When all the exposures have been made the print can be processed in the normal way.

It's unlikely that your first attempt will be completely successful, so look carefully at the areas where the image is too dark or light to determine how the shading times can be adjusted to create a better balance of tones.

This technique can be used in exactly the same way for making montages from colour negatives. Combined prints from transparencies, using Cibachrome for example or duplicate transparency film, can be made in a similar way but in this case the light tones of one image will dominate the darker areas of another.

Above *Adding a range of buttock hills to this shot of Romney Marshes was also quite easy to do since the sky area was almost pure white. All I had to do, after positioning the nude image on the tracing of the landscape, was to vignette the nude carefully during the exposure along the sky line so that it blended smoothly*

Left *This was the trickiest to do since a hole had to be held back in the sky of the landscape image and the eye vignetted to fit the hole fairly accurately to ensure a smooth join*

TEXTURE SCREENS

A photograph can sometimes be *too* precise, with a degree of clarity and detail which overwhelms the image. The use of a texture screen is one of the ways in whch a more simplified, graphic quality can be introduced. The principle is to superimpose another image with a pattern or texture onto a negative or transparency in order to break up the finer detail and create a quality which is less 'photographic'.

Texture screens can be bought from photographic stores with ready-made textures like canvas or silk printed onto film. One of these is simply placed in contact with the negative or transparency and an enlargement made in the normal way. However, it can be far more interesting, and the results more individual, to produce your own texture screens.

One way of doing this is to photograph a suitable surface and to use the resulting negative, or transparency, as a texture screen. Something with a very fine texture will have a quite subtle effect leaving all but the smallest details of the image visible, but a surface with a coarser, more defined texture will leave only the boldest shapes and outlines in clear relief.

Woven fabrics like hessian and linen are obvious choices and can be quite effective with the right subject. They can be side lit and photographed in close-up to emphasise the texture. Soft frontal lighting with a larger area of the fabric photographed will produce a more subtle effect.

You need not be limited to close-ups of fabrics however. More distant shots of surfaces like a rough-cast wall, a field of wheat, rippled sand on a beach, the bark of a tree or rain on a window pane, can all be used to create interesting effects. The main point is that the area used should have a relatively even tone and colour.

Texture screens can also be made from translucent materials like tissue paper or frosted plastic and, if large enough, be used in contact with the printing paper instead of the negative or transparency. You can also experiment with placing a texture screen in the camera before loading the film so that it is in close contact in front of the film. This is fairly easy to do with a camera which has a detachable magazine.

The effect of a texture screen can also be created by placing a large piece of translucent material between the camera and the subject: muslin stretched over a wooden frame, for instance, or droplets of water on a sheet of glass. The screen needs to be quite close to the subject so this technique is best suited to portraits and still lives which are small enough to be contained within the screen. A small aperture should be used to obtain adequate depth of field.

A sheet of glass sprayed with water provided an 'in camera' texture screen for this pensive portrait

A black-and-white print was made from this picture of Venice using a piece of translucent negative envelope in contact with the negative which has given it a crystalline granular quality. The print was then toned using the Colorvir kit

TRANSPARENCY SANDWICHES

In addition to multiple exposures there are other ways of combining two or more images. Perhaps the simplest of these is by making a transparency sandwich. This technique involves simply placing two, or more, transparencies in contact with each other, but it must be done in an imaginative and planned way to produce a worthwhile result.

While making multiple exposures on film is, in essence, adding light tones to an essentially dark image, making transparency sandwiches works in reverse. The individual images should be pre-planned so that the darker details of one image are superimposed on the light areas of another.

As in the case of multiple exposures, it helps to think in terms of background and foreground images. In its simplest form it is best if the subordinate image is predominately light in tone without too much detail or strong colour, while the more dominant image should have a bold shape, or clearly defined outline, against a light and fairly plain background. An illustration of this would be a close-up of a flower against a white background superimposed on a cloudscape. It's often very effective when the background image has a subtle texture or pattern and the main image an interesting and boldly defined shape.

If you wish to plan an image where both transparencies have quite dominant features, they should be photographed so that each is positioned in its respective frame to create a pleasing composition when combined.

It helps to make a sketch of your idea first and then to shoot the pictures as close to the design as possible. You will have more control over the way the images are juxtaposed if you leave some space around the important areas of each image. If you have two different camera formats you can shoot background images on 6 × 6cm film and the main images on 35mm, for instance, to allow even more freedom of movement.

It is best to slightly overexpose each transparency by about half or one stop. By making the background exposure lighter still you can make the other image more dominant. Like multiple-exposure techniques you can also use focus and filtration to help make the images more distinct from one another.

A light box is a useful piece of equipment when it comes to making the sandwich. By taping one transparency by its edges to the light box you can simply lay the other in contact with it and move it around until you find the best position, finally taping it carefully by its edges to the first. It can then be put into a slide mount and at a later time used to make a print or duplicate transparency if required. The great advantage is that it gives you flexibility.

This transparency sandwich was made by making a colour print of an eye which was vignetted so that it appeared isolated on a white background. This was then copied and juxtaposed with the shot of a tree against a very-light-toned background

PHYSIOGRAMS

Light is what makes photography possible, but it is seldom used as the subject of a photograph. The technique under discussion here is a method of using one or more light sources to create patterns and effects on film and without a subject in the normal sense. It is an entertaining way of experimenting with photographic effects in the comfort of your home on those dark, damp winter days when the great outdoors loses its appeal.

You will need a camera with the means of giving time exposures and a tripod or support of some kind. You will also need a flashlight or batteries and small lightbulb holders and a room which can be made completely dark.

In its simplest form a physiogram can be made by suspending a flashlight on a length of cord from a point above the camera. Ideally the cord needs to be a metre or so long and the camera a metre or so below the torch. If your ceiling will not allow these distances you can use a mirror set at a 45° angle and the camera to one side of the suspended torch. This arrangement will also make it more convenient to view the image.

The pattern is created by simply swinging the flashlight in a gentle arc and keeping the camera shutter open until it has completed a number of circuits. It is best to make a number of dry runs watching the path of the light bulb on the camera screen to judge how wide an arc is necessary and how long to let it record on the film before the lines it creates become too compressed. Obviously a degree of trial and error is involved but this is part of the fun of creating an effective pattern.

Before switching off the room light and making the exposure focus on the flashlight bulb, although you can also experiment by using an out-of-focus image. Colour can be introduced by placing filters over either the flashlight bulb or the camera lens. Multicoloured effects can be easily produced by placing three or four different coloured filters in a single mount and simply sliding it back and forth across the camera lens as the light source rotates.

Another method of making the colours more interesting and the pattern more complex is to use more than one light source. A quite simple arrangement can be made by mounting say three flashlight bulbs onto a thin bar of wood about 20cm long, each with a different coloured filter. The wood can then be suspended from its ends with two pieces of cord and these can be wound up like the propeller of a toy aeroplane. As the bar itself swings in an arc it will also unwind and rotate creating a far more complex pattern and mixture of colours.

There are many other ways of adding interest and complexity to this technique. You can combine a number of different swings and patterns on the same piece of film, for example, or you can alter the camera's focus during the exposure time. You can also introduce a piece of patterned glass over the camera lens for some or part of the exposure time to distort the light path.

The length of the exposure is relevant only to the extent of the pattern, and the density of the image will depend upon the choice of aperture, the brightness of the flashlight bulb, the density of the filters used and of course the speed of film used. It is best to try a test roll and to bracket exposures to begin with. As a rough guide, with a normal flashlight bulb and a film of ISO 200, I would suggest that the best approach is to try apertures in the region of f8.

Three separate exposures were used to make this physiogram using a different arc and colour filter for each

PINHOLE PHOTOGRAPHY

To look at the array of cameras and lenses in a photographic-store window it might seem that taking photographs was a very hi-tech business, depending upon the miracles of the micro-chip, complex optics and advanced electronics. It is however, in essence, a quite simple process and producing a photographic image is something which can be done with quite crude and make-shift equipment.

A camera is nothing more than a light-tight box with an image-forming device, usually a lens, at one end and a piece of sensitive material at the other. Very pleasing images can be made using a simple cardboard box, some kitchen foil and a pin.

The pinhole forms the image and the definition will depend upon the size of the pinhole in relation to the size of the image it creates; the smaller the hole the better the image. Find a good-sized cardboard box with a tight-fitting lid. For this type of pinhole camera it is best to use bromide paper as your sensitive material, so choose a box which allows you to use a standard paper size like 10 × 8in.

The angle of view depends upon the size of the paper and the distance of the pinhole from it. With 10 × 8 paper a pinhole about 12in distant will give an angle of view roughly equal to a standard lens. Significantly less than this will give you a wide-angle camera and greater will produce a long-focus effect. At one end of the box cut a small hole an inch or so in diameter in the centre. Pierce a hole in a piece of kitchen foil about two-inches square with a fine pin or needle, tape it over the hole in the box and cover it with black masking tape. This is the camera.

You need to load it in a darkroom by taping a piece of bromide paper to the end of the box opposite the pinhole and then to fix the lid in place with black tape. To take the picture you will need a firm support — a tripod is ideal. You will have to aim the camera mainly by guesswork, but lines drawn on the top of the box from the corners each side of the pinhole to the centre of the side where the paper is positioned will enable you to sight it approximately.

The exposure is made by simply removing and replacing the black tape over the pinhole. You will need to make a test to determine the exposure time but, as a rough guide, on a sunny day try about 3 or 4 minutes. Processing in the normal way will produce a negative print which can be contact-printed onto another piece of bromide paper to produce a positive.

If you make colour prints you can try using Cibachrome paper, or something similar, to make direct colour-positive prints. Pinhole photographs can be also made, more conveniently, by replacing the camera lens with the pinhole foil and exposing directly onto colour or black-and-white film. Remember, when using small formats the pinhole will need to be as small as possible to ensure reasonable definition.

For this abstract flower picture, I pierced four minute holes close together in a piece of foil which was then taped over the end of an extension tube attached to the camera body. Surprisingly, the meter on my Mamiya 645 gave an exposure reading which proved to be accurate although the image was very dim

PRESENTATION AND DISPLAY

Even a great photograph can be enhanced by good presentation, and more modest efforts may be transformed by the way they are mounted and displayed. The most self-defeating way of showing photographs is probably the flip-over album which encourages every print from a roll to be included. I'm sure everyone has experienced the mind-boggling boredom of looking through a hundred or so similar images in one of these folders; the main consideration is how fast they can be flipped over without giving offence.

The first step in good presentation is to edit your pictures quite ruthlessly. Never include two or more similar images unless they form part of a sequence. Don't include anything which is badly over- or underexposed. An unsharp picture is only justified if it captures a spontaneous moment successfully, but never for a view or a portrait. Pictures with messy backgrounds or wonky horizons should also be eliminated.

As a general rule small prints are best displayed as a group rather than as single images. An album which allows say three or four prints to be mounted on a double page can look very effective if they are chosen to enhance each other and are laid out in a pleasing and balanced way. Don't be restricted by the size and shape of the prints which the lab has supplied. If cropping will improve the composition or give the picture more impact it is a simple matter to trim it with a craft knife and straight-edge.

Larger prints can be mounted in a portfolio folder showing a single picture to a page; one with protective acetate sleeves is ideal. It's best to mount the prints first on to thin mounting board to give them some rigidity and protection. Choose images for facing pages which complement each other. You can vary the pace of such a presentation by including some prints which fill the page and others which are smaller with wide borders.

Really great pictures deserve a more permanent mode of display and a nicely framed print on a living room or office wall can become a focal point of the decor. A group of well-matched smaller prints can look as pleasing as a single larger image. It should be appreciated, however, that a colour print is less permanent than a correctly processed black-and-white image and should not be hung for long periods where it will be subjected to direct sunlight.

There are a wide selection of good DIY frames available from the simple clip frame to aluminium, wood and plastic. As a rule, fairly plain frames suit photographs best. The print should be mounted on a thickish mounting board, spraymount can be used or dry mounting tissue is even better. Whichever type of frame is used, the effect is often improved by the use of a bevel-cut overlay in a tint chosen to enhance the photograph. These can be bought ready-made in standard sizes or, with a little practice and a sharp scalpel, you can cut them yourself.

Nicely mounted and framed photographs can be used to make an effective contribution to the décor of a room

PHOTOGRAMS

Electronically controlled cameras and fast processing laboratories make producing photographs a very simple and convenient business. It does, however, rather tend to take some of the fun out of the process and also some of the magic of seeing an image formed. One way of discovering some of the behind-the-scenes pleasures of photography is to experiment with making photograms.

A photogram is a means of reproducing an image directly onto photographic paper without the need for a camera, lenses or even a proper darkroom. You do need a room which can be made lightproof and a safelight bulb. You will also need some plastic dishes, black-and-white processing chemicals and a packet of bromide paper.

The basic principle is very simple. You just place an object, or objects, onto a sheet of bromide paper, expose it to a light source and process it in the normal way. The light source can be merely a bulb suspended above the table on which you place the photogram. If you have a darkroom you can use the enlarger as a light source.

If you choose a completely opaque object, the image produced will only be a white shape on a black background. If the object has an interesting

or detailed outline, or you make an arrangement of several objects, the result can be quite pleasing. However, if you really feel adventurous even more interesting effects can be created by using transparent or semi-opaque objects, like glass ornaments, thin fabric or plastic utensils for example.

The art of an interesting photogram is not only to make a pleasing composition but also to choose things which will produce a range of tones from white to black, just like a normal photographic image. This can be done by selecting items with different densities and by shading — giving selected areas of the image more or less exposure.

You can also introduce a range of tones by moving the light source. Instead of placing it directly above the paper you could make part of the exposure with the light at one angle to the paper, and then another changing its position. A hand torch can be used in a similar way by moving it from side to side during the exposure. The photograms produced initially can be contact printed to create an image with the tones reversed.

With an enlarger you can make enlarged photograms by placing small objects in the negative carrier and projecting them onto the paper. If you make your own colour prints why not use the flexibility it gives you to produce photograms by choosing semi-opaque objects of different hues like flowers for instance or tinted glass and plastic.

Left *The different weights of thread and density of weaving have created a range of tones in a single, straight exposure in this photogram of a lace table centre*

Below *I used the skeleton of a decayed leaf found in the garden to make an enlarged photogram for this image*

INDEX